AUSTIN
IN THE
JAZZ AGE

RICHARD ZELADE

THE
History
PRESS

Published by The History Press
Charleston, SC 29403
www.historypress.net

Copyright © 2015 by Richard Zelade
All rights reserved

First published 2015

Manufactured in the United States

ISBN 978.1.62619.918.7

Library of Congress Control Number: 2015941004

For Diana

CONTENTS

Contents

INTRODUCTION

As heady as the Austin music and arts scene is today, it has not equaled the explosion of talent that marked Austin's Jazz Age, which produced several dozen musicians, band leaders, singers, composers, movie stars, writers and dancers who achieved national, and sometimes international, fame. Some were born in Austin. The rest attended or graduated from the University of Texas.

The Jazz Age refers to the period from the end of World War I to the onset of the Great Depression (1918–29), also called the Roaring Twenties, when traditional values crumbled as fast as the stock market soared. The Jazz Age drew its name from F. Scott Fitzgerald's novel *Tales of the Jazz Age*.

The country was filled with optimism and excess during the Roaring Twenties. The Jazz Age went a few lively steps further.

Jazz was more than music; it was a lifestyle—a new and different attitude and way of living. It was a reaction to 1) the misery, destruction and perceived waste of World War I; 2) the worldwide influenza epidemic of 1918–19, which killed mostly young people; and 3) their elders' conservative moral values that brought on Prohibition and frowned on sexual freedom.

Individualism and the liberation of women marked the Jazz Age, and the "jazz life" dedicated itself to the pursuit of physical pleasure and enjoyment.

Most writers have an "ah ha!" moment when the idea for a book comes to them. I'm sure I did for *Austin in the Jazz Age*, but I sure don't remember

it. Still, I'm glad it came. The resulting tales are very interesting—even though this truncated version of the original sprawling manuscript leaves out dozens of interesting people and relationships.

So get ready to go, and "If You Can't Dance, Get On and Ride!"

PART I
JAZZ LIFE

1
ALL THAT JAZZ

Sometime in the early spring of 1919, Professor Carl Besserer was huddling with his young orchestra members. Besserer started Austin's modern live music scene when he opened his music store in 1868 and began selling musical instruments and organizing boy bands. He had been its king ever since. Besserer's Orchestra played everywhere, from University of Texas (UT) student dances to governors' receptions. It had been a great half century. But there were Huns at the door: jazz bands.

"Boys, if we don't play jazz, they throw us out, and then we lose our jobs."

For the first time, Besserer's Orchestra began advertising in UT's *Daily Texan* newspaper, offering music for all occasions, with "JAZZING A SPECIALTY!" But Besserer did not like or understand jazz, and his orchestra folded a year later.

Shakey's Jazz Orchestra left Besserer's Band in the dust.

Jack Tobin, the gifted and precocious eighteen-year-old son of a prominent Austin family, organized Shakey's Jazz Orchestra in January 1919. Its members were high school students, as young as sixteen. Tobin played piano and led the lively orchestra, despite never having taken a music lesson. The members played by ear.

Shakey's Orchestra was an instant hit. If it wasn't Shakey's, it wasn't jazz, fans said. Unadulterated, primitive jazz: beating on tin cans, skillets, garbage cans; stalking up and down the floor with the dancers; leaping all over the piano(s)—a "monkey show," in the parlance of the times.

Starting in March 1919, Shakey's Orchestra took over as the house band for the Saturday night German Club dances.

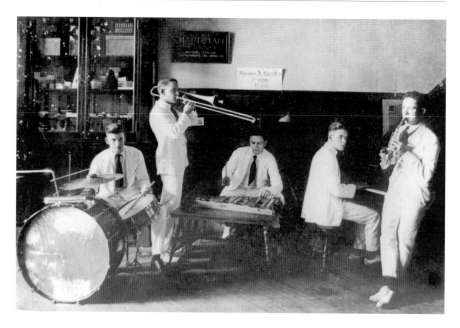

Shakey's Orchestra, circa 1919. *PICA 05447, Austin History Center, Austin Public Library.*

The German Club was not a group of students dedicated to the study of the German language; rather, it was a dance club whose name derived from a type of dancing party popular in Austin beginning about 1880. The Jazz Age Germans scarcely resembled their predecessors.

Shakey's never recorded, so we don't know what the orchestra sounded like, but the following poem from the campus humor magazine, the *Scalper*, in the spring of 1921 gives us an idea:

IMPRESSION IN SYNCOPATION
Drums and piano softly throb
And boom and vibrate mystically.
And the dancers sway to an eastern tune—
And pound the floor in perfect time.
Now the clarinet shrieks, then sobs and dies
While mute cornet sends out short stabs of melody.
Boom, boom, louder, reel, riot, sway,
The dancers shout and whirl,
Young girls feel a primitive urge,
Young men hold them and dream…
And incense from far Egyptia

Floats through the whirling hall
And Bacchus pales to see the revel
That intoxicates them all.
* Now louder boom the drums*
And wilder grows the rhythm
And a snarling flutter-tongue
From the cornet, sends my skin a-tremble:
A bombardment of molecules creeps of my spine
And the dancers hum the tune
And the dancers whirl like wild;
And the cymbals crash and crash...
And even old China wonders
At this barbarous discord
Such as she with her eerie music
Would certainly have deplored...

Shakey's Orchestra was Austin's first formally organized jazz combo with a name, but jazz had infected the city several years earlier.

In the early months of 1917, war fever against Germany was rising all over the country. The United States entered the world war on April 6, 1917, the same week as the word "jazz" first appeared in print in Austin, in a Columbia Records ad in the *Austin American* announcing "Hong Kong," a new "Jazz One-step" recorded by Prince's Band.

In August 1917, Prince's Band recorded "Mr. Jazz Himself," and "jazz" again cropped up in a tiny story from New York in the *Austin Statesman* called "Squabbling Dancers to 'Kiss and Make Up'":

> *Efforts to compose differences between the inner circle, the so-called "advocates of up-to-the-minute dancing," and the American National Association of Masters of Dancing, will be made when the association meets at its annual convention in this city Wednesday, according to G. Hepburn Wilson, head of the inner circle, which opened its convention here today.*
>
> * Mr. Wilson says his organization regards the fox trot and the one step as dances of a "by gone age" and will endeavor to impress the association with the interpretive value of the ramble, the jazz dance, and the toddle, which, he says, are the latest creations in the terpsichorean art.*

But what was "jazz?" The *Statesman* endeavored to shed some light on jazz's dark origins in August:

"Jazz" comes from the section and the race which produced the "jitney," but has mounted higher in the social scale. We speak of a five-cent piece as a "jitney," giving an accent to the word which sets it off as a word not our own. But "jazz" we have adopted as a proper adjective, descriptive of a form of music or of the band which plays it. The word is of negro origin and means "fast." The sort of syncopated music to which it is applied is not only fast, but furious. A writer in the New York "Sun" happily describes it as the "delirium tremens of syncopation." Born of the jungle, it has reached the American cafes and roof gardens as a result of the activities of those sailor-merchants who in the days of our grandfathers exchanged trinkets made in New England for the captives of African warriors.

Before the white man came in his slave ships the original "jazz" band played for the edification of dusky kings and their men of war. As the musicians were beaters of drums their music was made up of "beats," and so is the "jazz" music of today. The tom-tom lives again in the syncopations which set moderns dancing.

Most folks thought jazz music came from New Orleans and jazz dancing from New York, but Dr. Oscar Junek, head of the Goodrich Rubber Company's Educational Department, declared that jazz music and dance came from gypsies who roamed southern Europe. Austrian-born Junek said he often saw gypsies do the jazz dance. He thought some traveling American dancing masters had seen them, too.

Whatever the case, the first UT football season's pep rally on October 3 promised "to be the jazziest exhibit of Longhorn frenzy and go get 'em spirit that has been seen since the A&M game last year. The new yell leader to replace 'Rattle-de-Throat Jones' must enjoy the confidence as well as the respect of every 'jazzer.'"

On October 12, the Friday night German at the Knights of Columbus Hall featured the Majestic Theater's new jazz band. Dancing in Austin would never be the same again.

For the University of Oklahoma game pep rally a week later, yell leader Bill Collins and his crew sported "jazz uniforms" and jarred loose "some of that old stuff popularly called 'jass.'"

The Friday night German began early, at 8:30 p.m., so students could catch the night train for Dallas, where Texas would play Oklahoma the next day. The music was good, said one student, but after the previous week, when the Majestic's jazz band had played some of

the most heavenly music ever heard in the KC Hall, nothing short of another jazz band would ever appease the appetite that the wonderful performance aroused.

In October 1917, "The Texas Blues," a "jazz piece" by John S. Caldwell, debuted—the first jazz song to come out of Austin. "Mr. Caldwell," the *Austin Statesman* wrote,

> *has written a number of musical hits, but this latest achievement will probably be the most popular of them all. Vaudeville artists all over the country are featuring it and a large publishing company has bought the rights for the piece to be cut in player-piano rolls and these rolls have been placed on the market and are in great demand.*

Caldwell was composing music for publication as early as 1898 and continued writing songs through at least 1920. Caldwell's most enduring song is "The Graveyard Blues," published in 1916.

"It is not surprising," the *Statesman* wrote in January 1917,

> *that over a thousand copies of "The Graveyard Blues" have been sold, for it is strictly characteristic of the negro. It is written in four-four time—the words well suited to the appealing and mournful tune. There is nothing monotonous in the song; and the harmony well supports the strain, which, at times, drops into the well known "blue" moan or wail.*

Arthur Collins recorded "The Graveyard Blues" in 1917. His recording of "The Preacher and the Bear" in June 1905 was the first million-selling record. He was one of the earliest blues recorders, covering W.C. Handy's "Hesitating Blues" in 1916. In 1917, he recorded several solo records with "jazz" or "jass" in the titles.

The "blues" were an integral part of early jazz. Every other jazz song seemed to have blues in its title. The blues were as mysterious to white Americans as jazz.

In 1922, Texas Folklore Society member Dorothy Scarborough tracked down W.C. Handy, "the man who had put the bluing in the indigo," for the society's annual collection of folklore stories. His first blues song, "Memphis Blues," came out in 1910.

"There are fashions in music as in anything else, and the folk-song presents no exception to the rule," she wrote.

For the last several years the most popular type of negro song has been that peculiar, barbaric sort of melody called "blues," with its irregular rhythm, its lagging briskness, its mournful liveliness of tone. It has a jerky tempo, as of a cripple dancing because of some irresistible impulse. A "blues" likes to end its stanza abruptly, leaving the listener expectant for more, though, of course, there is no fixed law about it. One could scarcely imagine a convention of any kind in connection with this negroid free music. It is partial to the three-line stanza instead of the customary one of four or more, and it ends with a high note that has the effect of incompleteness. The close of a stanza comes with a shock like the whip-crack surprise at the end of an O. Henry story, for instance—a cheap trick, but effective as a novelty. Blues sing of themes remote from those of the old spirituals, and their incompleteness of stanza makes the listener gasp, and perhaps fancy that the censor has deleted the other line.

Handy told her that each of his blues was "based on some old Negro song of the South that I heard from my mammy when I was a child."

Were the blues a new musical invention? "No," he said. "Our people have been singing like that for many years. But they have been publicly developed and exploited in the last few years."

The 1917–18 *Cactus* yearbook staff announced in the fall of 1917 that the *Cactus* would feature a new department called "Jazz Parties," with photos featuring athletic rallies, pep gatherings, college yells and songs and yell leader antics. Everything was full of "pep" during the Jazz Age.

Despite the sudden popularity of jazz among the youth set, many saw it as a fad that would soon give way to other fads.

But jazz had such a grip on the University of Texas student body that the *Austin American* of November 11, 1917, in its weekly UT page, ran "Orlando, the Rabid Jazzer" to try to convince readers not to succumb to the jazz bug:

Every idea and each fad,
Be it good or be it bad,
Every time, it seems to me,
Has some rabid devotee
So the jazz.
　　Let me tell you of Orlando,
How he loved his little banjo,
How he liked this jazzy dancing
And its wild, ungainly prancing
He would jazz.

He feared not the dread jazzaritis,
And the crazy fool would fight us
If we pleaded against his jazzing.
Against his strange and frenzied jazzing
He'd always jazz.

When the jazz band started roaring,
It would set his spirits soaring;
His proverbial wicked knee
Took its cue for a new spree
He liked jazzing.

"Out upon the old veranda,
Come out and jazz my sweet Cassandra.
Come out on the old piazza,
Dear Cassandra, we will jazz-ah!"
They would jazz.

He would say unto the butler
(Than the butler none were subtler)
"Make the lights a little dimmer,
I can feel the slightest tremor!"
Old jazz tremors.

"Orlando, you are crazy."
Then he'd answer, slow and lazy,
"How this music flips and flops.
Can't you feel it in your props?"
Funny old jazz.

"And my soul goes in contortions
With these musical abortions.
When I hear the jazz band screaming
It is like the angels dreaming."
He jazzed lots.

And he had the sort of notion
That the crowned heads 'cross the ocean
Ought to learn this heavenly motion
As a sort of peaceful lotion.
Jazz in peace.

"Its erratic, zig-zag notes
Form a melody that floats
Like the foam upon some streams,
Like the mist in happy dreams."
He dreamed jazz.

But Orlando once was shaving
And about the jazz was raving
The Victrola started playing
And the razor started swaying.
The razor jazzed.
 Father Time is nearby lurking
When a razor starts to jerking;
The result was sad to note.
Poor Orlando cut his throat.
A jazzy death.
 Thus, we found him in his room.
He was slated for the tomb.
Though his breath was going fast,
Still he spoke this at the last:
The deadly jazz.
 "For the sake of my dear art,
I now know I must depart.
But I know I'm dying game
And I love jazz just the same.
True to jazz.
 "When you place me in my grave,
In my grave so cold and dank,
Just pile the clods in on me
To the tune of 'Slippery Hank.'"
Jazz
 No
 More!

"Slippery Hank" was the hottest record during the first year of jazz. Earl Fuller's Jazz Band recorded it in June 1917, and Victor Records issued it in September.

"Slippery Hank" has been described as "jazz about five minutes after its birth, kicking and wailing like hell. The drummer offered machine gun fire, the trombonist lows, the clarinet player howls above the rest."

Jazz was more than music; it was a new, radically different lifestyle.

The jazz life was a reaction to 1) World War I's misery, destruction and waste; 2) the 1918–19 influenza pandemic that killed millions of mostly young people; and 3) the conservative moral values that brought on Prohibition and frowned on sexual freedom.

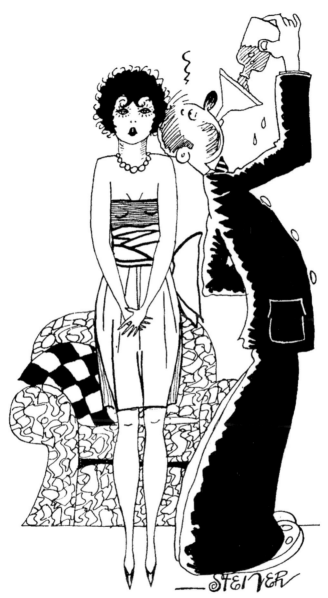

"Well, Thelma's just the kind of a girl that men overlook."
"You mean Thelma's just the kind of a girl men look over well."

From College Humor *(Collegiate World Publishing Company, 1927). Author's collection.*

In a speech before fellow members of the Knox College Alumni Association, Earnest Elmo Caulkins, dean of the American advertising profession, defended the youth of the day and issued a scathing denunciation of the mistakes made by a nation laboring under "old fogey" notions and ideals:

> *Youth has found its elders out. Disillusioned by the experiences of a world war, it no longer takes things for granted, since it now knows that much that was taught it so confidently was false—but not merely in physics, chemistry and biology, but in the older realms of history, literature, civil government, religion, and ethics. Youth sees a world bewildered and adrift under the guidance of age, operating by old copy book maxims—and its verdict is "not so good."*

The Jazz Age lasted roughly from 1918 to 1929 and drew its name from F. Scott Fitzgerald's novel *Tales of the Jazz Age*. The jazz life was characterized by its emphasis on the pursuit of pleasure. It involved liberal consumption of illegal alcoholic beverages (as well as cocaine, heroin and marijuana) and the reckless "sperm-of-the-moment" behavior that usually followed.

As this little ditty from a January 1922 issue of the *Daily Texan* put it:

> *Jazz has a naughty twang.*
> *I like it.*
> *It's written for the vulgar gang.*
> *I like it.*
> *It's full of discords, noise and din.*
> *Its syncopation is a sin.*
> *It warps your ears; it's low—oh, Min!*
> *I like it.*
> *Cheek dancing is a vulgar game.*
> *I like it.*
> *It makes your morals weak and lame.*
> *I like it.*
> *It teaches debutantes to pet.*
> *It ruins all the younger set.*

And since the jazz life was all about fun, UT jazzers got their own humor magazine in October 1919: the *Scalper*, a slick paper monthly. Since the death of the *Coyote* several years earlier, there had been no comic publication on campus, and the *Scalper* aimed to be like the *Harvard Lampoon*, the *Cornell*

Widow and others. Jack Hyman was the debut editor but was kicked out of school less than a month later. The *Scalper* would be in hot water with the UT administration throughout its short life.

The first issue's first words set the tone for the wild years to come at UT:

> *Welcome Home!*
> *Now that all the old gang is back again, with all the pep and jazz that used to characterize the Varsity, let us take up the reins of a new regime. Two years have passed since Texas has had anywhere near a representative attendance, and with the end of the big fiasco, and all the real he-men back in this man's school, we're going to have a big year.*

During its first year, each issue of the *Scalper* lampooned one of the burning issues of the day, including Bolshevism, the Ku Klux Klan, Prohibition, free love, jazz and intellectualism.

The *Scalper* featured the artwork of a good half dozen of the greatest cartoonists in Austin's history, including Roy Crane, Ralph Jester and Joe Ernest Steiner.

Roy Crane, Ralph Jester and Joe Ernest Steiner were UT freshmen in the fall of 1919. As the creator of Captain Easy, Crane was the father of adventure story cartoon strips. Some of Austin's foremost music poster artists cited Crane as a primary influence fifty years later. Crane began cartooning for the *Cactus* yearbook that year, along with Ralph Jester (see Chapter 10) and Joe Ernest Steiner.

Joe Ernest Steiner was the younger brother of Austin's legendary T.C. "Buck" Steiner, world rodeo champion, "bubble dancer" Sally Rand's boyfriend and founder of Austin's Capital Saddlery. Joe Ernest went on to become the most prolific cartoonist for college and mainstream humor magazines during the Jazz Age, before settling down as a lawyer in Austin.

"Vulgar cheek dancing" got the administration's long johns in such a knot that toward the middle of the evening of November 18, dean of women Miss Lucy Newton gave a short talk on modern dancing and its application in university activities, followed by floor manager G.F. Simmons, who said that "death grabs" and other objectionable forms of dancing were to be prohibited.

The UT administration was not just cracking down on objectionable forms of dancing, as the *Scalper*'s editors observed in November 1921: "The University of Texas' system of morality is based, it seems to us, on this sterling principle: that if a boy and a girl are alone for as much as one minute

they will instantly commit a loathsome indiscretion." Such editorializing did not win the *Scalper* many friends in the administration.

The *Scalper* was fighting for its life during April 1922, following the publication of its "Free Love" issue. In May, the *Scalper* staff resigned.

Following a series of controversial issues, the administration tomahawked the *Scalper* after the November 1922 issue, and UT was left without a comic magazine.

Dismissed at birth as just another short-lived fad, jazz proved to have remarkable staying power.

Sometime in the summer of 1922, Shakey's Orchestra broke up. But it turned out to be no big loss. Tobin had been exiled to the University of Virginia for the 1920–21 school year, and when he returned to Austin, he revived the band. But there was competition now from several hot combos, including the Moonshiners, Sole-Killers, Fire House Five, Band-Its, Hokum Kings, Apaches and others.

"When Shakey's Orchestra passed away, the trippers of the light fantastic mourned over the futures of University dances," a *Daily Texan* reporter wrote in 1925, "but into the breach stepped the soon-to-be renowned Jimmie's Joys, née the Sole/Soul Killers, to gladden the heart of the ed and co-ed. Jimmy Maloney renamed the group Jimmie's Joys—"the exterminators of gloom."

After the administrative axe fell on the *Scalper*, it fell elsewhere on campus as well. Male students were no longer allowed to have cars, and the Ribbon Clubs—Rattler, Arrowhead, Angler, Rabbitfoot, Court of Plasters—whose dances had been so notoriously memorable in recent years, were dissolved. Originally formed to better inter-fraternity relations, they had outrun—and out drunk—their lives.

In the spring of 1923, acknowledging the student body's need for a campus comic magazine, the Publications Board authorized the publication of a new comic magazine: the *Texas Ranger*.

When the *Texas Ranger* debuted in October 1923, it was an immediate success. It immediately attained a circulation of 4,500 copies and exchanged jokes and cartoons with the country's leading university and college comic magazines.

Despite promises of modesty, the *Ranger's* jokes, humorous pieces and artwork were as risqué as anything seen in the *Scalper*, if not more so.

When did the Jazz Age peak? It had reached new heights (or depths, depending on your perspective) during the holiday season of 1924–25, when the *Austin Statesman* ran a series of articles written by Mrs. Wallace Reid, widow of the late film star, on the problems confronting young people and

their parents. Wallace Reid had died almost two years earlier of problems related to his morphine addiction. In an installment called "Automobile Chief Aide to 'King Jazz,'" she wrote:

> *Of all the complex changes that affect young people today the automobile has had more to do with this so-called "jazz age" than any other one factor. The automobile makes it possible to cover great distances quickly. This means that in a very few minutes boys and girls may be far removed from home influence and jurisdiction.*
>
> *Furthermore, the very speed at which they travel contributes to the excitement of the occasion.*
>
> *Add to this situation the modern styles of dress, makeup, dancing, and, I am afraid in some instances, pocket flasks, and you have a situation that requires much more judgment and common sense than was asked of young people a generation ago.*
>
> *Now, how are we to prepare to meet this newly found freedom. We cannot keep our young people at home all of the time. And we cannot always occupy them when they go out. They must be educated to think and decide for themselves—to want to do the right thing.*
>
> *Pay even more attention to the companions of your sons and daughters at the "flapper" age. You can help to choose these companions without causing resentment, even without the knowledge of the young people. You can accomplish this by entertaining in your home and encouraging youngsters to come.*
>
> *A happy home is the deadly enemy of "Jazz."*

Dean of women Miss Lucy Newton told the *San Antonio Express* newspaper in October 1924 that there were no flappers at UT. "We do not think in terms of flappers," she declared. "They are not spirited away, but simply assimilated."

But just days earlier, a *Flapper* magazine photographer had hit town looking for two representatives of the species to represent the state of Texas in a forty-eight-state flapper photo revue. He hadn't found anyone in Houston and was headed for San Antonio when he decided to stop in Austin. Within a couple of hours, he had his flappers and moved on to the next state.

"Jazz is not dead; it just smells funny," Frank Zappa said in 1973.

"Jazz Music Improving" broached the same subject in the fall of 1926:

> *Is Jazz music bad? Or the question might be asked, "Is the music of the present-day orchestra jazz music?"*

When jazz music first originated, it is true that the person who could get the most notes in and give the most blare was acclaimed as the best musician; but that was jazz in its lowest form. Many, however, still judge the music of the modern orchestra from this early conception.

However, since that day many great figures such as Paul Whiteman, Vincent Lopez and others have entered the field and raised the standard of that music. Now the day of individuality in the orchestra is waning. The old idea of the loud solo has been changed. In its place has been substituted solos written by celebrated arrangers. Even those that are not written out are played much sweeter and softer and have as their keynote refinement rather than the same old blare.

Some of the leading musicians of the country believe that the day of the individual musician will pass within one or two years and team work will be substituted. The parts will be played note for note, without anything being added by the player.

All this is a step toward the classical form. The music of the jazz orchestra interprets American optimism, enthusiasm and life. It is altogether typical of our county. And that jazz is improving can hardly be denied.

But the jazz life smelled as sweet as ever. Joe Steiner, now editor of the *Ranger*, announced:

Under the leadership of Joe Steiner, Editor-in-chief, and Tom Holloway, Managing Editor, the negligent and irregular writers and artists of the campus please themselves and attempt to please their readers by their transgressions of propriety, subtlety, and all other standards of taste. The Editors and staff members of our college comic are connoisseurs of the inane. Their heads are crammed with jokes on liquor, love, and other froth of college life. Its airs are those of the dance, the fireside, the football game, and the petting party. The Ranger is rated as one of the best college comics in the United States. College Humor, Judge, Topics of the Day, and many other nationally famous publications clip a large amount of material from our campus comic.

On September 18, 1926, Bill Naylor, an NEA press syndicate rep who traveled the entire country every eighteen months, came through Austin and pronounced the place "paradise" chiefly because there were "more pretty girls here than almost any place. Came into town with a bunch of them on a bus. Plenty of them on the streets."

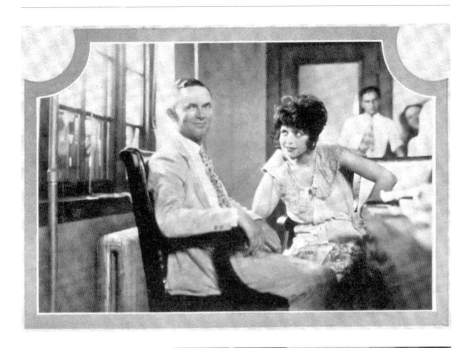

Above: "Clara Bow and President Splawn." *From the* Cactus, 1927, *Texas Student Publications. Author's collection.*

Right: "24 Vertebrae (Clara Bow)." *Publicity photo.*

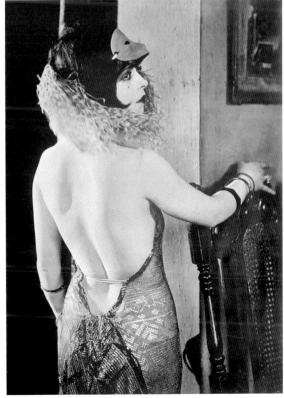

A week later, Clara Bow, the "It Girl," came to town from San Antonio, where the movie *Wings* was being made. Bow and her party arrived about noon on September 23 and paid a call on Governor "Ma" Ferguson. At 2:00 p.m., she and her managers headed to UT to meet as many students as possible and have a talk with President W.M.W. Splawn. "I have always wanted to visit the campus of the University of Texas," she said.

"Do I like the University of Texas students? Boy, I say I do. I believe they're livelier down here too, than they are at other colleges," Bow exclaimed, glancing at the crowd of five hundred or more students eagerly waiting in front of the Main Building for her. She thwarted them by stopping at the Education Building and running into Splawn's outer office, where she waited until he arrived. A photo was taken of them in conversation.

Leo Haney of Wichita Falls carried Bow on his shoulders from the Education Building to the *Daily Texan* office, where she stayed for a few minutes and left declaring that she would rather be in the moving picture game than work on a newspaper.

Announcing that she would kiss the first redheaded boy she encountered, Bow did not have to wait long for someone to take her dare, but the lucky student wished to remain anonymous.

After a short visit to the capitol to speak to the assembled senators there, she visited the Deke fraternity house before returning to San Antonio.

Her new hit movie, *The Plastic Age*, was showing at the Hancock Opera House. "This picture will give you a college education, but not the kind the school catalogues describe," ads for the movie promised.

She was surprised that *The Plastic Age* was showing here but said she could not stay over for it because she was Hollywood bound to work on a new movie.

The March 1927 issue of the *Ranger*, dedicated to campus beauties, featured a cover drawn by John Canaday. Canaday was one of the *Ranger*'s raciest cartoonists; his style was distinct from that of Joe Steiner, sexy in a sophisticated, artful, continental way, as opposed to Steiner's outlandish, more cartoony, sheba/sheik style—which was not surprising, since John was a French and English literature major. Canaday's girls were not afraid to show off their erect nipples, tight asses and shapely legs, clad in garter belts, bathing suits, clingy transparent dresses and even lesser forms of provocative dress.

The *Texas Ranger* bit the dust in May 1929, banned like the *Coyote* and *Scalper* before it, a victim of its own cleverness. It reemerged—emasculated—that fall, combined with the *Texas Longhorn*, the university's literary magazine, as the *Longhorn-Ranger Magazine*. It was a harbinger of things to come.

26

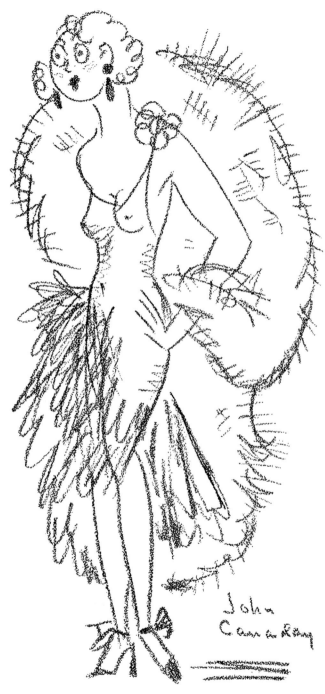

From the Texas Ranger, *Texas Student Publications, 1929.* *Author's collection.*

"For heaven's sake, Jim, hurry up with that taxi. My nose is simply frozen."

Meanwhile, the problem of students writing hot checks to area merchants had grown to the point that the university took out a full-page ad in the *Daily Texan* warning of the consequences, including suspension from school, that would befall hot-check writers.

As the Great Depression settled in, "jazz" was still part of the daily lexicon, but it was no longer the raison d'être for UT students. Most of the dance and band ads in 1930 didn't even mention jazz, and when they did, it was merely part of some larger context, as in the "whispering melodies, lilting tunes, and rhythmical jazz" that were promised for the first all-university dance in September 1930.

Dr. Sigmund Spaeth, New York music critic and popularly known "playboy of musical pedagogy," told an audience at Texas Christian University in the winter of 1930–31 that "the fundamental characteristics of jazz will be borrowed by the serious composers of America, if she ever produces any great music. The 'Rhapsody in Blue' by George Gershwin is a hint as to what this future may be."

The *Daily Texan* agreed with Spaeth and added:

> *If the progress of jazz is traced from the time it trumpeted upon the country's consciousness with a ragtime blare to the present day, it can be seen that the trend is definitely towards the expression of the more beautiful and finer, but still with all the retention of the elements of popular appeal. Jazz has still not yet realized upon its potentialities and possibilities. A little patience and tolerance is to be urged of critics.*

Jazz music had lost its edginess, and so had the jazz life.

On October 31, 1931, a *Daily Texan* editorial chucked the jazz life into the dustbin of history:

> *We consider it high time that we refute the charges of the older generation, the inimitable critics of youth. It was almost necessary that we accept supinely the odious criticism heaped upon us when we were passing through that phase following the war when precocious youth had its fling. But we have passed the threshold into a new era.*
>
> *The pendulum is swinging back. We can, and will, protest that the average student of today is as sober and ambitious as the average non-college man or woman. There are still vestiges of the "jazz era" but they are rapidly being supplanted by the pre-war type.*

2

JUST GRIPPE WITH A FASHIONABLE NAME

As school started in the fall of 1918, there was a general optimism on campus and across the country that the Germans would surrender soon and the awful war could be ended. Too many UT boys had already given their lives in the War to End All Wars.

The world war was indeed only six weeks away from its end, but the dying was not; many more soldier boys would succumb to the "Spanish flu," which, despite its name, was first observed in Fort Riley, Kansas, on March 4, 1918, and in Queens, New York, on March 11, 1918.

This influenza pandemic, which ended in 1919 or 1920, killed between 20 million and 100 million people and about one-third of the European population—more than double the number of people killed in the war—because of the extremely high infection rate (up to 50 percent) and the severity of symptoms. For some mysterious reason, the flu favored young people as its victims.

Austinites had read about the flu in the newspapers for several months, and as summer finally gave way to fall, influenza finally hit home.

On October 5, the student health center overflowed with students "who thought they had it, though their appearances failed to indicate unusual suffering." Dr. Joe Gilbert dismissed the Spanish influenza as not dangerous. It was "just plain grippe, with a fashionable name," and not an epidemic, although several faculty members had gotten so sick that several classes were dismissed.

Two days later, flu closed down the UT campus.

A couple of weeks later, the number of infections was down, and the disease appeared to be receding, so classes resumed on November 4, a week before the war ended.

Two days before the November 11 Armistice, the Camp Mabry Ball, given by the officers of Company Seventeen at the Driskill Hotel, featured a nine-piece jazz band composed of company members.

A "gazoo band" produced "the Jazz" at Athletic Night at the Woman's Gym on November 10, in addition to the athletic stunts.

Sales of the 1918 *Cactus* began just before Thanksgiving "with pep and jazz."

The pep rally preceding the Turkey Day football clash with Texas A&M was the first really big pep rally of the year, owing to the epidemic. The *Daily Texan* listed eight reasons "Why You Should Come to the Rally," including the fact that the co-eds would be there, and the Varsity Band would be there with lots of jazz.

An orchestra of twenty or more pieces "played the liveliest and most up-to-date jazzes ever heard in Austin" at the 1918 Thanksgiving German. It was the first informal Thanksgiving German, keeping with the spirit of the times by minimizing expenses, and the larger portion of boys was garbed in army khaki or navy blue. Lovers of the by-now "ever-popular jazz music" were treated to an abundance of trombones, saxophones, violins and clarinets.

But after this bit of fun, the flu again reared its ugly head—much worse than before—and campus was shut down. So many people were sick that all available hospital and housing space was filled, and patients had to be put in tents. The flu killed six UT students and two faculty members, but the army's School of Auto Mechanics at Camp Mabry was hardest hit. More than half of the enlisted men were sick in bed, and several died every day. When school reopened for the winter term on January 3, 1919, all dances and public gatherings were cancelled and did not resume until late February. Extraordinary methods were taken to suppress further outbreaks—like taking one's temperature every morning. Adding insult to injury, many recovering patients were losing their hair.

In an exception to the public gatherings ban, the UT Varsity Band gave a concert on January 21, with a program of "jazzy and snappy pieces."

Beyond this brief respite of entertainment, the influenza situation prevented indoor social gatherings for several more weeks before finally subsiding for good.

But the damage was done. The war and the flu pandemic had given the jazz life raison d'être: party now for tomorrow we could die.

3

DON'T GET EXCITED,
KEEP YOUR UNDERSHIRT ON

Sex drove the jazz life like a roaring locomotive.

Promiscuity was the cat's pajamas, even if it was limited to necking or heavy petting—petting being defined as "every sort of intimate caress practiced by a man and woman short of actual intercourse." Necking was left to the timid and unadventurous. Eds and co-eds bragged about the number and quality of their conquests.

The latex condom (latex was invented in 1920) supercharged the sexual revolution that started with World War I. But despite the condom's coming, there is little hard evidence that unwed UT students engaged in full-blown intercourse.

Unlike the 1970s, when many UT students quit dating if they weren't in the sack by the end of the third date, Jazz Age sheiks and consenting shebas got married to "go all the way." Then, when the thrill was gone, they got "quickie" divorces and went their separate ways—to the point that in January 1923, Fort Worth senator Robert Stuart introduced a bill that would require county clerks to delay issuing marriage licenses for sixty days. He wanted to decrease the number of hasty marriages, thereby relieving the divorce dockets of the courts.

"Such a law would give the flapper and the jelly bean, who have suddenly become infatuated, time to reflect, and in the event they changed their minds, it would not be necessary to have a divorce proceeding, as they would withdraw their application for a marriage license," said the bill's sponsor.

"His True Feelings." *From* College Humor *(Collegiate World Publishing Company, 1928).*
Author's collection.

He: "It wouldn't be much trouble for us to marry, my father is a minister you know."

She: "Well, let's have a try at it anyway—my dad's a lawyer."

From College Humor *(Collegiate World Publishing Company, 1923). Author's collection.*

Young men were no longer satisfied with wistful gazes, kissing hands and lusting after exposed ankles and arms. Neither were the girls. UT "eds" had mourned the loss of "sex by the dollar" in Austin's tenderloin district (formerly known as Guy Town) in 1913. Now young men enjoyed "amateur" partners as willing as they were. In December 1920, the *Scalper* published the following poem:

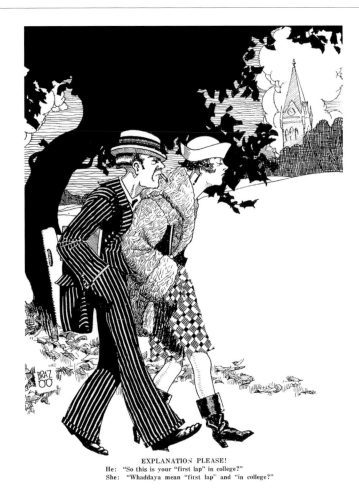

EXPLANATION PLEASE!
He: "So this is your "first lap" in college?"
She: "Whaddaya mean "first lap" and "in college?""

From College Humor *(Collegiate World Publishing Company, 1923).*
Author's collection.

These men
Who ask
If they can
Kiss you
Are
Annoying things.
I think it is the Bible
That says:
"The Lord helps them,
Who help themselves."

UT doughboys came back to Austin from Europe with a French-kissed zest for life. To wit, according to the *Scalper* in November 1919:

> *She (enthusiastically)—"Didn't you love the French?"*
> *He (musing)—"Oh, boy—I'd say I did!"*

And from December 1919:

> *Professor in Government (speaking on Woman Suffrage in France): "In comparison with other countries, the woman's movement in France has been slow."*
> *AEF (American Expeditionary Force) Buck: "Not where I was, professor."*

World War I got people talking about sex for the first time—albeit negatively—triggered by the rate of venereal disease among American soldier boys. In the twelve weeks ending on December 7, 1917, thirty-one camps across the country reported 21,742 new cases of venereal diseases. Doctors and generals had seen what happened in the French army. One regiment ravaged in battle went to the back of the line to recover. Its replacement regiment had more men out of commission from VD than the front-line regiment had lost in battle. One hospital had 2,300 patients; 25 percent had syphilis.

You didn't have to look to Europe to realize the terrible results from tolerating prostitutes near soldiers' camps. During the army's recent Mexican campaign chasing Pancho Villa, venereal diseases had spread at an appalling rate despite official regulations.

When the United States entered the world war, military camps cropped up across the country. Thousands of boys got their first tastes of booze and booty on their trips to camp.

Venereal diseases were the greatest cause of disability in the army, the surgeon general of the War Department declared. Of the VD infections discovered in military camps, 80 percent occurred in the boys' hometowns or in the cities they passed through on the way to camp.

Authorities threw aside evasion and prudery. They began battling the clap by educating soldiers, treating those already infected and setting up five-mile no-tolerance zones around camps. They got their fight into the newspapers.

But during the world war, the U.S. military, unlike that of any other nation, promoted abstinence over condom use.

In England, by the fall of 1918, even the most conservative newspapers, which before the war had blinked at such subjects, blared the names

of these diseases in large type, and you could read frank discussions of preventative measures.

Episcopal bishop William Lawrence challenged American newspapers to publish whatever facts the U.S. Army and Navy Medical Departments gave them:

> *It is a war question as vital as food and fuel. They say that the people do not like such facts: they offend their taste. It is the time that the lid be off and men and women meet this problem as they have met diphtheria and tuberculosis. People are talking. You are talking. I am talking. Our boys and girls are talking. Why not come out into the open and let the talk be healthy, sane, medical, and practiced.*

VD was not just an armed forces problem. The Council of National Defense conservatively estimated in August 1918 that more than 500,000 adult Texans had some flavor of VD. Texas's state health officer opined that at least one million Texans were infected. According to the 1920 U.S. census, Texas had 4.663 million inhabitants, which meant that about half of Texas adults had VD, if you believe worst-case estimates.

The United States Public Health Service and the Texas Bureau of Venereal Diseases urged local communities to keep up the fight against venereal disease as their boys came marching home:

> *You may hear from the unthinking, "You are fanatically hounding the poor prostitute," or "tip up the lid a bit so that everybody can have a good time, and business will be better." An open town may mean more business for some doctors, hospitals, and undertakers. It certainly means prosperity for the pimps and landlords who live on the earnings of the unfortunate prostitute.*

The crusaders weren't just talking about women: "By county and municipal co-operation isolation detention hospitals are provided for, to minimize the danger from the chronic prostitute—male and female."

An "interesting" sex hygiene exhibit was on display at Austin's YMCA in January 1919, "of particular interest in that it deals with conditions caused by the war."

Once people started talking frankly about sex, and despite attempts to promote student morality—especially among the sweet and vulnerable co-eds—the pussycat was out of the bag.

"What do you boys talk about at the frater-nity house?"
"The same things you girls do."
"Why, youl foul-minded things."

From College Humor *(Collegiate World Publishing Company, 1928). Author's collection.*

Those sweet girls talked just as much "trash" about the boys they had dated as the boys talked about the girls, the *Austin American* reported in February 1918.

> *Many a pair of masculine ears would have turned red hot if they could hear what was said about them in these secret sessions. The talk started with the various girls' adventures before tailing off into a comparison of the stunts and love-making techniques of different fellows…they just found most of the boys' varied attempts at this level of intimacy to be awkward and sometimes amusing.*

Soldiers home from France were knowledgeable of, if not practiced in, exotic oral sexual pleasures like French kissing, *soixante-neuf* and the "French Cigarette." The military taught them to bathe and brush their teeth daily. Coupled with the American plumbing industry's national daily bath campaign, there was little to discourage these oral delights except social inhibitions, and those were wilting fast among the young, especially among students at public colleges like the University of Texas.

Austin was far from Paris, but there were temptations enough, as this poem in the *Daily Texan*'s first issue of the fall of 1919 describes:

> *How ya gonna keep 'em,*
> *Down on their books*
> *After they've seen Austin?*
> *How ya gonna keep 'em*
> *Away from—you know,*
> *Jazzin' along, humming a song?*
> *How ya gonna keep 'em,*
> *Where they belong?*

J. Lewis Guyon, Chicago's biggest dance hall operator, proclaimed in December 1921 that anyone who said that the youth of both sexes could mingle in close embrace without suffering harm was a liar. He defined "close embrace" as "limbs intertwined and torsos in contact. Add to this position, the wriggling movements and the sensual stimulation of the abominable jazz orchestra with its voodoo-born minors and its direct appeal to the sensory centers, and if you can believe that youth is the same after the experience as before, then God help your child."

Fenton T. Bott, director of dance reform with the National Association of Dancing Masters, declared, "These moaning saxophones call out the low

and rowdy instinct. The jazz is too often followed by the joy ride. The lower nature is stirred up as a prelude to unchaperoned adventure."

Change was in the air as UT's 1920 fall semester began. Hemlines were rising and traditional morals decaying. Seasoned, savvy war veterans refilled their old classrooms alongside precocious young ladies like Sarah Cash, a debutante "frosh" from Houston.

That fall, an unnamed male student began keeping tabs on his dates with university girls. He recorded their names and the results, so far as necking and petting were concerned. During 1920–21, he dated 114 university girls. Of the 86 girls on his list, he had kissed 65 of them on the first night.

It must be noted that he had a car and used it to his good advantage. All the buzzards knew that "an automobile opens red lips."

"It has been stated that they will give a struggle before the coveted kiss is won. But it was supposed that the girls liked it and did not fuss too much. One of the most startling facts about the kiss record was that they were supposed to be in the so-called 'unapproachable' class of University women. The boy did not have the best of looks but the smoothest of ways," those who knew him said.

Sex appeal and dishabille go together like six and nine. Nothing beckons like forbidden territory. Even a fig leaf leaves a little something to the imagination. Jazz baby fashion gave boys lots to look at and fantasize about without giving away the game.

The world war blasted the hell out of traditional American life. It lit the fire of sexual revolution at the University of Texas and elsewhere.

University of Texas dean of women Mrs. Helen Kirby and dean of engineering T.U. Taylor had put the proverbial foot down on "rag" dances, including the turkey trot, bunny hug, raggie rag and the grizzly bear, in 1912. UT co-eds were limited to three dates a week, and 10:30 p.m. was the official parting hour, although sometimes the housemother let the boys stay until 11:00 p.m. Couples couldn't go buggy riding at night without a chaperone, and sitting on the campus unchaperoned was forbidden.

But come the war, Kirby permitted the girls to stay alongside their soldier beaux until their trains left, no matter how late the hour. She also permitted them to have dates every night their boys were here.

The prettiest girls in Austin hosted a weekly "dansante" for the soldiers at the Community House. A band played free of charge for these dances or any other war effort–related event.

Even bathing beauty revues, once roundly condemned, contributed to the war effort.

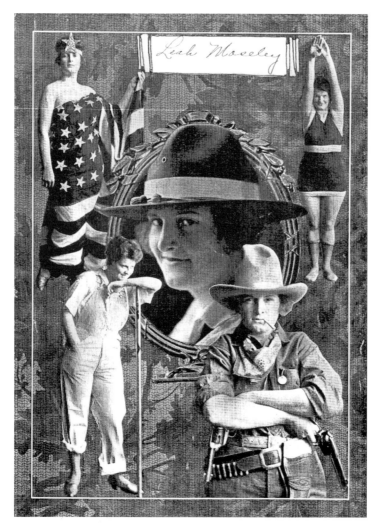

"Leah Mosely, 'Bluebonnet Belle.'" *From the* Cactus 1918, *Texas Student Publications. Author's collection.*

Annette Kellerman was arrested in 1907 when she appeared at a Boston beach in a one-piece bathing suit that revealed her arms, legs and voluptuous body.

Ten years later, pretty, patriotic young women were encouraged to bare skin and show off their physiques in the same form-fitting, knit-wool suits as they promenaded along Galveston beach inspiring soldier boys to die for their country. They wrapped themselves, bare shouldered, in the stars and stripes.

Their swimsuits covered them from the neck to almost the knees but would shrink dramatically with time, like everything else they would wear during the Jazz Age.

Flappers' ever-shorter skirts and flimsier blouses prompted campus jokes like "Zekiel remarks that the girl who sits in front of him in his English 1 class wears a shirt waist that reminds him of Pa's barb wire fence. It protects the property but don't shut off the view."

CUPID AND THE FLAPPER
A ST. VALENTINE DAY STORY

Women's undies were undergoing a revolution, marked by a rainbow of colors and new and varied styles. Adventuresome girls combined silk teddies with bloomers and loose-fitting underbodies into a three-piece set.

Back in grandma's day, "buzzards" gathered at muddy street corners to see some ankle as the ladies lifted their skirts above the mud. Boys made jokes when the doctor held mama's bare arm too long.

By 1920, jokes in the *Scalper* were baring all:

> *Artist (to new model): "I shall expect you to pose in the nude."*
> *Model (confidently): "Oh, that's all right, I went swimming all last summer."*

> SOME GIRL
> *She wore her silk pajamas in the summer when 'twas hot.*
> *She wore her flannel nightie in the winter when 'twas not.*
> *And sometimes, so they say, in both the springtime and the fall,*
> *She'd climb right in between the sheets with nothing on at all.*

> UNIVERSITY TYPES
> *Reggie: "Joe's new model isn't very modest about appearing nude. Where did he find her?"*
> *Lucille: "Oh, he found her at a German at college."*

Student dances typified Jazz Age excess. Men dressed up for the occasion, and women dressed "down," as evidenced by these jokes from the *Scalper* in 1921:

> THE MODERN EVENING GOWN
> *A little tulle,*
> *A yard of silk;*
> *A little skin,*
> *As white as milk.*
> *A little strap—*
> *How dare she breathe?*
> *A little cough—*
> *"Good evening, Eve!"*

And this choice one-liner: "You'll be late for the dance if you don't hurry—aren't you nearly undressed yet?"

These jokes were no joke; take the 1921 Rattlers Club party and dance. The Rattlers had been thrown out of the Driskill Hotel the year before for

Hula: What do you think of these costume dances?
He: Well, the less costume and the more dance, the better I like 'em.

From College Humor, *1928.*

excessive debauchery. For 1921, the KC hall looked "something like a cross between a chameleon and a quart of tequila." Shakey's Orchestra played this "memorial exercise in honor of the memory of John Barleycorn," the *Blunderbuss* reported in its annual April Fools' Day issue:

CASH'S BACKOUT

The gaiety of the Rattler Party was at its height, the orchestra was playing its opening number, and the dancers swayed to the oriental strains. Suddenly a hum of a mighty swarm of bees arose, and curious necks were strained in the direction of the doors. Some bird issued a low whistle, expressive of amazement and new found joy. The Kappas were seen to aggregate as the last strains of the music swelled and died away and many were the lowering glances cast in the direction of some poor girl who had brought the wrath of those governing upon her fair shoulders.

The cause of all the commotion stood in the door happily unconscious of the many glances cast her way. A small group behind her were rumbling in low tones about the beauty of unadorned nature, with historical sketches of Eve's first costume thrown in.

The Buss *reporter could see nothing. Straying around to the group in back of her, he gazed upon the Lady Innocent and saw that her dress was in imminent peril of slipping off. Rushing to the Lady, he tendered assistance and a safety pin, but she smilingly told him that the dress was made that way. Before a picture could be made of the exposed landscape, the Kappas descended upon poor Sara and told her something, the only parts that could be caught being "Scandalous," "Where is your cloak," "My dear, 24 of your vertebrae are exposed to these hungry masculine eyes," and finally the inelegant but very expressive, "My Gawd, Sara, go home and put on some clothes."*

When the reporter got back with his larger drawing paper, the lady had gone home, but soon returned fully clothed, to the satisfaction of the Kappas and the eternal disgust of the male onlookers.

Sarah Cash belonged to the "twenty-inch skirt crowd" and had the calves to show off. "Cornfed Cash" was just one of her nicknames, and a *Cactus* yearbook photo titled "Sarah throws a party" showed a line of nine slouching "buzzards" admiring Cash's knees as she sat on a bench across the commons.

On March 1, 1921, the "Barton Math Academy" announced an upcoming "practical course in figures and curves." Swimming season at Barton Springs was approaching, and the boys were ready. Women's nipples always came to their most erect state upon entering Barton's brisk sixty-nine-degree water. The "knit-to-fit" wool suits the girls wore left little to the imagination when wet.

The automobile revolutionized dating, and Pease Park was a favorite destination. In March, one of the best-known Zeta Tau Alpha sorority girls was driving through Pease Park and noted with amazement the large number of parked automobiles. She sighed gently and told her escort, "How

From the Cactus, *1922, Texas Student Publications. Author's collection.*

can they be so common and act so out in public? When I feel that way, I always go home!" The young man's reply wasn't recorded.

Lake Austin was another favored make-out getaway for Cash and company, as "Ima Longtongue" wrote in the 1921 *Cactus*:

> *'Twas a lake side cool and soothing.*
> *The moon so pale, yet bright*

Enough to see wee figures
In its soft, revealing light.
As I see sweet Mamma Ritchie
There—but not by himself.
Can it be the little Kappa,
The Kappa with the Cash.
Who upon our inn'cent Ritchie
Has made a powerful mash?
The story soon is ended
The Cash is up and gone.
And there'll be no other party
Without a chaperone.

Starting in May, UT student couples were forbidden on Lake Austin after dark.

Sarah Cash did not return to UT in the fall of 1921.

The *Austin American* began campaigning in April 1921 for a city entertainment censor for moving pictures and vaudeville acts, while at the same time running advertisements for the movies to which it objected—such as *Is Your Daughter Safe?* for ladies only. It was impossible to show it to mixed audiences because of "The naked truth laid bare—Nothing left to the imagination."

One of the paper's daily sewing patterns was for a bra and garter belt as skimpy and sexy as anything from Victoria's Secret today.

The latest campus co-ed fad in December 1921 was the "morality test," which revealed a sad lack of moral fiber. Its ten questions included: "Have you ever been kissed?"; "Have you ever indulged in the use of intoxicating liquor?"; "Have you ever deliberately lied?"; "Have you ever broken the rules of any institution?"; and "Have you ever smoked?"

A passing score was six "no's." Sad to say, the fair damsel's grade was abnormally low. It hovered between 20 and 30 percent, with a number of round zeros dragging it steadily downward. "Can we wonder that wise old heads wag wistfully and wonder what the younger generation is coming to?" concluded a *Daily Texan* report.

The knee-length, loose-fitting skirts of 1922 were creating some "excitable boys" on campus. Their collective libido came to a head on the windy morning of February 6, 1922, on the steps of the library as they gathered to hoot their approval when the girls' skirts took thigh-ward flight in the brisk breezes. The flock of campus buzzards was such that an assistant dean was posted to advise the girls to take the inside stairway.

In the aftermath of the flying skirts incident, President R.E. Vinson called the university's women to a compulsory meeting; about one thousand girls showed up.

"There are about 200 female 'floosies' in the University," Vinson said,

who come to the university solely to have a good time. News of the action of these few students goes all over the state, and impresses the people that their kind is the prevalent type represented at this school so that the average person and legislator does not understand the pure and true type we have. Then when the legislature meets and I go to them for funds by which to keep the university going I meet with trouble on account of the impressions these few make.

The standards will be what the women make them, and men will treat the women as the women demand that they be treated. In all my varied experience with people I never saw a man take liberty that the woman did not allow.

I came here tonight to ask the women of the university to get behind the administration and their own officers and organizations and eliminate this source of trouble by setting high, clean standards and holding to them by means of healthy public opinion.

Vinson's plea was an "amusing spectacle of an educator attempting to maintain the exclusive school discipline of the Eighteenth Century among the freer associations of the Twentieth," the *Austin Statesman* opined the next day. "Due to the great progress of freedom and the general influence of public education, young people have already entered into the world of their elders and, therefore, can no longer be kept under that degree of restraint which the old idea of education presupposes."

"There is no reason why women should be hampered by clothing any more than men. Modern dress for women is much more sensible, much more hygienic, much more conducive to safety than it has ever been," declared a progressive sextet of co-eds in response to "they had it coming" comments.

In May 1924, the *Tattler*, a short-lived student scandal sheet, told of wild parties alleged to have taken place in an apartment occupied by three girls:

*The story about the parties which were thrown in the apartment * * * is a good one, but we hate to talk about such things even in such a dirty sheet as this. We will say, however, that they were in the apartment three weeks without a chaperone and that at times some of the ----- were carried out feet first.*

Merry Christmas!

From College Humor *(Collegiate World Publishing Company, 1927). Author's collection.*

It also named a "Hall American Team" of twelve university students. Team positions included front end, rear end, wiener grabber and bump back. Almost all copies were seized before they could be distributed, but those that did get into circulation were much in demand, some being rented for fifty cents an hour.

Skinny Chorine (despondently): "Gee! I wish I was a star!"
Perfect 36 Chorine (maliciously): "Well, you'd look better, dearie, if you was a little meteor."

From College Humor *(Collegiate World Publishing Company, 1923). Author's collection.*

In the 1970s, student organizations showed porn films like *Deep Throat* at campus midnight matinees. In the fall of 1924, the Hancock Opera House's midnight matinees included the provocative *The Temple of Venus*—"Unhook my gown for the Devil's Dance," the advertisements promised. The next week's midnight matinee was *The Foolish Virgin*.

In fashion, women's waists were back; the "spritely slip of boyish shapelessness" was disappearing.

The summer of 1925 was one of the hottest in Austin history. The boys retaliated against the hot weather by going tieless and without buttoned collars, exposing their brawny necks to every breeze that blew, while the girls adopted sleeveless and neckless dresses—to the great delight of the boys, as expressed by two verses from the poem "Mysterious Woman":

Her corset has been flung away,
No more to mar her suppleness;
I think that I may safely say
Few things are thinner than her dress.
No undergarments check her stride
So I've been given to believe;
She cannot hope to lay aside
Much more without stripping Eve.

If the buzzards enjoyed what they saw in 1925, they were going to love 1926, theatrical producer Ernie Young promised when he described Miss 1926 during a visit to Austin. She would be about five-foot-four and between 115 and 120 pounds. Everything from hair to skirts would be abbreviated. Skirts would be four inches shorter than in 1925. As for her undies, she would either do without or reduce them to the utmost irreducible minimum.

A reporter for the *Cotton Trade Journal* was in town in 1925 looking for a cotton story. He didn't find one; he found something even better:

Besides the capitol there is something else that makes life worth living here—the state University. Or rather that section of it devoted to the deadlier of the species. E.H. Perry of E.H. Perry & Co. says that he has traveled the world over and nowhere has he seen girls who could match the beauty of these University girls and your correspondent certainly agrees with him.

As the Jazz Age surged on, Austin's growth rendered Pease Park and other close-in locations unfit for "parking." And "petting" was getting heavy enough that a back seat no longer provided enough room for smooth moves. "Keep Your Undershirt On," by the Ben Pollack Orchestra in 1929, advised:

Curb your emotion
Don't go off your nut
I've got a notion
I could love you but
Don't get excited
keep your undershirt on
Maybe I've got stuff you admire sis
babe I'm hot stuff
so remember this
don't get excited

keep your undershirt on
I always let the girls kiss me
if they like it (oh)
or they love it (oh)
After I leave them they're total wrecks
Oh babe I'm just full of sex
Though you'll upset me
That's the chance I take
go on and pet me
but for heaven's sakes
don't get excited
keep your undershirt on.

"Navajo parties" became increasingly popular. One of the most popular "Navajo" spots was Dillingham's Pasture, far enough from campus for fun lovers to "turn on the heat." "Dad" Dillingham's one-hundred-acre sheep pasture was eight miles north of town on the Georgetown road (North Lamar today). It took fifteen or twenty minutes to spin out there, allowing blind daters to get thoroughly acquainted with each other.

When asked what kind of place it was, Dillingham laughed heartily and told a *Daily Texan* reporter in 1929, "You'll have to come and stay for a week and see for yourself!"

His place hosted Sunday school wiener roasts, baseball games, horse shoe matches, "hen" and "stag" parties—even church services—but especially "Navajos," named for the style of blanket on which party-goers stretched out.

"Most people are very friendly, but some I [would] a whole lot rather not come around," Dillingham told the reporter.

Sunday school classes described the pasture as a scenic, ideal picnic spot. Students just gave a knowing glance and said there were no burs or thistles and "not a chigger in an acre." Saturday night was the big night since the co-eds could stay out after midnight. Dillingham didn't keep tabs on the number of visitors but did note that one party entertained two hundred guests while another one that night involved thirty-two cars, in addition to the more numerous—and personal—duets and quartets.

Dillingham was an accommodating host, supplying firewood and operating a lost and found bureau for the dozens of lost purses, vanities, rings and watches. In return, many "picnickers" invited him to supper or brought him dinner. Someone even gave him a white Stetson hat with a five-dollar gold piece in it.

From College Humor *(Collegiate World Publishing Company, 1927). Author's collection.*

He made the rounds of his pasture nightly, usually on horseback and sometimes in his truck when he was hauling firewood. He began the nightly rides about 1924, when he got wind that the Texas Rangers were going to raid the place. Every night for a week, he rode out to warn the students,

even making trips to the Drag to tell his pals. By the time the Ranger scare was over, he enjoyed his rides so much that he tried to spend some time with every bunch, although that got harder to do as the pasture's popularity increased. Still, he usually managed to greet everyone as they left, inviting them all to "come back."

There was a real sense of comradeship and cooperation among the students. When a fellow Dillinghamer was stuck in the mud or had other trouble, his brothers were always willing to help. Even a flat tire excuse was a flop for opportunists because there was always a next-door parker to take the girl home.

By 1931, it was a tradition to meet at Dillingham's "opening" party, which took place the day before school began. The parties drew "hi-uppity-ups" from all around, including a California photographer who was so impressed by the wild woods of the wild state that he made moving pictures to take back to California, leaving party-goers to wonder which prominent Longhorns might be seen behind the scrub oaks.

The lights went out on another time-honored UT tradition—of male student voyeurism—during the Christmas holidays of 1931, as Venetian blinds replaced the old-time window shades at the Littlefield girls' dorm. No longer would the girls be called down by the dormitory matrons or by any outsiders who lived across the street or those who happened to be passing by. Ensuring privacy without depriving the girls of fresh air and sunshine, the blinds were quite an improvement over the shades, which had to be kept down to ensure proper privacy while keeping the rooms hot as ovens. The Venetian blinds' only defect was that they deprived the girls of a good place to hang the weekly washing.

Legal and religious restrictions on condom use were relaxed as the Jazz Age ended, but with the onset of student conservatism on the UT campus, petting remained the primary means of sexual gratification outside of marriage.

4
"Lit" Liza Jane

"Beautiful, light flecked, sweet, ambrosial glass,
Oh, how I love your luring lips' rich foam,
Caught in your snare, I'll love you till the last,
Kiss you ten thousand times and stagger home."
—*the* Cactus *(1917)*

Austin hasn't always been Texas's oasis of liberality and libertines. Austin was the first Texas city to shutter its whorehouse district (1913) and to outlaw alcohol (1918, two years before the Volstead Act dried out the rest of the country).

Prohibitionists had tried to dry out Austin for decades in the name of UT students' well-being. One month before the January 21, 1918 election that brought prohibition to Austin, the *Daily Texan* admitted:

> *That there has been an unusual amount of drunkenness in the student body of the University is an established fact. Just why students attending the present session should be more addicted to the drinking habit than students of other years, is not known, but time after time instances of drunkenness have been referred to certain faculty members and in turn referred to students implicated and to students interested in the welfare of the institution.*

Mrs. Nannie Webb Curtis, president of the Woman's Christian Temperance Union, declared, "I would not let my boy come to the University of Texas in

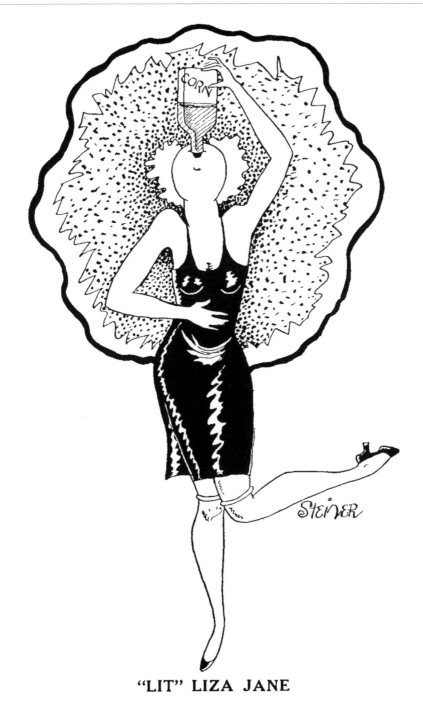

"LIT" LIZA JANE

From College Humor *(Collegiate World Publishing Company, 1927). Author's collection.*

Austin, because I would not expose him to the temptation of the saloons here. He is now studying for a commission and needs the studies the university could give, but, I said, better be as ignorant as a Fiji Islander than become a drunkard."

By 9:30 p.m. on January 21, prohibitionists were reveling in their one-hundred-vote victory, parading the streets and blocking the intersection of Sixth and Congress. Pastor "Fighting Bob" Shuler spoke triumphantly from a platform of shoulders. In his oration over "dead John Barleycorn," Shuler said this election was only the beginning of the end of the liquor traffic in Texas. He considered it very propitious that the capital of the state should "set an example of sobriety and high ideals to the people of this state."

The *Daily Texan* ran a contrite, cooperative editorial called "Howdy, Grape Juice" the next day:

> *Hence forth and forever Austin will be arid and unproductive as far as the sot and the coming-sot are concerned. We congratulate the voters of the city, and we especially commend the Fourth Ward—the University community—for the heavy blow dealt the saloon and its wares.*
>
> *Drunkenness among students will decrease. There has been some—we have never tried to hide that. But when the coffin of Old Man Drip N. Springs is laid to rest in about 30 days, the University can bid farewell to the isolated cases with which it has had to contend.*
>
> *The open saloon found at every corner is a standing invitation, and on a free night or on a night following a hard day, the invitation is too urgent to be turned down by the man who loves occasional contact with Bacchus.*
>
> *The bar will be out of the way within a month, thanks to the one hundred majority. It is our only hope now that this last chance in duration of time will not find too many purchasers of the unmentionable.*

It was a hell of a welcome home for thirsty soldier boys.

Prohibition closed Austin saloons but didn't keep jazz hounds and babies from partying. Pre-Prohibition whiskey cost as much as "Willie Weed" ninety years later, but homemade hooch was as cheap and easy as water to buy. Rustic cedar choppers tended dozens of stills in the rough hills west of Austin. Frank Hamer, Travis County special Prohibition enforcement agent, hunted and killed Bonnie and Clyde in 1934 but couldn't keep moonshine out of Austin.

Alcohol consumption was so blatant that a *Summer Texan* ad on July 2, 1920, for an upcoming German Club dance closed with "P.B.Y.O.B."—an early variation of the well-known acronym BYOB. (Folks were more polite back then; they said "please" first.)

From Stars & Stripes, *official newspaper of the United States Armed Forces, 1918.*

Desperate for stimulating drink, folks guzzled all kinds of concoctions, sometimes with fatal results, prompting jokes like these from student humor magazine the *Scalper* in May 1920:

> *First you take a cocktail shaker,*
> *Add wood alcohol,*
> *Neighbors get the undertaker;*
> *Pretty flowers. That's all.*

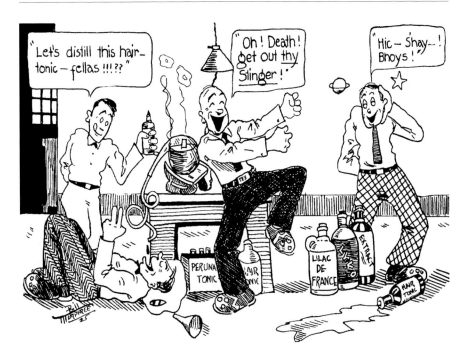

From the Scalper, *Texas Student Publications, 1921. Author's collection.*

Formerly hair tonic was good for shampoo; now it is also good for sham-booze.

As an alternative to the German Club dances, which were held off campus in the Knights of Columbus Hall downtown, a series of all-university dances at the Woman's Gym open to everyone on campus, managed by the Students' Association, began in the fall of 1921 to "further a greater spirit of student body democracy and community friendship." More importantly, they were supervised by university authorities and limited to students only. German Club dances were not university supervised and attracted nonstudent guests and copious quantities of spirits.

The student drinking problem was so bad that on March 2, 1922, a mass city meeting was called. "We know there is considerable bootleg liquor being sold in Austin," stated Judge John C. Townes, dean of the UT Law School.

All they had to do was read the *Daily Texan* of February 14:

This prohibition gets worse every day, but we've reached the limit when our sweet little grind illustrator wheezes around for a couple of days and then

turns up with a bottle of cough medicine with a kick stronger than any East Texas Corn or Tequila we ever met. Give us back the old days!

Contrary to public perception, Prohibition did not outlaw booze altogether. Religious sects were allowed their communion wine, and physicians could prescribe ardent spirits to patients as they saw fit—or not.

A day later, two ambitious "stew-eds" made such a visit to a local doctor. The *Daily Texan* described it:

> *The procuring of first-class booze these days and times requires the procurer to be something of an artist. Well, it happened like this:*
>
> *Two of the simple loving brothers decided yesterday they wanted to pull a party. The first one of them, Richard, went to the Doc but had no luck, so the other fellow decided to try his luck although he was in the best physical condition.*
>
> *"I wanta get some whiskey for my cold, Dr.," the bird announced hesitatingly. "Get drunk? Gosh no! Never touched a drop in my life except to cure a cold."*
>
> *"Have to examine you first," Mr. "Box" the M.D. replied with a knowing air. "Pulse is all right. So is your temperature."*
>
> *The said booze fighter momentarily felt like a D.F.*
>
> *"Take off your coat and count 99. That's bad; something wrong," the M.D. stated after the youthful one had counted 99 about 99 times. Then he punched him in various parts of the anatomy, to which the booze fighter would make guesses as to which poke he would say had hurt him. After a reassurance from the doc that he could probably "fix him up o.k.," said booze fighter felt somewhat relieved and began to dream of the party he was to have from the prescription.*
>
> *"I can tell you've had either flu or pneumonia," the M.D. said, "because one side of your chest is weaker than the other."*
>
> *"Yes, had the flu, and never completely recovered. Thought maybe some whiskey would help," the d.f. dreamed. "Think you can give me a prescription to fix me up, Doctor?"*
>
> *"Yes, that's easy," the M.D. smiled, and began writing out a prescription to the boy he addressed as Mr. "Box."*
>
> *Said Box could hardly keep from laughing out loud at the way he had fooled the doc into believing he was really sick and had bulled him out of his whiskey. He gladly paid two dollars and walked out as tho he were floating on a cloud. After turning the prescription over to a drug store to be filled, he and his companion returned in about 20 minutes to get their pint of whiskey.*

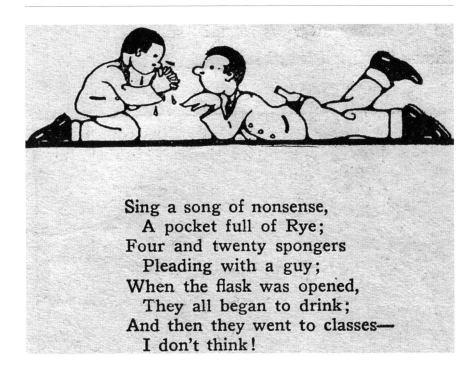

Sing a song of nonsense,
A pocket full of Rye;
Four and twenty spongers
Pleading with a guy;
When the flask was opened,
They all began to drink;
And then they went to classes—
I don't think!

From College Humor *(Collegiate World Publishing Company, 1928). Author's collection..*

"Eighty-five cents, please," the clerk said in a bored tone.
Hesitatingly, they paid the eighty-five cents, and scowlingly stared at the two-ounce bottle, the contents of which resembled white wash.

"The old discipline is gone," mourned an *Austin Statesman* editorial, "Insurgent Youth," on February 22:

> *Whether we like it or not, the young are now entrusted to situations in which they must act for themselves. They often err because they have not been permitted to acquire any practical knowledge or experience in self control. They have, indeed, been loosed from the bonds of the old discipline and yet are not free. Unsuccessful attempts to restrain them arouse their opposition and move them to efforts often productive of mischief, to show their independence.*

Beginning on Friday, February 24, co-eds had to show their blanket tax receipts to gain admittance to the dance floor for the weekly gym dances; too many non-university girls had been attending the dances.

On Tuesday evening, March 7, 1922, eight hundred men and women met in the capitol senate chamber to form a new prohibition enforcement league targeting high school and university students. Newly elected chairman Sam Sparks charged that Travis County bootleggers had the idea that they had friends among local officials and said he had seen some university students drunk at local gatherings.

UT president R.E. Vinson told the audience he had just come from the city jail.

Rangers Hamer and J.B. Wheatley had arrested two UT students that afternoon, following a long automobile chase out East Sixth Street from Congress Avenue to the outskirts of the city, and a sensational battle ensued when the Rangers attempted to arrest the students.

Governor Pat Neff attacked newspaper editorials discussing constitutional privileges of persons, which he said was giving disguised defense to bootleggers.

"We need," Neff said,

> to elect some real officers not afraid to enforce law. I asked the last legislature three times to pass a law so the attorney general could remove a local officer who willfully and corruptly refused to do his duty. The senate, right here in this room, afraid they would take away the constitutional right of someone who would take bribe money, refused to pass it.

Sparks's criticism of lawyers who would defend bootleggers received the heartiest applause of the meeting. The next day, David Morris, federal Prohibition director for Texas, expressed his pleasure with the citizens' plan:

> I have no sympathy for persons who manufacture and sell moonshine whiskey. I believe it will only be a matter of a year or two until we will see the terrible results from the drinking of this liquor. Men, healthy today, will be dying then as a result of drinking such liquors offered to the public by the bootleggers of today.

Earlier that day, the Students' Association had met to discuss the cases of several Austin students placed on probation for attending a February 15 dance not on the school's social calendar. Perhaps it was Willie Williams's party at the Austin Country Club, as the 1922 Cactus reports:

> The party was a clever and novel affair. Naughty Willie and Miss [Margaret] Wessendorf inaugurated a game of "now you chase me"

under the table much to the amusement of all the guests, and Miss Maverick, celebrated for limitless energy, subtle manner, and dansante interpretations at other affairs, did a few graceful steps on top of the table, to the patent delight of the male contingency present. Mr. Ray Jackass (or is it Jackson?), engaged Miss Dizzy Camp in a clever and epigrammatic conversation to the unconcealed merriment of Mr. "Tea-do" Morgan, Fermin, McCullough, Tobin and others who graced the festal board. Naughty Willie is to be complimented for the cleverness of his party, and for the good judgment displayed in picking such talented and congenial guests.

"Reckon she's on the way to English Lit?"
"Hell, no. I think she's sober this morning."

From College Humor *(Collegiate World Publishing Company, 1928). Author's collection.*

Jazz babies held their own against the boys when it came to booze, as evidenced by this poem from *College Humor* in 1923:

> *Mary had a little flask,*
> *She held it very tightly,*
> *She drained the damn thing every day,*
> *And had it refilled daily.*

The stockpiles of old, bonded liquors were almost gone, replaced by "rotgut," the *Austin American* reported on January 15.

Austin police sergeant R.E. Nitschke warned Austin citizens and UT students in January 1922 that large quantities of denatured alcohol were being sold for drinking purposes, causing more than eight deaths in Austin during the past two years.

Denatured alcohol was a deadly poison, and if it did not cause instantaneous death, it caused blindness and rotting of the bones, Nitschke said. Until recently, it had retailed only in a local drink known as "juk." But during the past few days, he had found that grape juice and other nonalcoholic drinks had been spiked with denatured alcohol and sold as "bottled in bond."

Prohibition officers discovered a still on Rainey Street during a January 7 raid. The still's owner had fled on foot, leaving a running automobile standing in front of his home.

Part of the still was buried in the yard, part of it was lodged under the ceiling of the house and the greater part of it was suspended in the well.

State chemist E.H. Golax warned that the average corn whiskey, commonly known as "moonshine," "white mule" or "shinney," was unfit for human consumption:

> *Moonshine is mostly a nasty, filthy beverage. The manufacture is simple enough. It consists of one or two barrels of mash and a distilling apparatus or still. The mash generally consists of a mixture of cornmeal, sugar, and water, with yeast added to induce fermentation. Through the process of fermentation the mash will develop about 7 to 8 per cent alcohol, which is then concentrated to 30 to 50 percent by distillation. The whole process is in theory harmless enough. The nature of the still itself, whether made of copper, tin or lead, has no bearing on the finished product.*
>
> *It is the condition that surrounds the manufacture that introduces the element of danger. The illicit still by its very nature must be clandestine— it hides itself in thickets, fields and barns—the containers consist of*

old barrels unspeakably filthy and ill smelling after repeated use. The unprotected fermenting mixture attracts animal life—flies, cockroaches, mice, rats and bugs of every description feed upon the material and often drown in it.

The simplest expression of a still seen by the writer consisted of a common boiler covered with a filthy blanket—the alcohol vapors passing from the boiling liquid were retained in the blanket and wrung out of same into a bottle. In another instance, a torn-up mattress had furnished the necessary cotton for the straining of the finished product.

The result of the distillation, "singling" or "doubling" in bootleg parlance, is therefore a mixture of water and alcohol together with many byproducts of putrefaction and a large amount of "fussel oils" which impart to the stuff its distinctive and repulsive odor. Fussel oil is the common name given to a group of higher alcohols formed simultaneously during the process of fermentation with the better known grain alcohol. Most of these higher alcohols are distinctively toxic. The symptoms they provoke are headache, giddiness, double vision, staggering, and unconsciousness. In repeated and frequent doses, they may cause acute nephritis and affect the composition of the blood.

The whiskies sold in the years gone by were kept under strict control under the Federal and State Food and Drug Laws and only traces of fussel oil were present in the brands offered for sale on the open market. Moonshine cannot be supervised and the purchaser must assume all responsibility as to the wholesomeness or the purity of the article.

It is hard to believe that man would find a bottle in a street corner and drink its contents because it smells of booze; and still the "white mule," "shinney," or "white lightning" handled mysteriously by some unknown go-between is certainly no safer.

Booze was not the only problem. A few days after Chemist Golax railed against 'shine, the chief of police permitted a "dope fiend"—a "snow snoozer"—to spend the night in the station to escape the cold. The vagabond checked out early the next morning, with instructions from officers to "keep moving."

Prohibition didn't cause an increase in the number of dope fiends, a government narcotics agent explained in the *Austin American*. Most new victims of the drug habit were teens who hadn't had time to become alcoholics. The spread of the drug habit was called a reaction to the strain of war, which brought people to a high pitch.

By February, morphine parties were taking the place of liquor parties in Dallas.

At a March 10 student meeting, President Vinson appealed for better student behavior with regard to violations of the Prohibition law in light of recent reports of lawlessness, which included the newest fad of 1922: "joy riding" in "borrowed" cars.

"To the eternal triangle, 'wine, women and song,' must be added a fourth unit, the indispensable 'car,' to make a proper recipe for a lark of the present-day type," police clerk C.M. Browne told the *Austin American* on February 15. Since the first of the year, sixteen automobiles had been stolen; eleven were stolen in February. The recent increased activity smacked more forcefully of joy riders than the previous thefts. All but two of the cars were found several hours after their reported thefts, abandoned on some side street.

If UT jazzers toked, no one talked or wrote about it, but marijuana was enough of a problem in Austin that in April 1924, police chief J.H. Rogers asked the city council to enact an ordinance prohibiting the cultivation or possession of "marihuana, Mexican drug weed." He told the council that use of "hop" weed by smokers, particularly in the Mexican section, would be checked more effectively by the police if the ordinance were enacted.

Miss Lucy Newton, UT's dean of women, launched a campaign that fall to have UT girls pledge not to date boys who smoked or boozed. Newton made so little progress, the *Cactus Thorn* observed in the spring of 1925, that

> *very few of you have even heard that she made the attempt. If she had succeeded, imagine the result. The girls would have to buy their own cigarettes, or we might hear Jane, who only smokes Fatimas, saying, "Oh! Charlie, how nice of you to bring me this carton of Chesterfields. I love them so; so sorry you can't smoke." And from Charlie, "Here's my flask. Remember that I ordinarily drink my half, and don't misjudge your capacity." Lay on, Lady McDuff; we rejoice to see you spread your wings in vain.*

As Austin approached its tenth anniversary of turning "dry," drinking was a bigger problem than ever at student dances. The Students' Association and university discipline committee cracked down.

Students' Association president Robert "Bob" Eikel led the charge, becoming the most despised UT student of the Jazz Age.

Drinking by university students at university dances was absolutely forbidden, Eikel declared in December 1927. Anyone who appeared to

have been drinking would not be allowed on or near the dance hall, and offenders' names would be reported to university authorities for possible suspension or expulsion.

The floor managers for the weekly university dances had to record the names of all offenders and see that they leave the dance floor or they would be relieved from duty.

About one month after the dances started, Eikel had to remind the floor managers that the tenure of their positions depended on faithful performance of their duty. He hoped that their friends would "lighten this duty by keeping strictly sober."

Under the current system of tag dancing, it was virtually impossible for a girl to refuse to dance with a boy who had been boozing. Drinkers had too long confused acquiescence with approval, Eikel thundered.

Some dancers were discreet in their drinking, but others were not, the *Daily Texan* noted:

> *The Saturday night dance was in full swing. Another half hour and the "Eyes of Texas" would announce the end. With glazed eyes he wandered across the floor, looking at the girls and seeing two where others saw but one. He was wallowing on the necks of friends who were more kind than particular, and laughing with the hoarse cackle of the one who is dead gone—shot—or what you will.*
>
> *A boy introduced him to a girl, then stood back and laughed while the drunken man staggered through a few steps. I wonder if it amused the girl. Her friends, forming a silent league, cut quickly in on the dance, and he rolled away to hang on the neck of another friend and tell of the wonderful dance he had had, and of the great fun he was having.*

After postponement because of final exams, the Saturday all-university dance and regular KC German were held on Thursday night, January 31. The students evidently had a lot of steam to blow off because a week later, the social calendar committee of the Eikel-controlled Students' Association cancelled the upcoming German Club dance. The dance was suspended for a week because the January 31 German was "the worst that has ever been given," accused Eikel, citing drinking and rowdy conduct.

Because of slow ticket sales, the all-university dance committee decided on October 8, 1928, to discontinue the gym dances. At the same time, the German Club dances were moved from the KC Hall to the Woman's Gym: 1) for economic reasons because the Woman's Gym

could accommodate more people at less expense; 2) for safety reasons because in the gym there was less danger of overcrowding, cave-in and fire traps; and 3) because there was a positive moral advantage of holding the Germans on campus.

"Inebriates whose indulgence has been noticeable have caused the removal of the University Germans from the KC Hall to the Woman's Gym under the strict supervision of university authorities," the *Austin Statesman* reported. "Policing of campus is expected to result in less drinking. The Theta Xi fraternity will take over management tonight." German Club dance management had been on a rotating basis, shared among the university's social fraternities.

Resentment resulted when the negligence of the fraternity in charge of the German Club caused the Germans' change of venue. The Germans had been in hot water for firewater throughout the Jazz Age.

On August 19, 1929, the Board of Regents abolished Rush Week, the German Club and other inter-fraternal groups such as Skull and Crossbones and put all the fraternities and sororities on four-year probation.

When UT opened for the 1929–30 school year one month later, the campus seemed dead for lack of excitement. Only the all-university dances would continue. The first dance on Saturday night, September 21, featuring Fred Gardner's Troubadours, was originally scheduled for the Stephen F. Austin Hotel's roof garden but was moved at the last minute to the Woman's Gym because of a row at a student-attended dance held the night before at the roof garden. Student discontent and mischief had been brewing since the KC Hall Germans were shut down; it was harder for students to get drunk at the campus Germans.

But youthful excess would not be denied.

Detectives Ted Klaus and Rex Fowler were on the dance floor most of that evening and noticed that the dancers got a little more hilarious with each passing moment. About four hundred were present when a lot more poured out of the elevator. To say the newcomers were rather inebriated was putting it mildly. Close on their heels came Detectives Flow and Waggoner to reinforce Klaus and Fowler.

The coppers took considerable guff off the students, including some disparaging remarks about police in general, until somebody tossed a chair off the roof and it crashed into an automobile ten stories below.

Quite a little corn whiskey had already been seized, but after that, the four detectives and hotel manager J.C. Clopton searched the dancing couples for wet goods. They confiscated about sixteen or eighteen bottles.

The students were not entirely to blame. There was a sizeable percentage of local "jellies" in the crowd. Several state senators were on hand with their daughters to observe the moral standard of the Austin dance, it was said, but none was overheard to express an opinion. There was no complaint of police interference after the jolly evening ended with "Home, Sweet Home," for nobody got arrested.

The next day, city manager Adam Johnson and police chief R.D. Thorp met with university officials to deliberate on just how an overenthusiastic student should be handled in a public place. The affair was a striking reminder of the famous "baby party" back at the hotel's opening in 1924, when co-eds clad in "nighties" conquered the coffee shop and poured ketchup on the manager's best dress suit.

Change was in the air when students returned to campus in September 1930. There was a growing feeling that the Depression might be settling in for the long run, and many students would suffer in this new era.

"Jazz," while still part of the collegiate lexicon, was no longer raison d'être for UT students.

But students' taste for alcohol hadn't changed. As students registered for the 1930–31 term, Governor Dan Moody opened a war on liquor sales to all students in state and private universities, offering a $100 reward for information leading to a conviction for selling to students and a $50 reward to prosecutors who convicted in such cases.

Austin police and the Texas Rangers, headed by Captain Frank Hamer, launched a drive to find those who were selling to students. Their first catch was a large still on university-owned land leased to private parties. Hamer and Austin officers Fowler and Wade Stubbs trailed a suspect from the university neighborhood to a place on Lake Austin Boulevard, where they found and destroyed a one-hundred-gallon still under a bathhouse floor near the Texas Botanical Gardens.

They discovered fifteen barrels of mash, poured out several half barrels of whiskey and beer and found a new automobile near the house. L.P. Starnes and Robert W. Golightly were arrested on multiple charges, including transporting, possessing, selling and manufacturing liquor and owning property and equipment designed for making liquor.

A *Daily Texan* editorial on October 31, 1931, tossed flappers, sheiks and their bathtub booze into the dustbin of history:

> *We have long since passed the stage when the collegiate youth may be characterized as flappers and sheiks. It was almost necessary that we accept*

Captain Frank Hamer, 1922.

supinely the odious criticism heaped upon us when we were passing through that phase following the war when precocious youth had its fling; the fling being concocted of thrills and cocktails.

Gone are the crass mannerisms, the gin-drinking and thrill-seeking masses that composed the population of the campuses. At least they are no longer objects of admiration and emulation.

5

You Look Like a Boy, but You Say You're a Girl

Did Ernest Hemingway and his better half engage in role reversal during their Jazz Age romps in the sack, as some scholars claim? Chances are that the chances are pretty good. Gender bending was a hallmark of the age.

Hemingway's writing is full of effeminate men and boyish women. In *The Sun Also Rises*, Lady Brett Ashley, despite her boyish hair and androgynous appearance, is described as a "damned fine-looking woman," and she screws like a randy sailor. The man she loves, poor Jake Barnes, emasculated by war, survives in a nether world, a man in name only, unable to make love beyond words and caresses, filled with frustration.

The jazz life liberated women more than men.

When the Nineteenth Amendment guaranteed women the right to vote, feminism was on a roll. Many young women felt they had the right to do pretty much anything men did, including wearing what men wore. They also had the world war to thank for that. America needed all the cloth it could get for the war effort, so it was goodbye underskirts and hello higher hemlines. As women went to work in war production, they demanded suitable, comfortable clothing; that meant men's-style apparel. Besides looking pretty comfortable and uninhibiting, wearing men's clothing was heretofore forbidden territory. Their mothers would have been thrown in jail for cross dressing—and their fathers, too, for that matter.

The days of the uncomfortable, corseted, hourglass figure were over. The lack of a corset and a low, loose waistline gave girls that boyish, straight-waist

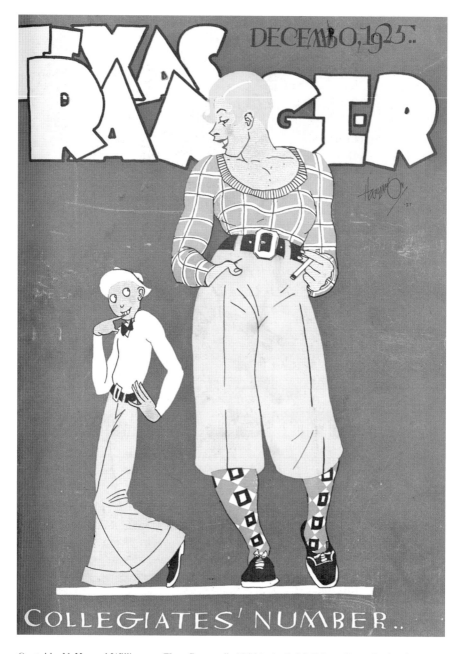

Created by N. Howard Williamson, Texas Ranger, di_09990, the Dolph Briscoe Center for American History, University of Texas at Austin.

flapper look. Large breasts were looked down upon as a sign of unsophistication, and amply endowed jazz babies pulled theirs in as best they could. Flappers not blessed with small busts wore uncomfortable bras that pulled in their backs to flatten their chests for that boyish look.

Whether boys actually liked that androgynous flapper look is beside the point: then, as now, they didn't care about the box, just what lurked inside.

Bobbed, boy-length hair also defined the flapper look. A Victorian woman's crowning glory was her hair—the longer the better. But with the world war, women working in factories had little time to spend caring for long hair. They cut their hair short for safety reasons. It also helped that their favorite Hollywood stars were doing the bob.

The *Daily Texan* and *Austin American* did investigative reports on why co-eds were bobbing their hair. One girl

Golddigger: Oh, lookit that beautiful pair of hose in that window. Let's go buy 'em.

Boy Friend: Sure, we'll go right by 'em.

From the Ranger, *1927, Texas Student Publications. Author's collection.*

said that she liked shocking her family. Another said she liked the adventure of going into a men's barbershop to get a cut. A couple of practical girls noted that it was absurd to trouble oneself with long hair when bobbed hair could be tended to in a matter of a few minutes and that such practicality allowed

Gulp: "You say that's your sister? I thought she was abroad."
Ulp: "No, she's a damn 'nice girl." *Brown Jug*

a girl to sleep until almost the beginning of her nine o'clock class. A certain athletic and strong-minded young co-ed declared, "This is one step toward masculine freedom that I intend to take."

Men's pajamas were soon considered to be ideal boudoir wear.

The co-ed fad of wearing men's knickers became so widespread that Austin stores were sold out by March 1, 1922.

Women's bathing suits that spring were practically indistinguishable from men's suits; their mothers' seaside parasols and bloomers were gone forever. Some girls dropped all pretenses and just started wearing men's bathing suits. Most UT eds largely favored liberated co-eds—but not when it came to smoking.

The *Austin Statesman* took a random campus census regarding the number of co-ed smokers in February 1922. "I

Top: From College Humor *(Collegiate World Publishing Company, 1928). Author's collection.*

Left: From College Humor *(Collegiate World Publishing Company, 1923). Author's collection.*

believe there are at least 500 girls at the University who smoke," one UT woman declared.

"They may not all make a constant practice of it," she conceded, "but they smoke every now and then."

"Any woman has a perfect right to smoke if she so desires" was the concurrent expression among both male and female students on campus. Opinion differed, however, on the question of whether a girl who smoked was worthy of equal respect as that due to one who did not.

Just a few days earlier, the *Texan's* "Ripples on the River Styx" gossip column had included a little ditty called "Curses":

> *Between her teeth a cigarette.*
> *Between her arms me.*
> *Between us both that damn cigarette.*

TURNABOUT IS FAIR PLAY

Transvestitism is a time-honored tradition in Austin that goes back to at least 1874, when "the Monstrosity" appeared, bustle and all, in Guy Town, Austin's red-light district. He was promptly thrown in jail and kicked out of town a couple days later.

In 1881, city marshal Ben Thompson arrested Mrs. Amanda Skeris, a well-known Austin woman of questionable virtue, at the train station dressed and armed as a deputy sheriff of Lee County. (S)he was accompanied by the high sheriff himself, who swore he and his deputy were escorting a prisoner back to Lee County. His story did not impress Austin's city marshal, who chucked Skeris in the can for wearing men's clothing in public. She was fined twenty-five dollars and loaded on the eastbound train the next day.

But by the turn of the century, times were changing.

One of the highlights of the UT school year during the Jazz Age was the "Junior Prom," when tuxedo-clad junior-class co-eds escorted their begowned senior-class schoolmates to an evening of dance and other gustatory delights, short of love itself. "The love that dares not speak its name" was never spoken of, not even joked about.

The first Junior Prom took place sometime around the turn of the twentieth century. From the beginning, it was a dance given by the junior girls for the senior girls. An account of one of the first proms taken from the

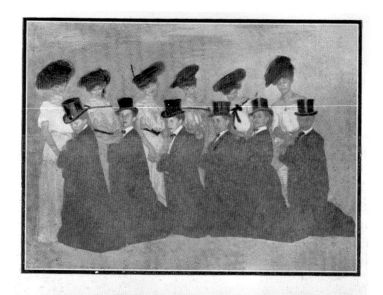

"TELL ME PRETTY MAIDEN."

"Junior Prom, 1903." *From the* Cactus, *1903, Texas Student Publications.*
Author's collection.

Daily Texan states that the conventional black skirt and white waist was worn by the juniors, and the seniors wore exquisite evening gowns. The party was not lacking in pep or excitement, according to several women who attended the event. Mrs. Eleanor Wells recalled that the stronger sex was in evidence at the party, but outside of the building. Freshwomen, in the role of henchwomen for the juniors, did valiant work in dispersing the uninvited guests with buckets of water emptied from the upstairs windows.

By 1903, the junior escorts had graduated to top hats and ankle-length black cloaks.

Stacomb hair wax, "Arrow" collars, bow ties and canes, stove pipe hats and tuxedoes all combined, making perfect jelly beans and jazz hounds of the junior girls, who escorted their senior ladies to the 1924 Junior Prom in the Women's Gym. It was a formal affair, the escorts sending flowers to their ladies and calling for them in cabs.

"Mr." Agatha McLarry led the grand march, favoring Miss Katrina Kirby. "Mr." Katherine Lemly, honoring Miss Anna Hiss, led the cotillion. The prom consisted of ten dances and three extras, of which the "Harper Hesitation," "T.U. Taylor Toddle" and "Calloway Canter" proved by far the most popular. The large number of stags added much to the prom's gaiety and helped make it a perfect party. The Texettes played for the dance and scored a hit with their jazzy jazz, their mournful minor waltzes and their general pep.

More than 350 girls attended the prom, the largest attendance ever. The boys got to peep through the windows at the festivities.

The cross-dressing cut both ways. In the midst of all the wonders of Greenwich Village, Podunk and Pflugerville at the WAA combination Bohemian-tacky party on April 17, 1924, in the Women's Gym, one beautifully bewitching "girl" caused much comment because she was so adept at leading when the dancing started. Besides proving that she was a past master at the Terpsichorean art, the young lady caused much speculation about where on earth she had gathered her costume. After several dances, the stranger removed hat, wig and mask and, as she bowed at the door before making a dash for the free open spaces, blushingly confessed that he was only a prominent sophomore at the university.

In March 1925, Miss Helen Sandel "came out" in the *Daily Texan*. Formerly known only as "There he goes—what's his name?" Sandel was a superb dancer.

At a recent university dance, "he" had been immaculately attired in a tuxedo, with blond hair thick and glossy, his face smooth and his eyes

flashing. "He" was altogether a striking figure, possessing a grace and nonchalance easily the envy of any sheik.

Sandel had danced with her partner before audiences ranging from a faculty tea to the Queen Theater for three years. During that time, she became well versed in the art of being a gentleman. She made her first appearance in boy's clothes at a freshman banquet in 1922.

"It is harder to dance before a university crowd than any other," Sandel told the reporter. "They are more critical. It is easier to 'get over' in a mixed crowd."

She laughed:

> *I've often been asked how it feels to be a "man among men." Instead of that free, unshackled feeling that one would naturally accord to a girl in boy's clothing, I always have a queer feeling of reserve. My friends tell me that I am noticeably more dignified as a boy than I am normally. I never have the desire to accentuate my masquerade by doing anything that would not be "lady-like" or even "gentlemanly."*

Her friends were accustomed to seeing Sandel in male attire, but they were still unable to master a momentary fright that took hold of them when they came upon her unexpectedly.

> *I have been greeted by more than one frightened squeal when I entered a girl's room unannounced. I shall never forget the time I slipped into a neighbor's room while she was asleep. When she woke and saw a "man" in her room, she grabbed her shoe and chased me up one hall and down another until I finally hid from her. She was infuriated, but she wasn't half as scared of me as I was of her and that slipper.*

Sandel was peculiarly suited to her manly role, being five feet, ten inches in height; fair; boyishly graceful; and strong. Yet she was not masculine in experience. The softness of her features and the femininity of her manner disproved any masculinity that might be attributed to her costume.

She had three suits of men's clothing and wished she could afford a man's whole wardrobe: "I love to dress as a boy occasionally, but I must confess that it is a relief to get skirts on once more."

A few months later, students pranked night watchman "Governor" Roberts as he was making his ten o'clock rounds. He noticed a young couple engaged in the social art of necking on a campus bench.

"Young people, you'll have to get off the campus if you want to do that."

"We weren't harming anybody, sir," retorted a coquettish little voice. "Just me and my sweetie sittin' here."

"That's all right. You'll have to get off."

"Aw shucks!" replied the dear little co-ed. "Let us sit here just a little longer, won't you please?"

"If you don't leave pronto, I'll place you both under arrest."

"Come along, honey," she cooed to her seemingly frightened escort, "the bad old man says we've got to drag."

They started toward the edge of the campus with the Governor in close pursuit.

As they neared the street, a crowd of approximately thirty closed in on the Governor and gave him the royal equestrian bray, for the sweet young co-ed was George Livingston, *Longhorn Magazine* art editor and erstwhile dramatist.

Then there was "It": another defining phenomenon of the age. "To have 'It,' the fortunate possessor must have that strange magnetism which attracts both sexes…In the animal world 'It' demonstrates in tigers and cats—both animals being fascinating and mysterious, and quite unbiddable," Elinor Glinn wrote in her novel, *It*.

Sounds awfully metrosexual.

The "It Girl" was a beautiful, stylish young woman who was sexy without flaunting it. But young men could also have "It."

The expression reached global attention in 1927 with the popularity of the Paramount Studios film *It* starring Clara Bow. Glyn, the notorious Englishwoman who wrote the novel and the screenplay based on it, lectured: "With 'It,' you win all men if you are a woman and all women if you are a man. 'It' can be a quality of the mind as well as a physical attraction."

Once a manifestation of youthful rebellion, jazz and gender bending had entered the cultural mainstream by 1925. How else to explain the Austin Kiwanis Club "Flapper Night" on October 20, 1925, "when to jazzy strains they flung a 'wicked shin' on the Stephen F. Austin roof, after being incited thereto" by a "revue" put on by several "flappers."

The occasion was ladies' night, and the fair sex was diverted exceedingly by the flappers, who were none other than DeWitt McGee, Sam Austin and Louis Shurr. The makeup was good—too good, for somebody started to date them up.

The annual 1927 Junior Prom in April featured a dance skit by Helen Sandel and Nan Bennett. But the evening's most memorable events were the buzzing, biting bugs that disturbed the prom-goers' equanimity. "Help!

From the Cactus 1925, *Texas Student Publications. Author's collection.*

I gotta varmint down my back!" and "Take 'em away!" were among the exclamations that greeted the horde of small black bugs that had invaded campus. Students and business houses were considerably troubled with the pests, and campus politicians would have garnered many votes if they had shown up at the opportune moment with some insect powder.

Even when a flapper or vamp dressed like a man, she was still all woman. Women had been drinking, drugging, dressing provocatively, painting their faces and having sex for fun (or money) instead of for babies for centuries—but they had been whores, outside the mainstream of decent life. UT's no-holds-barred jazz babies came from Texas's most prominent families. As did the jelly beans.

"Craps" (the dice game once reserved for back alleys) was now the rage among the smart young set. Among the most appreciated tokens of admiration offered to young girls were onyx dice, with the spots set in

HER BOSOM COMPANION

From College Humor *(Collegiate World Publishing Company, 1928). Author's collection.*

diamonds, pearls, emeralds, rubies and sapphires. No beaded purse or vanity case was without its set of jeweled dice, often in a platinum container, four times as expensive as gold. All the leading jewelers carried a large assortment. They were frequently seen at fashionable restaurants, where the dice were openly shaken in order to determine who should pay the luncheon check or the tea bill. Wags speculated that it would not be long ere the dainty young things would resort to artistically embroidered knee-pads, "for no habitual darkey crap player would be caught without his pads to protect his knees when kneeling down on the hard floor to shoot the dice."

Conventional wisdom is that the classic flapper style of bobbed hair, flat chest and straight waist lasted throughout the Jazz Age, but feminine curves were coming back into fashion by 1924, helped by modern bras like Maiden Form, which accentuated and lifted the bust instead of flattening it.

Many women were unwilling to pay the uncomfortable price for the flat look. Maiden Form sales outstripped sales of its competitor, Boyishform, in 1924. More-or-less modern bras could be seen hanging from co-ed clotheslines.

While lesbianism went unmentioned, fears that each incoming class of freshmen was a little further down the road to the gay male lifestyle go back to at least November 1920, when the *Scalper* editors opined:

The head of the Chicago Psychopathic Laboratories recently expressed the opinion that with the gradual obliteration of the world's "bad habits," man is becoming proportionately effeminate and puritanical.

Such a statement may appear an exaggeration of facts, nevertheless, there is a certain amount of truth contained therein. A careful observation of life's passing show in America will convince one that there are indications of a slow waning of masculinity among certain classes of men.

Take, for instance, the vaudeville stage. The novel introduction, a few years ago, of a song and dance act by apparently a beautiful girl—but in reality a man, has grown to be a regularity on the stage, so great has become the number of males with female instincts and accomplishments. Then, it has become the fad for male actors to act effeminate to amuse the audience, all of which, scientists maintain, is conducive to actual effeminacy. So thoroughly was this recognized by the president of one of our larger Eastern

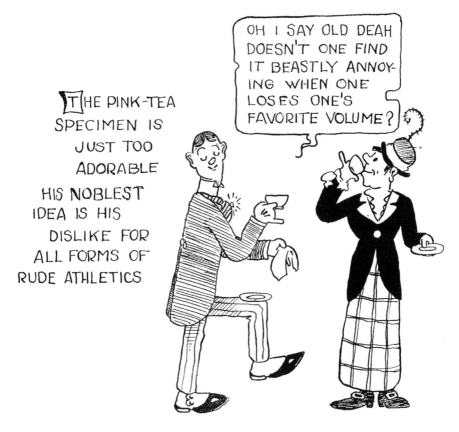

"Cartoon by Ralph Jester." *From the* Cactus, *1920, Texas Student Publications. Author's collection.*

Colleges, that he forbade the dramatic clubs of the institution giving plays, wherein men would fill women's roles. This appears to be stretching a point, but it merely shows that the "tender tendencies" of the male is recognized.

The large number of so-called "tea hounds" and "lounge lizards" that infest the parlors and tea rooms of the hotels in the larger cities is disgusting—another comparatively recent type of "effeminates." This class has even invaded our colleges to some extent, and seems to predominate in the Nation's highest social circles...the trend of the times seems to foreshadow that we will soon be smoking cubeb cigarettes and witnessing boxing matches between men with thirty-ounce gloves stuffed with rose petals.

Cartoons in the *Cactus* yearbook and the *Texas Ranger* humor magazine (successor to the *Scalper*) throughout the rest of the Jazz Age helped keep the "pink tea" fear alive.

"Barbette" was the Jazz Age's master female impersonator. The *Summer Texan* ran photos in July 1930 of the "World's Champion She-Man," who had been wowing Berliners with his clever female impersonations, unaware that he was little old Vander Clyde from nearby Round Rock.

Clyde, who achieved international fame as Barbette, female impersonator and trapeze and high-wire performer, was born in 1904 in Round Rock. Enamored of the circus after his mother took him to his first performance

From the Cactus, *1927, Texas Student Publications. Author's collection.*

in Austin, Clyde began walking the family's clothesline and working in the fields for money to go to as many circuses as possible. After graduating from high school at age fourteen, he traveled to San Antonio to answer a *Billboard* advertisement placed by one of the Alfaretta Sisters, "World Famous Aerial Queens." He joined the act on the condition that he dress as a girl, since his partner believed that women's clothes made a wire act more dramatic.

Clyde began developing a solo act in which he appeared and performed as a woman and removed his wig to reveal his masculinity at the end of the performance. After adopting the name Barbette, he performed throughout the United States, and his act became quite popular. In the fall of 1923, he traveled to England and then to Paris, where he opened at the Alhambra Music Hall.

Barbette became the talk of Paris and was the darling of American café society and French literary and social circles. French poet and dramatist Jean Cocteau championed his artistry. Inspired by Barbette's act, which Cocteau described as "an extraordinary lesson in theatrical professionalism," he wrote a review in the July 1926 issue of the *Nouvelle Revue Française* entitled "Le Numéro Barbette."

Cocteau, who was openly bisexual, described Barbette's acrobatics as a vehicle for theatrical illusion. From his entrance, when he appeared in an elaborate ball gown and an ostrich feather hat, to an elaborate striptease down to tights and leotard in the middle of the act, Barbette enacted a feminine allure that was maintained despite the vigorous muscular activity required by his trapeze routine. Only at the end of the performance, when he removed his wig, did he dispel the illusion, at which time he mugged and flexed in a masculine manner to emphasize the success of his earlier deception. To Cocteau, Barbette's craftsmanship—practiced on the fine edge of danger—elevated a rather dubious stunt to the level of art, analogous to the struggle of a poet. Cocteau wrote about Barbette on several other occasions, and in 1930, he used Clyde in his first film, *Le Sang d'un Poète* (*Blood of a Poet*), in which the bejeweled and Chanel-clad Barbette and other aristocrats applauded a card game that ended in suicide.

Clyde performed in Berlin, Hamburg, Copenhagen, Warsaw, Madrid and Barcelona, but his spiritual home remained in Paris, where he performed at the Casino de Paris, the Moulin Rouge and the Alhambra. His popularity peaked in the early 1930s, and his performing career ended in 1938, when he caught pneumonia after performing at Loew's vaudeville theater in New York. Left crippled, he required surgery and eighteen months of rehabilitation, which included learning to walk again.

Who says there's nothing new in college comics?

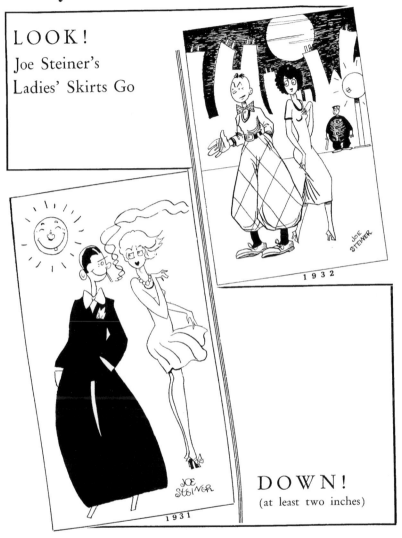

LOOK!
Joe Steiner's
Ladies' Skirts Go

1932

DOWN!
(at least two inches)

1931

From College Humor *(Collegiate World Publishing Company, 1932). Author's collection.*

Clyde continued his circus work, staging productions and training performers for Ringling Bros. and Barnum & Bailey and other circuses. He spent his last years living with his sister in Round Rock. He committed suicide at home in 1973.

There was change in the air when students returned to campus in September 1930—changes in fashion, demeanor and attitude. There was a sinking, growing feeling that the Depression was settling in for the long run.

Boyish hair and figures were out. Women decided to look like women again and make use of the charm of being feminine. Women's fashion once again emphasized femininity. Dresses had shapely lines designed to celebrate the female figure, but skirts dropped from knee length back to calf length.

Hair remained almost as short, but it was styled, and those silly flapper caps were canned. Rayon and good old Texas cotton replaced silk. Bras were sized by the cup starting in 1932, and the classic 36-24-36 figure was just another world war away.

6
JAZZ TALKIN'

Every lifestyle has its lingo, meant to be mysteriously unintelligible to the uninitiated. Hippies, valley girls and gangstas—regular folks have needed a dictionary to understand them. Like every outrageous lifestyle, the Jazz Age had its own peculiar palaver, which oozed sex and outrageous behavior.

"Jazz" was the buzzword of the 1917–18 UT school year, even though most folks—including budding "jazzbos"—didn't exactly know what all that "jazz" was about. The *Daily Texan* tried to explain in September 1917:

> *"Jasm" is this year's password, and for fear some of you will not recognize it, we will repeat the definition coming to our ears: A spit fire buzz saw going through a keg of 10-penny nails.*
>
> *Texas spirit of the 1917–18 variety must be depicted by the one word: jazz. It means more pep in each student than could be secured by simmering the bodies of the last dozen or so varsity yell leaders and concocting a more concentrated solution of their efforts and energies.*

"Jasm" goes back at least to the 1860s and is likely a variant of "jism," defined as far back as 1842 as "spirit; energy; spunk." *Jism* also means semen or sperm, the meaning that predominates today. "Spunk" is also a slang term for semen.

J. Lewis Guyon, Chicago's biggest dance hall operator, told "The Truth About Jazz," saying that for half a century it had been a slang expression to describe immoral acts and that if the great numbers of refined persons who

now carelessly used this word knew its actual meaning as used in parts of the underworld, they probably never would use it again.

To wit, as documented in *Criminal Slang: The Vernacular of the Underground Lingo* by Vincent Joseph Monteleone in 1945:

> *Jazz (n.): sexual union, a lively time.*
> *Jazz baby: woman of easy morals, passionate woman, prostitute or whore.*
> *Jazzed up Jane: a female no longer a virgin.*
> *Jelly: easily acquired money; girl easily made.*
> *Jelly bean: weakling; a coward.*
> *Vamp: (v.) to seduce by use of sex appeal; (n.) a seductress*

Although "flappers" defined the jazz life, "flapper" had been a well-known slang term for any impetuous and/or immature teenage girl or young woman as far back as the dawn of the twentieth century,

By 1915, the great curmudgeon H.L. Mencken had described what constituted a flapper. "The Flapper of 1915," he wrote, "has forgotten how to simper; she seldom blushes; and it is impossible to shock her."

In one of the twentieth century's most spectacularly wrong predictions, the *Austin American* declared in January 1918:

> *"The Idle Flapper" is going out of style. "The young girl, to be stylish now, must work," says Anne Hedges Talbot, state specialist for vocational training for girls in New York. This condition was brought about by Red Cross work taken up by the younger set.*

How wrong Talbot was; four years later, the flapper lifestyle was so ubiquitous that the *Flapper's Dictionary: As Compiled by One of Them*, was published for the benefit of bewildered parents and flapper would-bes. Therein she was defined as

> *the ultra-modern, young girl, full of pep and life, beautiful (naturally or artificially), blasé, imitative, and intelligent to a degree who is about to bloom into the period of womanhood and believes that her sex has been and will continue to be, emancipated to a level higher than most mortals have been able to attain.*

Jazz Age flappers embraced the essential flapper traits Mencken described in 1915 and added looser dress, looser morals and dancing to jazz music.

"Vamp," another defining word of the Jazz Age, was part of the Austin lexicon by 1918, as Mrs. Fred Scott noted in her *Austin Statesman* column "Principally People":

> *Don't tell me the movies aren't educational! Where would we have learned about "vamping" if it hadn't been for the movies? How many 16-year-old girls imagine they are just the greatest little "vamps" in the world and try to look like the vampire of the screen?*
>
> *In the matter of adding to the vocabulary, isn't "vamping" and "he vamp" and "she vamp" just the most entrancing additions to our language? Yet they will be in the next edition of Webster's unabridged as full-fledged American words, and no mistake.*
>
> *The vampire of the screen has done it.*

The use of the word "vamp" for a seductress dates to about 1910, but movie actress Theda Bara brought it into the mainstream with a series of scantily clad movies in which she seduced men into moral doom, most notably in *Cleopatra*, which premiered in Austin in May 1918.

Austin Statesman, 1918. *Author's collection.*

GLOSSARY (JANUARY 1923)

For those who wish to enrich their language

applesauce: something that is ruled out.

bee's knees: something that is in your good graces.

blow the joint: leave the place.

bozark: a girl with a solid ivory head.

Brooksy boy: a good dresser or an overdressed man.

buffos: dollars, and plenty of them.

butt me: give me a cigarette.

cast your glimmers: to look at.

cellar smeller: a young man who always turns up where liquor is to be had without cost.

cluck: a girl who dances clumsily.

cookie: a particularly young and tender "cake," as in "He's so sweet, you can eat him with a spoon," the flappers say admiringly.

crashers: people who butt into parties where they are not wanted.

crumb gobblers: people whose idea of a good time is to eat and talk.

darbs: a good-natured fellow with lots of money who insists on paying the check.

did I was: an exclamation of approval.

dose of shellac: too much to drink.

dud: a boy or girl who lacks pep.

dumb Otis: a stupid man.

Gerry flapper: a girl who thinks she looks like Geraldine Farrar (an American soprano opera singer and film actress, noted for her beauty, acting ability and "the intimate timbre of her voice") and adores her.

gobby: lacking in style generally.

grab a flop: sit down.

grease ball: a handsome foreigner.

grubber: a person who is always borrowing cigarettes.

holaholy: a girl or boy who objects to necking.

jelly bean: a new term for "cake eater"; an effeminate man of ease and pleasure who wears tailor-made trousers, frequents teas and "brasses" into private club dances; a "jazzbo" (the lover of a

flapper or jazz baby). (Made famous by F. Scott Fitzgerald in a short story, "The Jelly-Bean," in 1920.)

mad money: money a girl carries in her pocket in case the boy who invites her out runs short of berries, or jack, or chips or whatever he calls his purchasing power.

one-way kid: a fellow who likes to start an outing and lets somebody else pay for it.

out on parole: a person of either sex who has been divorced.

pocket twisting: costing a young man who takes you out as much as possible.

punk: any sort of an undesirable person of either sex.

scandal walker: a college boy or girl, so called from his or her manner of walking and dancing.

slummer: a person who seeks social enjoyment at studio parties.

slunge: the lowest form of human being to be found in smart society.

sub chaser: a man who tries to pick up girls on the street.

they: uttered in tones of disgust, this word means parents or elderly people who object to modern ways and manners.

tomato: a girl who is a wonder as a dancing partner and will dance all night; otherwise, she is a wash out.

Wallie: a goof with patent leather hair.

An overheard dance conversation might sound like this:

Fred: Dis sure is de berries of a hop, ain't it?
Mame: Yuh said it, kid, hear them jazz babies play.
Fred: Swell rig yuh's got on, girlie.
Mame: Yuh ain't so wurse lookin' yuself.
Fred: Yu're my style, girlie, and yuh know how to shake the dogs.
Mame: Now I'll tell one.
Fred: But yuh got de goods, honest, betcha dere ain't a better lookin' skirt here.
Mame: Quit cher kiddin'.
Fred: I ain't kiddin' yuh. Won't cher come up wid me to de balcony after dis round?
Mame: You tell 'em, kid.

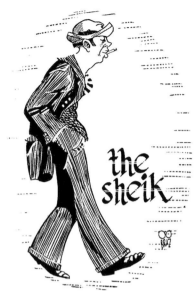
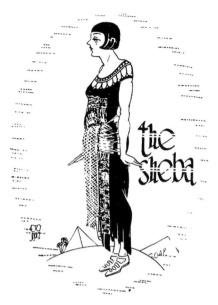

THE SHEIK

I do believe Dar-win was right
Each Time I get the merest Sight
Of Ginks like him, this Col-lege Sheik,
A Cook-ie Push-er, so to speak.
His Dress de-notes an emp-ty Dome,
Me thinks there is no one at Home.
You note his slouch Walk at a Glance,
His freakish Coat, Bell Bot-tom Pants.
The Pat-ent Leath-er Shoes are there,
And he has bob-bed and Sta-combed Hair.
There're Side-Burns, too, (how can he bear 'em!)
Red strip-ed Ties, he loves to wear 'em.
"Miss Ag-nes," is his fav-o-rite by-word,
And on his Lips, and turned up skyward
There rest be-neath his pinkish Snoot
A high-ly scent-ed Ci-gar-root.
The Cor-ner Drug-Store is his Shrine
For there Co-eds can see him fine.
He's quite a Dan-cer and a Pet-ter,
And, though I'm not known as a Bet-ter,
I'd like to wag-er that this Sheik
Leaves Col-lege just a Mid-Term Week.

THE SHEBA

Just gaze up-on this lit-tle She-ba,
As mush-y as a young A-moe-ba.
Now this fair Maid so lithe and dap-per
Was last Year's short-Skirt Wool-Hose Flap-per
But last Year's Styles are out of Date.
For In-stance, Bob-Hair now is straight.
Her Dress Hem is un-ev-en cut.
Em-broid-'ry bor-row-ed from King Tut.
The Sleeves and Neck of each De-scrip-tion,
Must show that they are quite E-gyp-tian,
The Van-i-ty has I-vo-ry Han-dles,
And she wears col-or-ed low cut San-dals.
This Pow-der Plant car-ries a puff,
And Rouge and Lip-stick, just such Stuff.
With swag-ger Walk, and Hat set rak-ish,
This Gra-vy Ha-ter looks more Snak-ish.
And do Boys fol-low this Bun Dus-ter?
Why she has all that she can mus-ter.
She grabs them in the Ford or Re-o,
This cap-ti-vat-ing mo-dern Cle-o.
If dig-ging up this old man Tut-ty
Has caused the Girls to go so nut-ty,
I won-der how the Girls would rig up,
Should Eve, we hap-pen-ed, so to dig up.

From College Humor *(Collegiate World Publishing Company, 1923). Author's collection.*

The Sheik, starring Rudolph Valentino, was the hit movie of 1922, at least among American women. Men almost universally loathed *The Sheik*. Many refused to see it, and many who went walked out during the film. Those who stayed laughed out loud at the love scenes, scornful of

Valentino's style of lovemaking. Most American men considered him effeminate—even homosexual—because of his character's long, flowing robes, and they scornfully referred to him as Rudolph "Vaselino" for his greased-back hair, a nickname applied to any young man with slicked-back hair and questionable masculinity.

Nevertheless, *The Sheik* was such a box-office smash that the word "sheik" quickly came to mean a "young man on the prowl," the object of his desire being called a "sheba."

Like all languages, jazz talk evolved with time, and in January 1925, the *Daily Texan* published "Jazz English":

> *We hear much about the merits and demerits of jazz music, but we hear more jazz English in a week than we hear jazz music in a lifetime.*
>
> *A student in Emerson College, Boston, writes: "A dear little flapper friend of mine found complete and satisfying self expression for all that favorably affected her in the adjective 'grand'—whether she had in mind a poem, salad, or sunset.*
>
> *"The same sort of mental indolence has caused the phrase 'you bet' to break out like a rash all over the far Northwest. Multitudes who have no wager of any sort in mind express all affirmatives and agreements in 'you bet.' 'Please bring me lamb chops.' 'You bet.' 'Mark me for a six o'clock call.' 'You bet.' 'It looks like rain.' 'You bet.' 'Do you enjoy Browning?' 'You bet.' 'Does this street lead to the station?' 'You bet.' 'Will you be my wife?' Maybe another 'you bet.' It is 'you bet' ad nauseum."*
>
> *These and many other jazz English expressions are common among the students at the University of Texas. Instead of asking "how are you?" many of us say, "how you got 'em?" If an act at the Hancock vaudeville is good, or if a basket ball player throws a goal from a difficult position, or if a girl's appearance is especially attractive, many of us say "that's the stuff." "Don't try to Canary me" or "I certainly was griped" and "You're not locking" are expressions upon various and varied occasions. We say, "boy, that's hot!" irrespective of whether we are referring to good ice cream, an interesting lecture, a vaudeville actress scantily clad, or an enjoyable musical program.*
>
> *Some contend that there is some argument for using such jazz English, that it is "snappy" and often very expressive. But the advantages of jazz English are trivial in comparison to the disadvantages. We may laugh at jazz expressions, but when we start using them, we find it extremely difficult to use good English; it soon becomes almost impossible for us to*

express ourselves correctly. Inability to use the English language correctly is a great detriment in any walk of life, and a boy or girl who is unable to express himself or herself when young, finds it almost impossible to use good English in later years.

As the Jazz Age melted away in the face of the Great Depression, so did jazz talk.

In September 1930, in an editorial called "No Joe College," the *Daily Texan* marked the passing of the era:

The day of the painted slicker and the Ford decorated with so-called collegiate wisecracks is surely passing into limbo. The new definition of a collegian does no longer lay emphasis upon freakish and highly exaggerated mannerisms, fantastic vocabularies, and other forms of immature manifestations.

THREE COWS, MAKE 'EM CRY

New Mexico has a state question: red or green? As in chiles. During the Jazz Age in Austin, it was "with or without?" As in onions. On your hamburger. "Three cows, make 'em cry" signifying three burgers with onions.

Hamburgers fed the Jazz Age. Before the war, they had been circus or county fair food. The world war changed everything, including eating habits. The sweet/smoky scent of good old ham and eggs, a longtime student staple, gave way to the pungent odor of hamburgers with onions and toasted buns.

As the 1919 school year began, UT students were eating ice cream sandwiches, drinking cold Bevo at ten cents a pop, eating hot hamburgers and swimming and dancing at the Deep Eddy pool and pavilion.

Near campus, they were eating big hamburgers with I.N. Taylor's kettle-cooked potato chips at the War Savings Bank. Co-eds were eating raw onions on their midnight hamburgers for the first time.

The way to a jazz baby's heart was through her tummy. Even a chance of getting to first base with your date cost you at least three burgers and a Coke. French fries? They were still in France.

Dancing worked up appetites, and hot dogs and hamburgers were popular fuel by 1923. But it was generally "hold the onions" before dances, except for those who could not do without them even before a dance. The heaviest eaters of hamburgers were girls, judging from the sales of two campus stands surveyed by the *Daily Texan*. Boys consumed more onions, however. Boys came more often, but girls bought more at a time, said W.C. Byrd of Kum Bak. Girls ate more and often took advantage of the three-for-

MACK'S

DELICIOUS HAMBURGERS

*With Tomatoes and
Toasted Buns*

ARE THE TALK OF ALL THE
UNIVERSITY

Above: "Hamburger stand, Harlingen, Texas." February 1939. *Russell Lee. Library of Congress, Prints & Photographs Division, FSA/OWI Collection.*

Left: From the Cactus, *1925, Texas Student Publications. Author's collection.*

a-quarter specials, Lawrence "Mac" McInnis of Mac's Hamburgers stand said. The biggest sales were at night, from nine to twelve o'clock, students being hungriest at ten o'clock.

Toasted sandwiches were all the rage at campus-area eateries, and speaking of toast, on October 25, 1924, "Mac" McInnis died tragically in a predawn fire at his little one-room house located behind his burger stand. Stricken with paralysis, Mac had been unable to move for a year. Awakened by Mac's screams, neighbors rushed to the burning house but found the doors locked. After bashing in a door, they entered into a roaring furnace and were forced back. After putting out the fire, firemen found Mac's charred corpse on what used to be a cot. His sister, Mrs. John H. Tobin, was Jack "Shakey" Tobin's mother.

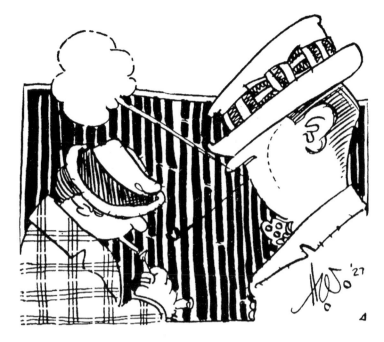

'26: 'Jever hear about the fellow who bet he could eat fifteen hamburgers?

'27: No. What happened?

'26: He won the bet but lost the hamburgers.

From College Humor *(Collegiate World Publishing Company, 1927). Author's collection.*

One of February 1926's highlights was the contest to rename the former Mac's Hamburger stand at 2400 Guadalupe. First prize was one hundred hamburgers. The winning name, Tom's Hamburger Heaven, was submitted by a pair of co-eds.

For the past quarter of a century, after all the varsity dances, it was unwritten law that as soon as the drummer's cymbal whined out its last crash, each couple snatched its wraps and galloped madly to the nearest joint. The cafés that lined Congress Avenue had been the traditional destinations for dancegoers after the final strains of "Home, Sweet Home."

But by the fall of 1927, *Daily Texan* reporter Bill Dyer wrote,

> *rather than head down to Congress Avenue, many dance-goers headed for Hamburger Alley on Guadalupe Street. Poets made much of the scent of flowers, of rich perfumes, and the fragrant smell of new-mown hay. Hamburger Alley had a seductive fragrance peculiarly its own—the heavy, piercing odor of onions, raw and fried, old and new—an odor suggestive of tears and eats. Even a stranger could not miss it; all you had to do was walk from campus until you smelled the onions, then stop.*
>
> *There the valuable queller of appetite was dealt out in miniature shops, the recipients sitting on stools along the counters. Almost every shop was equipped with a phonograph or a radio. Just as the urchins of the poem watched the Village Blacksmith potter around, students liked to sit on the high stools and watch the skillful cook flip the hamburger patties over and over, slap mustard on the bun, put infinitesimal slices of pickles and tomatoes atop the little piece of scorched meat and generously wrap the*

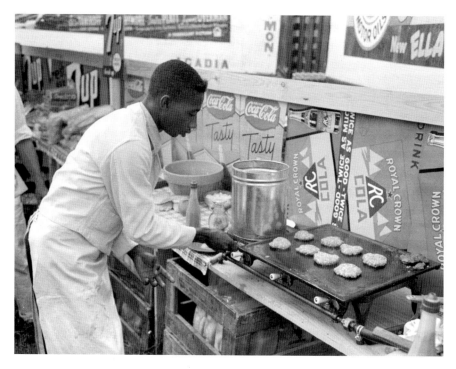

"Making Hamburgers." *October 1938. Russell Lee. Library of Congress, Prints & Photographs Division, FSA/OWI Collection.*

finished hamburger in a paper napkin. The call for three, with or without onions, depended on whether or not the diner had a date.

Guadalupe, also called "U Town," was made up primarily of hamburger stands, drugstores, cafés and fruit stands. The tiniest local hamburger stand near the south end of the street and the largest drugstores across from the campus enjoyed the patronage of hungry college students.

"They were as thick with each other as Guadalupe is with hamburger stands" was a popular euphemism for overly loving couples.

The burger stands had their vogue at night. Girls from the dorms went out in groups of two and four down to the corner stand to taste the appetizing bun and meat with or without onions.

Some enterprising girls profited from their fellow dorm inhabitants' gnawing hunger pangs by taking hamburger orders and buying them for their customers. Some stands sold three hamburgers for twenty-five cents, and the girls would take orders for twenty or thirty hamburgers at ten cents apiece.

As you wandered away from Hamburger Alley into the region of drugstores and confectionaries on upper Guadalupe, the ozone improved to a marked extent, and the hamburger with bottle soda gave way to the sandwich and fountain drink. Among soft drinks, Coke ("Atlanta Special") was the overwhelming favorite, and ginger ale wasn't in the race.

Then, as now, when they weren't pigging out on three-for-a-quarter nocturnal burgers, co-eds obsessed about their weight. The scales in the University Cafeteria were, at the same time, one of the most popular and unpopular hangouts on campus. Popular in that by the end of January 1928, cafeteria customers had weighed 232,462 times since the scales had been installed in March 1925. Unpopular in that the usual wail from the female customers was "Oh, these old scales are wrong. I know I don't weigh that much!" or "Are these scales really right?" Girls agonized over their weights whether great or small. Some perceived that they were losing that perfect thirty-four and acquiring proportions similar to the figure eight, became alarmed, cut out carbohydrates for a while and began consuming Cokes. Others who had a lean and hungry look began feeding on fat sandwiches and many-calorie "Oh, Charleys."

Fruit stands, like the hamburger stands, were busy at night, appealing to those who were "keeping hygiene"—fruit being permitted between meals for those who would not break the health rules. Fruit stands understood the rules well enough to also sell bottles of milk, which was not one of the health seekers' forbidden beverages.

Despite all its blatant lovers, there were still lots of hamburger snobs who cast uplifted eyebrows when passing hamburger stands; they felt that when they bought a hamburger at one of the stands near campus, they were committing an unlawful act.

The stigma they attached to eating hamburgers around the campus was perplexing to believers. Why did the pseudo aristocrats among them scorn such a delicious assemblage of good food sandwiched into one unit? Was it because hamburgers were made out on Coney Island and not along Park Avenue? Was it because a hamburger cost ten cents the country over and therefore was automatically classed among those so-called lowbrow dishes of corned beef and cabbage ("Irish turkey") and sauerkraut and weenies ("Bloodhounds in the Hay")?

But there were hypocrites among the snobs. They would first pass by the stand nonchalantly, softly whistling a tune. If no one was in sight, they retraced their steps, darted quickly inside and took a seat farthest from the door. Their actions were much the same in leaving the place. Then they walked toward home in fine spirits and in a self-congratulatory attitude for having escaped unnoticed and for having deliberately appeased their hunger.

Perhaps someday the Prince of Wales would be reported as having a taste for hamburgers, and eating them would become as dignified among university students as eating a fruit cocktail after the Saturday night German.

With the crack of dawn, hungry students crowded into campus-area cafés and drugstores before making the traditional 8:00 a.m. class.

Coffee and a sandwich was standard fare, but some chose all sorts of combinations, and a few English students got tea every morning. Waiters quickly learned what each person wanted and, as they walked in, shouted, "Adam and Eve on a raft!" (two poached eggs on toast) or "Cops and robbers!" (donuts and coffee) as the occasion might demand.

Students with an hour or two in between classes or in the afternoons occupied drugstores and eating places along Guadalupe. Even gropers after higher things had to come down to chocolate sodas and toasted sandwiches between slices of acquired learning—or rest—in classes.

Drifting into the stores by twos, threes or fours, students kept the soda jerks busy slicing bread and pouring iced glasses of Coke and phosphates. Someone would be playing the Victrola or dialing the radio, and music mixed with the laughter and sound of clinking glasses.

Drugstore daily sales might average 1,100 soft drinks (two-thirds of these being Cokes), 150 sandwiches, 100 packages of cigarettes, 75 cigars, 200 packages of gum, 75 nickel candy bars and quite a bit of fruit.

Apples, oranges and candy bars were popular between-class encores and acted as buffers between appetite and duty as the weary minutes of that 12:00 to 1:00 p.m. class crept slowly by.

Even though nachos were nearly a lifetime away, tamales, enchiladas and chili con carne had been Austin dietary staples for fifty years. When they tired of hamburgers, hot-blooded students cut a trail down to the Original Mexican Café on Congress. On Sunday nights, when boardinghouse landladies and cooks balked at lighting the gas, El Poblano was a favorite student rendezvous. It had plenty of exotic atmosphere, and they could listen to the *chinky-chink* of the tin music, sneeze over the pepper in the chile and feel just like they were in Greenwich Village. Co-eds enjoyed their cigarettes there without being ogled as curiosities.

And just as it was with their hamburgers, the question was "with or without?" Onions. With your chili.

8
BLACK AND WHITE

If it seems that this book is extraordinarily white, so it goes, as goes recorded history. Austin had no black newspaper during the Jazz Age to record local happenings.

Black music generally went unnoticed unless it was gospel music from the Ebenezer Church Choir, which was very popular with mainstream whites. Black jazz bands from east Austin played at UT student dances but were generally referred to only as "colored" or "Negro" bands in the occasional published newspaper account. Quite a contrast to San Antonio, where WOAI radio regularly broadcast local black musicians like Troy Floyd and his Plaza Hotel Orchestra, and Dallas, where Alphonso Trent and his Adolphus Hotel Orchestra played at the Adolphus and Gunter Hotels and on Dallas's WFAA, America's first African American band to appear regularly on the airwaves.

The University of Texas was lily-white until 1950, when, under great protest, a handful of black men were admitted to the Law School and to graduate programs not offered at Texas Southern or Prairie View, the state's principal black colleges.

The Varsity Minstrels Show in December 1919 at the Hancock Opera House, in addition to the customary blackface comedians and buffoons, featured a "Nigger Jazz Band" number entitled Eight Ebony Entertainers, with Longhorn Band members presenting "blues" with true jazz adaptation.

Austin was one the most conservative, segregated cities in Texas during the Jazz Age. The city fathers passed an ordinance in 1928 that pushed

the blacks living in west Austin into east Austin. The plan did not target Hispanics, but those who lived in today's "warehouse district" also moved to east Austin.

Austin's oppressive Sunday "blue laws" closed down just about everything except the churches.

The *Austin American* estimated that the strict "blue law" closings sent $1,500 of Austin money to San Antonio every Sunday as bored Austinites and Austin visitors trekked to that city for something fun to do. The Missouri Pacific ran a special "Weekend Frolic" train from Austin to San Antonio and back for just $1.50. Imagine not being able to go to the movies on Sunday! That's what Austinites couldn't do.

But when it came to the Klan…In March 1924, the Rodger and Harris Circus played Austin for a benefit of the Ku Klux Klan Charity Fund, featuring the Rodgers and Harris Cowboy Band playing its "Original Jazz and Feet Ticklers." There were no blackface or minstrel acts.

Jimmie's Joys ruled the Dallas jazz band roost in 1925. That year, Alphonso Trent and his band arrived looking for work. After hearing them busking on the street, the Adolphus Hotel picked them up for a two-week gig that lasted over a year. The Klan threatened to tar and feather them, and there was opposition from Jimmie's Joys and other leading white bands. Despite this opposition, Trent's orchestra became one of the dominant bands in the Southwest and Midwest. They played great jazz but never broke out of the regional, or "territorial," ranks.

Trent's band played a few gigs at the end of the UT 1925 long term, culminating with the May 22 German. They spent the summer playing at San Antonio's St. Anthony Hotel.

Trent's orchestra, including two Charleston troupers, came from Dallas to play the KC Hall German on April 10, 1926.

Harold Caldwell's orchestra had been the Stephen F. Austin Hotel's summer house band and played the 1926 UT Pre-Rush Week Dance. But Trent's Gunter Hotel Orchestra played the prestigious UT Rush Week German series in September. The eleven-piece group wore a variety of costumes throughout the week to give a college atmosphere to the dance, including one night in knicker suits. Their specialty numbers included one by the drummer on a washboard.

The UT-affiliated dance schedule during the winter and spring of 1927 was quite diverse, featuring Trent's Black Aces from Dallas, the Oleander Black Aces from Dallas, an unnamed Mexican orchestra and a local "Negro" ten-piece orchestra.

"Colored" music may have been popular on the UT campus, but this did not translate into respect for the race. The sky was being lit up nightly by spectacular meteor showers in August 1928, which prompted university president Dr. Harry Benedict to remark, "When I was a boy, I used to hear about the shower of 1866 and how frightened the darkies were. They thought the world was coming to an end. But, of course, it doesn't take much to make a darkey think that."

Carl Sandburg, the great poet, was also a folklorist and visited Austin many times to perform. On one trip, John Lomax and Frank Dobie took him to the Silver King, a black restaurant in east Austin run by a man named Martinez. They stayed until after midnight listening to the songs. Sandburg enjoyed himself more than anyone in the crowd.

"I so much enjoyed the atmosphere there and the negro songs I heard in the place," he told Anne Elliot, a *Daily Texan* reporter. "I heard some of the best material on the collection of historical biographies one day, and on the very same day got some of my very best crap-shooting songs." So saying, he threw back his shaggy head and almost roared at the idea.

Austin's black popular music scene, almost never mentioned in white newspapers, hopped with talent, young and old, like Gene Ramey, jazz bassist, born in Austin in 1913. Music was a Ramey family tradition. His was a family of singers. A grandfather was a violin player, "one of those hot violin players of the late 1800s and the early 1900s. He was one of those entertaining violinists," Ramey said in a 1980 interview. His brother Joe sang with the Capital City Quartet at the capitol, governor's mansion, Stephen F. Austin Hotel and Driskill Hotel and around Central Texas. "They had Austin sewed up, they were making so much money singing for senators and doctors," Ramey said.

The Capital City Quartet was not jazzers but held a special place in students' hearts.

On Friday, October 13, 1922, a *Daily Texan* reporter wrote,

> *finishing up a day that seemed destined to be gloomy, because of the date and the appearance on campus of a coal black bird of ill omen, four residents of Wheatville, Austin's "colored section" just west of campus, rendered a concert in front of Mac's hamburger stand.*
>
> *The Capital City Quartet, consisting of W.H. "Stonewall" Jackson, Harvey Burke, Joe Brown, and Mincie Elgin, sang in the melodious tones of the true Southern "darkies," giving the appreciative crowd such songs as "Old Black Joe" and "Kentucky Blues."*

The expressions on their faces as they sang ranged from doleful, to sad and weeping, to actually pained. Their listeners' expressions were anything but pained and they expressed the hope that the quartet might favor them again soon with their music.

Not much is known of the quartet today. Stonewall Jackson is now largely forgotten. It appears that Jackson may have been a waiter at the Driskill Hotel at one point in his life. The late Austin humorist Richard "Cactus" Pryor, who sang a mean baritone in his time, went often to east Austin to hear the quartet sing. Jackson's awesome voice greatly impressed and influenced Pryor in his own singing career.

As a youth, Gene Ramey started pounding blocks together in tempo and then got a trumpet, followed by a baritone horn and bass horn. Ramey even played ukulele and sang in a quartet. Every Friday night during the summer a black band of around twenty pieces gave concerts in the park. Ramey attended Anderson High School and played drums in the Boy Scout marching band.

By 1927, Eddie and Sugar Lou's Hotel Tyler Orchestra had moved to Austin, and they were Gene Ramey's favorite band. They were said to have spent a year headquartered here, but nothing more is known; they were never mentioned in Austin's newspapers. Ramey and others who could tell us more of those days have passed on to their eternal glory.

That same year, the Oklahoma Blue Devils lured up-and-coming Dallas-born trumpet player Oran "Hot Lips" Page away from Eddie Fennell and Charles "Sugar Lou" Morgan. In his early years, Page had traveled the Southwest backing blues singers Ma Rainey, Bessie Smith and Ida Cox. He would go on to play with Bennie Moten and Count Basie's original Reno Club orchestra.

In high school, Ramey belonged to a social group called the Moonlight Serenaders, who got tired of spending their money on musicians for their dances and organized their eponymously named band, a six-piece group that became very popular among other social clubs such as the Mystic Knights and Wild Fire Sheiks. Eugene Love, who later played with Sammy Holmes's La Palma Orchestra, tutored them. He met tenor sax player Herschel Evans through the social club; Evans and Buddy Tate played with Sammy Holmes. Holmes hired Ramey to play jobs when Love wasn't busy. Evans went on to work with Count Basie. The Moonlight Serenaders "tore up" Taylor, Bastrop, Elgin and other local small towns, earning the boys up to $1.50 apiece per night.

Ramey joined George Corley's Royal Aces on sousaphone that year.

Born in Austin in 1912, Corley was a trombonist. In high school (1926), he formed the Deluxe Melody Boys, who played around Austin and did some touring, and lasted until 1930, when Corley founded the Royal Aces. Herschel Evans played tenor sax with Corley in 1930.

The Corley family was steeped in music. Brothers Reginald Corley (trumpet) and Wilford Corley (tenor sax) were Royal Aces.

They bought music at J.R. Reed's Music Store. You could buy a whole orchestration. Stuff like Duke Ellington's "Ring Them Bells," "When the Moon Comes Over the Mountain," "Should I?" and "Dream a Little Dream of Me." Some of them were in off keys, which they'd give as a sample. The Aces got lots of those. They improvised, rarely using the chart, except for the first and last chorus. That was the general idea of most of the bands from Texas, Ramey said.

Ramey went to Kansas City to study electrical engineering at Western University in 1932. He played tuba in the school band and discovered his love for the string bass.

Ramey was soon leading his own bands around Kansas City, Missouri. He began a lifelong friendship with saxophonist Lester Young. In 1938, Ramey played bass with the last of the great Kansas City bands, led by pianist Jay McShann. The band included saxophonist Charlie Parker. Ramey worked with Parker and helped him develop his mastery of keys and chord progressions.

In 1944, Ramey moved to New York City, where he played with Lester Young, Count Basie, Ben Webster, Coleman Hawkins, Charlie Parker, "Hot Lips" Page, Thelonious Monk and Miles Davis. In 1976, he moved back to Austin, playing occasionally until his death in 1984.

Ironically, Louis Armstrong played at least one documented gig in Austin, at a UT dance in the fall of 1931, in the dusk of the Jazz Age.

Even less is known about the Mexican jazz scene. Don Cortes and his nine-piece "Texonians" orchestra played against Burney Stinson's band in a street battle dance in May 1931 and went on to play at the newly opened "Tokio" later that month, as well as in Llano. Amos Ayala, a San Antonio drummer, played with Jimmie's Joys on several road trips.

There were no Latino newspapers, and the mainstream (white) publications paid as little, if not less, attention to goings on in the "Mexican" community as they did to the black community.

P.R. Carmona's "Mexican Band" began a series of free evening concerts in the city park at Fifth and Guadalupe Streets (present-day

Republic Square Park) in March 1921. The twelve-piece band played waltzes, marches and popular airs, such as "Grenoble" (march), "Amor Mexicano" (waltz), "Voluntarios Mexicanos" (march), "Elida" (foxtrot), "Zacatecas" (march), "La Paloma" (waltz) and "La Golondrina" (waltz). Most of the group's members had played with bands in Mexico City or with Mexican military bands.

The Varsity Peacocks played quite a few UT-affiliated dances during the winter and spring of 1927, along with the Ligon Smith Orchestra, Trent's Black Aces and the Oleander Black Aces from Dallas and an unnamed Mexican orchestra, which we can assume jazzed, but whether it was from Austin is a mystery.

The 1932 Thanksgiving dance featured a "battle of music" between Fred Gardner's Troubadours and the ten-piece Aggieland Orchestra. A four-piece Mexican orchestra played at the pre-dance reception in the Main Building; nothing is known about it.

PART II
JAZZ PEOPLE

9
IF YOU CAN'T DANCE, GET ON AND RIDE

Shakey's Orchestra was UT's first Jazz Age "house band," but of all the jazz bands that followed, none out jazzed Jimmie's Joys.

While Shakey's Orchestra shook things up at student dances in the winter of 1919–20, the Original Sole-Killers, founded by eighteen-year-old Jimmy Maloney, began playing its own "wicked low-down music" in early 1920. Born in 1902 in Mount Vernon, Texas, Maloney began playing clarinet as a boy while living in Commerce, Texas. Maloney attended Texas A&M for a year and then transferred to UT. Since dates with co-eds weren't cheap, he formed the Sole Killers to earn spending money.

Maloney's claim to fame was his ability to play two clarinets at once.

Following in the footsteps of Shakey's Orchestra the previous summer, Maloney and the Sole Killers spent much of the summer of 1921 in Galveston, playing at Joyland Park's brand-new Garden of Tokio.

Galveston was a popular summer refuge for Austinites, who brought their musical tastes with them, and so Jimmy's Sole Killers and Soul Thrillers had its first Joyland gig in mid-May 1921. It was an immediate, resounding hit, "playing dance music so different."

Quite a change from 1919, when Joyland Park featured light operas the entire summer season.

The Sole Killers' "pull" was evident, as the *Galveston Daily News* described on July 20:

"Jimmy Joy." *Promotional photo, 1930s. Author's collection.*

What is said to have been the largest crowd of the present summer season was in attendance at the weekly Garden dance last night, where as an added attraction Jimmy's Sole Killers and Soul Thrillers, the University of Texas orchestra which has met with such approval on previous appearances here, rendered the program. The pavilion was attractively decorated in Japanese lanterns, and during the time that the dancers were on the floor a novel lighting effect was frequently used.

While in Galveston, the Sole Killers met the Texajazzers, from Austin College in Sherman. The Texajazzers included Tommy Joiner, trumpet;

Jack Brown, trombone; Charlie Potts, sax; Charlie Ballew, piano; Smith Ballew, banjo; and Dee Orr, drums.

Later that summer, the Texajazzers played the Youree Hotel's roof garden in Shreveport. While there, the Ballew brothers and Jack Brown decided to go to the University of Texas, where they joined up with Maloney and several of his friends to form Jimmie's Joys, "the exterminators of gloom": Charlie Willis, trumpet; Jack Brown, trombone; Jimmy Maloney, clarinet, alto sax; Collis Bradt, tenor sax; Charlie Ballew, piano; Smith Ballew, banjo; and Dick Hamel, drums.

The origin of the band's name probably owes to an eccentric newspaper cartoon Maloney enjoyed. *Joys and Glooms*, by prominent political cartoonist Ted Powers, featured the characters Joy and Gloom. If optimism was in order, Joy chased Gloom and vice versa.

Jimmie's Joys' earliest known gig was a fraternity dance on November 10, 1921. It was an instant hit, and the group played a number of student dances in the winter and spring of 1922.

"When Shakey's Orchestra passed away, the trippers of the light fantastic mourned over the futures of University dances," a *Daily Texan* reporter wrote

No. 101—"Joy" Drives "Gloom" Away No. 104—"Mother's Joy" Takes a Ride

Advertisement, circa 1919.

in 1925, "but into the breach stepped the soon-to-be renowned Jimmy's Joys, née the Sole/Soul Killers, to gladden the heart of the ed and co-ed."

Jimmie's Joys played the summer of 1922 at the Garden of Tokio, with its new motto, "If you can't dance, get on and ride."

In January 1923, Maloney got a tryout notice from Thomas Kirby, who had come from New York City to Fort Worth seeking talent. Kirby was the country's foremost vaudeville talent scout, having discovered performers like Ginger Rogers. Groups and acts from all over the Southwest came to try out. With its shoulder-shaking syncopations, Jimmie's Joys won the auditions at Fort Worth's Majestic Theater on January 15. The *Fort Worth Star-Telegram* said its "blue harmony" was irresistible. The Joys were encored time after time and immediately contracted for a national tour.

Maloney delighted audiences by playing two clarinets simultaneously—the melody of "St. Louis Blues" on one and the harmony on the other. Their tours would be built around Maloney's unique stunt.

The *Daily Texan* bade them a fond farewell:

> *"Dance, Dance, Dance!" say Jimmy's Joys, "for tomorrow we leave!" So every little flapper that could possibly get a German date, proceeded to do so, for was not Jimmy, the king of Jazz, playing for the last time at the old familiar rendezvous. The German, heretofore an ordinary weekly occurrence, became an event. When would those divine strains, sweeter to the Jazz Hound's ears than the angelic harp music, ring out on the night air again, and who could fill the royal place; were the thoughts that occurred to the dancers. But all things must end, and even the most perfect, so farewell to Jimmy and his Joys with the hope that they won't forget the dancers they leave behind them.*

The Joys started their forty-week tour on the Orpheum Keith circuit (which featured actors and comedians like the *Three Stooges'* Larry Fine) at the end of January in Houston and then moved to San Antonio and three other Texas cities before passing through cities in Oklahoma, Kansas and Missouri and then eastern cities, including Boston, Philadelphia and New York.

In San Antonio, UT students reserved the entire Majestic Theatre for the opening show, and there was bedlam when the curtains parted to the strains of "Wild Jazz." That bang continued throughout the tour. The road show included Henrietta Straw, who cakewalked, jigged and high kicked her way into audiences' hearts.

The Joys' San Antonio stand included a special program on WOAI radio on the evening of February 14 that included "Toot Toot Tootsie,"

"Chicago," "Rose of the Rio Grande" and "Gray Morn," followed by one of the show's highlights, a solo by road manager Marty Young—"the Male Nightingale"—on "Aggravatin' Papa."

In Atlanta, the theater was sold out to Georgia Tech students, and instead of "Wild Jazz," the band opened with "I'm a Ramblin' Wreck from Georgia Tech." The audience was hooked for the rest of the night.

They also played dances on the side on their way to New York.

In New York, they played at Fox's Theatre and then at Keeney's Theatre in Brooklyn. "When we played at Irving Berlin's Music House, musicians would be lined up listening to us play," Lynn Harrell remembered in the article "Jimmie's Joys," which appeared in *Storyville* in August/September 1985. "Most of the musicians in New York then were so corny it was just tragic."

Keith-Orpheum wanted them to play Canada, then New York's Palace Theatre and possibly abroad. Several members thought they should stay in New York and ride their wave of success, but the band voted to return to Texas.

While in New York, they took the Garden of Tokio's offer for a summer job. Their steamer voyage to Galveston took six days, including a stop in Havana. They played evenings on the deck when it wasn't storming.

When Jimmie's Joys returned in May to play the final dances of the UT school year, a great crowd of dancers welcomed the band, despite the impending agony of final exams.

The *Galveston Daily News* eagerly announced on June 6, "Following the old adage that chickens must come home to roost, Jimmy's Joys, after a whirlwind vaudeville tour, have just returned to Texas from New York and Sunday will be 'doing their stuff' at Tokio." The unusually large crowd that night was unusually insistent for encores.

They made a quick train trip over to San Antonio to play WOAI's evening broadcast on June 25, followed by a dance at the Gunter Hotel's rooftop Japanese Garden.

The *San Antonio Express* exuberantly announced the band's brief return:

> Are there any so benighted that they do not know who Jimmy Maloney's Joys are? Is there a faint, wee voice in the rear of the house which admits this thing? On the chance, then, that such a pitiable condition exists somewhere, Jimmy's Joys are—
>
> Only one of the best orchestras, producers, and manufacturers of high class jazz, in this part of the Southwest; merely seven joyous, jubilant, jazzy young fellows from the University of Texas who can play music, if anyone should chance to question you about it.

This orchestra has just returned from a tour of the Keith vaudeville wherein they knocked their ears out over the rest. Everywhere they went, they were proclaimed as good as the best, in New York and other eastern cities.

It is said that this band made quite some impression even up there on Broadway, where the very cream of the country is inclined to center. On one occasion they played for a dance at the Ritz-Carlton, alternating with Paul Whiteman's famous orchestra.

While in New York, the orchestra received several attractive offers, each of which called for 40 weeks of playing, and because this would have broken up their plans to return to college, the boys had to refuse them all.

Jimmy Maloney, who heads this musical outfit, is known all over these parts as the chap who takes two clarinets, puts them both to his lips at one time, and plays them in a way that would bring tears of envy to the eyes of any nightingale. At his chosen instrument, Jimmy can't be beaten anywhere. Whether he can even be tied is doubtful in the extreme.

The Garden of Tokio stint ended with a big Labor Day dance, and they returned to Austin for the 1923 Rush Week dances.

Young Glenn Miller drove a loaned car from the University of Colorado to Austin in September 1923 to audition, invited by Smith Ballew. Trombonist Jack Brown was leaving the band. The Joys played mostly by ear. Each man had his parts memorized, so practically nothing was written down. Miller had to have music before him, so he didn't know what the group was doing. He flunked. It wasn't fair, Ballew told Reagan Houston in 1975, but that's the way it went.

The band journeyed to Commerce, Maloney's hometown, for a two-night stand on September 20 and 21. The *Commerce Journal* proudly wrote:

One night several years back, at the old Dreamland Theater, little boys of about twelve years of age were surprised, and were perhaps a little bit envious, to find another little boy of their age playing in the orchestra. On Thursday and Friday nights of this week this same little boy, now grown, played at the Hippodrome and was recognized by the home folks as being the star that he is.

Jimmy Maloney has been one of the most popular students at the University of Texas for three years, and whenever the University Band appears it is unusual if cries of "Give us Jimmy" are not heard, for his solos are always in high favor.

Despite the praise and popularity, he is still just the same old "Jim," a fine, affable, well-polished gentleman, whom all like and respect.

The band played the La Tertulia Club dance on September 28 and left for Los Angeles. Why? Because it had never been there.

Jack Brown had returned to the band. Drummer Dick Hamel had returned to his Los Angeles home and was waiting for the band. Charlie Willis and Collis Bradt wanted to stay in school that fall, so they didn't go west; cornetist Rex Preis went in Willis's place.

They drove. It rained a lot, and the roads were often impassable, forcing detours. They went by the Grand Canyon and rehearsed a bunch of new tunes along the way.

In Los Angeles, they quickly established a reputation as "the snappiest dance band that ever invaded the West." They auditioned at Sid Grauman's Metropolitan Theatre and played during the prologue before the featured movie. They played the El Rancho Country Club and on radio station KFI. Fitz Theopolis listened to the broadcasts and liked what he heard. He had established the West Coast's first permanent recording studio and asked the group to make the first recordings under the name of Golden Records. The Joys were thrilled to death. There had been several offers to make records while they were on tour, but they felt it wasn't time yet.

They recorded "Bugle Call Rag," "No, No Nora," "Sobbin' Blues," "St. Louis Blues," "Tiger Rag" and "Wolverine Blues."

Band members were Smith Ballew (banjo), Jack Brown (trombone), Johnny Cole (brass bass), Dick Hamel (drums), Lynn Harrell (piano), Jimmy Maloney (clarinet) and Rex Preis (cornet).

Theopolis invited the group to his house for dinner when the records were ready. After dinner, Theopolis played the first record. The Joys were elated.

They returned to Austin carrying five hundred records. Hamel remained in LA, though he later rejoined the group. In El Paso, they picked up drummer Frank "Fats" Obernier. Collis Bradt rejoined the band upon its return to Austin.

The Joys played two shows to enthusiastic audiences at the University Co-op on January 4 and 5. The records flew off the shelves for one dollar each. Harrell figured they could have sold five thousand records.

Brother David Shields advised all his Pi Kappa Alpha fraternity brothers to buy as many of Brother James Maloney's Jimmie's Joys records as possible, reminding them they had sworn to aid one another.

Jimmie's Joys were students once more, and Maloney planned to take his degree in June. He had no plans for orchestra tours after that date.

The band zipped down to Galveston to play the Garden of Tokio on February 9, 1924. There was a large turnout for what was one of the winter

season's most anticipated dances. The band had added a helicon (an early day sousaphone).

Two nights earlier in San Antonio, the Sun Dodgers Orchestra had proved that imitation is the sincerest form of flattery when Jimmy Kline played a twin clarinet solo on the "St. Louis Blues" during its WOAI broadcast.

On February 15, Jimmie's Joys played for the first Texas Cowboys Round-Up Dance. They had just turned down a gig at the University of the South in Sewanee, Tennessee. Former UT students there had highly recommended the band, but their studies came first.

They played a farewell to San Antonio gig at the Empire Theater during the first week of March, with a blend of snappy jazz and semi-classical music. "China Girl" opened the program with a clash, followed by "The Waters of Minnetonka" with a scenic effect and finishing with Maloney's twin-clarinet rendition of "St. Louis Blues."

The UT Longhorn Band's annual state tour in March featured Jimmie's Joys, with stops in Brenham, Orange, Beaumont, Port Arthur, Houston, Mexia, Corsicana and Ennis. At Corsicana, matinee and night shows were given, and the theater was packed. At Mexia, the opera house was filled to its seven-hundred-person capacity, and the fire chief locked the doors, turning away more than two hundred people. Jimmie's Joys played encore after encore at every concert.

The Joys' lineup had changed again. Smith Ballew left the band in April to get married; Clyde "Fooley" Austin replaced him on banjo. Fats Obernier

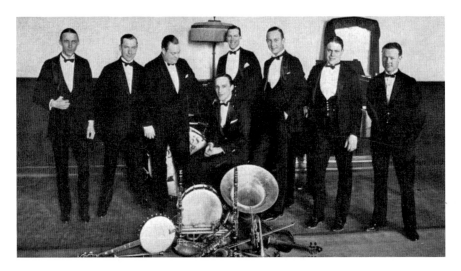

"Jimmie's Joys, circa 1924–25." *Publicity photo. Author's collection.*

replaced Hamel on drums, and Johnny Cole, on helicon, was added. Gilbert "Gib" O'Shaughnessy joined on clarinet and alto sax a few months later.

Ballew moved to Fort Worth, revived the Texajazzers and began playing at the Fort Worth Club.

Maloney had changed his mind about the band's future—there was a larger world to conquer, and the *Cactus* bade them an affectionate farewell in May 1924: "May our long to be remembered jazzters be so prosperous that in a few years the motto on the dollar will have been changed from 'E Pluribus Unum' to 'If You Can't Dance, Get On and Ride.'"

For his part, Dean Hanson Parlin told them, "I would confer a degree on you boys because you deserve it for doing more in public relations for the university than anyone else could have possibly done."

Jimmie's "Nothing Hotter Since the Chicago Fire" Joys left Austin in June to tour Texas, playing the first part of the summer at the Garden of Tokio.

The Joys then became the house band at the St. Anthony Hotel's glass-enclosed roof garden in San Antonio, playing six nights a week with Sundays off and on WOAI radio. Their St. Anthony's gig lasted more than a year.

"King of Jazz" Paul Whiteman and his band played at the Majestic during the Joys' St. Anthony tenure. Whiteman's band stayed at the St. Anthony, and the band came up to the garden to hear the Joys play. After hearing them, Whiteman got them their first written arrangements. This coincided with their gradual transformation from a jazz band to a hotel ballroom dance orchestra.

In the beginning, they were a hot jazz band. There was no arranger; everyone contributed, inspired by other bands' records, especially the New Orleans Rhythm Kings. They had one hundred or more tunes memorized.

With Jimmie's Joys now rooted in San Antonio, a number of bands filled the musical vacuum on campus. But the Joys took time off from their St. Anthony gig to play the 1924 Rush Week dances. Rush Week would have been incomplete without them. The dances were, of course, well attended.

The final Saturday night Rush Week German was one for the record books. Nine-tenths of the freshmen who had never heard the Joys before preferred to listen to the music than dance. A student tabloid, the *Freshie*, declared:

> *Jimmy Maloney's music was not the only thing that was hot last Saturday night. The temperature was 110 degrees in the middle of the floor, according to Bob Bledsoe, and Johnnie Price said it was 109 by the coolest window. One freshman said he felt as if he had put his coat on over a bathing suit.*

Jimmie's Joys resumed their WOAI broadcasts from the St. Anthony on September 23.

In October, elementary school kids, churches, park employees and individuals were collecting money to help "Old Peg," a nice old man who had given kiddies donkey rides for years in a local park and was now seriously ill. By October 5, the "Help Peg" fund stood at nearly $300.00, including $12.50 donated by Jimmie's Joys and the chefs at the St. Anthony.

"Most of the men have no children," Maloney said, "but we are anxious to do our part. We wanted to help the children in their response to Peg's needs."

On October 18, the band played the Queen's Ball at the state fair in Dallas. A special student train ran from Austin to the fairgrounds, eliminating the need to walk or catch a cab between the train station and the fairgrounds.

The Joys had just premiered a Collis Bradt song, "Springtime Is Lovetime," which he dedicated to his mother. Bradt offered a prize of five dollars for the naming of his song, won by Robert Martin of Austin.

On October 14, WOAI's new fall broadcasting schedule included Jimmie's Joys dances at the St. Anthony on Tuesday and Thursday nights, heard by listeners all over the continental United States.

On October 21, Maloney offered a five-dollar prize for a name for a new double clarinet number he played that night. The suggestions came pouring in.

"Name It Twin Cylinder Blues. The cylinders were hitting on all eight last night," wrote Cooley of the North Plains Wranglers of Hays, Kansas.

"A name suggested for the piece of music played by the orchestra is 'Autumn Blues.' This is appropriate, I think, because you could hear the cold wind blow and the chicken crow for the changing of the weather," wrote Alice Barber of Ardmore, Oklahoma.

W.A. Killiam of St. Louis simply wrote, "I stay home every night you broadcast Jimmy's Joys Orchestra."

The Joys continued their charitable activities on Armistice Night, November 11, when they played a few numbers at the Majestic Theater's midnight matinee to benefit the Crippled Children's Fund.

Sometime in October or December 1924 (depending on the source), the Joys journeyed to Dallas to record "Milenburg Joys," "Clarinet Marmalade Blues" and "Mama Will Be Gone" for OKeh Records.

Personnel at the session included Clyde Austin (banjo), Collis Bradt (alto, tenor sax), Jack Brown (trombone), Johnny Cole (brass bass), Dick Hamel (drums), Lynn Harrell (piano), Jimmy Maloney (clarinet), Gilbert O'Shaughnessy (alto, tenor sax) and Rex Preis (cornet).

The records were on sale a week later at San Antonio stores. The Beyer Company's Houston Street store played the new records every day during the first week of January. The phonograph shop was crowded each time the records were played. OKeh records could be played on any phonograph, the store manager pointed out.

"This is a distinction that has never before been accorded a Texas orchestra," reported the *San Antonio Express*, "and radio fans may now 'tune in' on Jimmy's Joys at any time of the day or night without fear of tiring the members of this splendid musical organization."

For the big New Year's Eve dance at the St. Anthony, Maloney added a special twist. Since WOAI was broadcasting the party, Maloney offered a prize of the band's phonograph records to the person telegraphing from the farthest point his reception of the program. Major Sherman at Summerside, Prince Edward Island, won the prize.

WOAI later received a letter from Owen Meals, a Ford dealer in Valdez, Alaska, some 3,200 miles distant, who heard the broadcast but either didn't hear the announcement about the records or wasn't able to wire the station because the prize would have gone to him.

Jimmie's Joys returned to Austin on January 20 to play at Governor Miriam Ferguson's inaugural reception and ball and at a student dance following the inauguration ball.

During the first week of March, they played a special program at San Antonio's Majestic Theater as part of Syncopation Week. They received ovations greater than those accorded to Paul Whiteman. The Joys departed San Antonio on April 6 on a "working vacation" to record new pieces for OKeh.

By April 26, A.F. Beyer in San Antonio was selling the latest "wailing fox trot record" by Jimmie's Joys, "Clarinet Marmalade Blues," "full of snappy syncopation with all the breezy blues His Highness loves, the kind of tune that makes them throw away their crutches at the old soldiers' home," backed with "Common Street Blues."

Jimmie's Joys went to Kansas City that spring. MCA had them playing dances through Texas and Oklahoma on their way from San Antonio. Wallace Robinson, who owned the St. Anthony Hotel, had a chain of hotels that included the Muehlebach in Kansas City. The Joys played there and at the Plantation Grill, as well as on the Muehlebach's radio station. In Kansas City, they recorded "Memphis Bound," "Riverboat Shuffle," "Indian Dawn," "Be Yourself," "China Girl," "Wild Jazz" and "Springtime Is Love Time."

The personnel included Clyde Austin (banjo), Amos Ayala (drums), Collis Bradt (alto, tenor sax), Jack Brown (trombone), Johnny Cole (brass bass), Dick Hamel (drums), Lynn Harrell (piano), Jimmy Maloney (clarinet), Gilbert O'Shaughnessy (alto, tenor sax), Rex Preis (cornet) and Norman Smith (clarinet; alto, tenor sax).

From Kansas City, the band headed to Chicago, settled in and went looking for famed cornetist Bix Beiderbecke. It found him playing piano with Charlie Straight's group at the Rendezvous Café. After he finished, the Joys introduced themselves, and Beiderbecke invited them to stay and listen to his six-piece band, which played at midnight. When he started, it seemed that every musician in Chicago was in the room. Beiderbecke insisted that the Joys sit in with him, which, owing to the small stage, only half the group could do. After they left Chicago, they played a string of one-nighters on their way to San Antonio.

The boys returned to Austin in time to play several of the big, end of the 1924–25 school year dances.

At this point, Harrell and Bradt left the band. Harrell wanted to marry and settle down and was living in Greenville when the Joys came to Dallas to play the Baker Hotel and record with OKeh. Maloney wanted Harrell for "St. Louis Blues" and "Stomp It Mr. Kelly." Harrell drove over from Greenville for those two songs, and Red Bourn, who replaced him and became the band's first arranger, played on the rest of that session's recordings, which comprised "Red Hot Henry Brown," "My Sweet Gal," "Fallin' Down," "Hay Foot, Straw Foot; Everybody Stomp," "St. Louis Blues" and "Stomp It, Mr. Kelly." After the session was over, Preis returned to his new wife in San Antonio. He led his own band there for several years before joining Herman Waldman at the St. Anthony in 1929. He played with Waldman for nine years. A young Harry James played with the group for a while, too.

The Joys stayed for ten months at the Baker Hotel. Maloney was enlarging the band and changing its scope. They were no longer the wild student band of old, playing by ear instead of by sheet music. Most of the UT boys were gone.

They broke out of the Baker Hotel for something of a Thanksgiving vacation to play a dance at San Antonio's Gunter Hotel on November 23, their first San Antonio gig since leaving the St. Anthony Hotel. Maloney, a self-described motoring enthusiast, cruised down in his brand-new Studebaker Big Six sports roadster.

Maloney went to court in 1927 to legally change his name to Jimmy Joy. People called him that anyway, and the band had just signed with MCA,

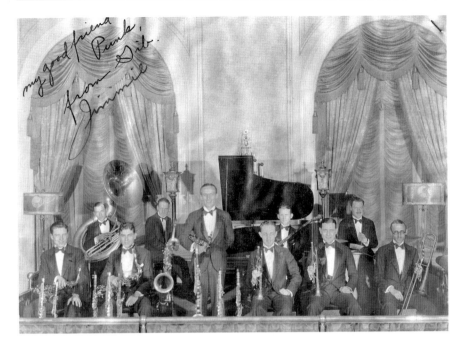

"Jimmie's Joys." *Promotional photo, late 1920s. Author's collection.*

which insisted that all its bands have a leader's name. They wanted Maloney to establish a legal claim to the name so that no other band could adopt the name, as had been the case with the Sole Killers name, which had been adopted by several subsequent bands, such as the Glenn Wallace Sole Killers and Loraine Hoover's Sole Killers of San Antonio, as well as Vick's Sole Killers and Henry "Lazy Daddy" Filmore and His Soul Killers of Galveston.

And thus, Jimmie's Joys became Jimmy Joy and His Orchestra.

One of Joy's favorite stories was about changing his name. The federal judge before whom he appeared was Irish and felt compelled to remark, "I can't see why a person would ever want to give up a good Irish name like Maloney."

From the Baker Hotel, the orchestra migrated to the Brown Hotel in Louisville, Kentucky, where it played during the 1927 Kentucky Derby. The only old-timers left in the band were Joy, Hamel and Brown.

When the band left the Brown Hotel, it went on to recurring engagements at Cincinnati's Gibson Hotel and Pittsburgh's William Penn Hotel.

Jimmy Joy and His Orchestra (now eleven pieces) recorded "From Monday On," "Yale Blues" and "I Got Worry" in March 1928 for Brunswick in Chicago and again in May: "You're the First Thing I Think of in the Morning."

Spud Murphy, who became a noted arranger, joined the group, and his first recorded arrangement was "I Got Worry." He wrote several more arrangements for the band.

During the 1930s, the orchestra occasionally traveled to the East Coast and by the early 1940s was playing at the Casino Gardens in Santa Monica, California. This was now a fine hotel and ballroom orchestra. The group dropped "Wild Jazz," its traditional opener, in favor of "Shine on Harvest Moon" in 1927. Maloney still did the two-clarinet trick on the "St. Louis Blues" and began singing the blues, Jack Teagarden style. Texas made him an honorary Texas Ranger, and Kentucky made him a Kentucky Colonel. His orchestra served as the official Kentucky Derby Orchestra from 1929 to 1931.

In 1933, *San Antonio Light* columnist Jeff Davis profiled Joy on the eve of his engagement at San Antonio's Cocoanut Grove nightclub, his first San Antonio appearance in six years:

Texas university alumni consider it a mark of ill breeding not to stand up and shout when Jimmy Joy starts to play his piece d'resistance, "The Eyes of Texas Are Upon You." That gives you an idea of how deeply Mr. James Monte Maloney is entrenched in University traditions.

Twice a year one of the theatrical publications publishes a list of orchestras with Jimmy Joy listed in the A classification. Well, he's Jimmy Joy in the dance band world, but up in Commerce, Texas, he's just Jimmy Maloney, who used to play second clarinet in the First Methodist church orchestra.

Upright Commerce church-goers used to wonder where the syncopated obligato was creeping into the music and they finally traced it to that upstart Maloney boy. They kept him in the band, though, because he used to rear back and give them a swell job on "Onward Christian Soldiers."

Musicians say that Maloney first learned to play jazz by ad libbing an obligato to phonograph records and as far as he remembers, it's probably true. He has done almost as much for "The Eyes of Texas" as [Rudy] Vallee did for the Maine Stein song.

In common with most dance bands of the day, his early bands played by ear, usually copping their orchestrations from phonograph records. They considered it sissy to read music, and the first time someone suggested that Jimmy get a vocalist for the band he said he wasn't running a Glee club and for them to mind their own business.

In 1942, Dallas-born Harry "the Bear" Babasin, pioneering jazz cellist, joined the orchestra while it was based in Chicago and touring the Midwest.

In the summer of 1946, Patti Page joined the orchestra. Jack Rael, the band's sax man and manager, discovered Page in Tulsa while the band was there for a gig. She left Tulsa in December to join the band in Chicago, where it was playing at the Club Martinique. She got seventy-five dollars a week, but she was nineteen and unready for the life of a girl singer, so she left the orchestra in the spring of 1947. The era of the big dance orchestras was at an end anyway.

During his last years, Joy had a booking agency and continued to do some playing. In June 1961, he underwent surgery, never regained his health and died in Dallas in March 1962.

Designing Men

J ack "Shakey" Tobin reported to the University of Virginia in the fall of 1920, probably as a result of his first year at UT. With Tobin gone, the German Club announced that several different jazz bands would provide the music for the coming year's dances.

After a year at the University of Virginia, Tobin returned home and reorganized the band, which left Austin toward the end of June 1921 for a tour of the southern United States, including Little Rock, Memphis, Louisville, Atlanta and the fashionable Poland Springs.

After the summer tour, Tobin decided that giving parties was more fun than playing for them and organized something resembling a weekly student speakeasy described by the *Cactus* as "the little love nest down on 8th Street, which has been camouflaged with sheet music and passed off upon the unsuspecting city mothers under the style of a 'studio.'" After one particularly wild Wednesday night party, the attendees, who included Martha "Oof" LaPrelle (see Chapter 19, "Buzz Edens and His Girls"), were placed on scholastic probation

Tobin had also become a right-smart decorator, festooning the annual Angler Club dance in late March 1922. The KC Hall was closed for several days for Tobin to work his magic, which exemplified the Jazz Age's excesses in consumerism.

The *Austin American* was impressed with the results:

> *The glamour and mystery of the Orient were depicted in the setting arranged for the "Persian Garden" dance given Friday night by the Angler*

"Queen's Ball, 1926." *From the* Cactus, *1926, Texas Student Publications. Author's collection.*

Social Club. The stage represented the portals of a Persian Palace with gold pillars supporting the massive arches above. The palace opened on a walled-in garden, the high stone wall overgrown with flowering rose vines. In the distance against a black background, could be seen the towering domes of mosques. At intervals about the wall niches were constructed in which played jewelled fountains, the pearls, rhinestones and amethysts gleaming now red, now purple, now gold in the changing lights thrown by indirect lights.

Oriental lanterns shaded in green, rose, lavender and gold lighted the hall. Oriental designs were followed throughout and rich Oriental hangings added to the effect. Tall jars of peach blossoms were placed here and there about the hall and the windows were banked with the same blossoms.

Favors of Oriental ear rings for the girls and pearl studs for the men were distributed by Miss Tobin [Jackie's little sister, Bess] and Miss Agnes Smith in pearl-trimmed Oriental costumes of orchid and yellow crepe de chine over dark blue silk. Their headdresses were of pearls in the fountain design.

To Jack Tobin, who designed the affair and supervised the arrangements and decorations, is given the credit for the brilliant success of the affair.

Shakey's Orchestra, in a rare appearance, gave the music.

Tobin's "The Merry Whirl," a society revue, was the highlight of April 1923, presented at the Hancock Opera House after a successful two-night

stand in San Antonio. He designed all the elaborate scenery and gorgeous costumes. The show was an extravaganza in every sense.

"The Merry Whirl" began with a prologue depicting the life of the average society cad who calls up every girl he knows for a date and fails to get one. Then came glimpses of sunny Spain and the Pyrenees, Egypt, the Orient, Hawaii and the South Sea islands, all in rapid succession.

In *Laceland*, a combination ballet and musical number, the cast wore imported laces with a stage setting of black velvet, silk and lace lanterns and silver steps.

Katharine Gans made a big hit in the song number "Brownskin," which featured a snappy dance chorus of "high brown" girls.

George Duggans got a hand when he sang "Aggravatin' Papa" and "The Sheik of Alabam," while Jack Tinsdale was applauded for his two Harry Lauder numbers, "I Love to Be a Sailor" and "Stop Your Ticklin', Jock."

Tobin's production reflected the hottest cultural and fashion phenomena of his day.

After the discovery of King Tut's tomb in November 1922, an Egyptian craze occurred, and women's fashion design for the rest of the decade was influenced by Egyptian stylings, ad nauseum:

> *It's King Tut pearls,*
> *It's King Tut watch,*
> *It's even King Tut ring.*
> *It's King Tut hose,*
> *It's King Tut clothes,*
> *It's King Tut everything.*

Tobin was living in Dallas by May 1925, and the Bluebonnet Shop of San Antonio, which had supplied wigs and other makeup materials for "The Merry Whirl," was suing him for $237 in unpaid bills.

He arrived in Galveston on April 27, 1927, with a carload of material and several assistants to begin work on the floats for the upcoming second annual International Pageant of Pulchritude, flush with success at the recent Battle of Flowers parades in San Antonio, where he had designed and decorated many of the parades' floats. Three of his creations won first prizes.

The International Pageant of Pulchritude launched in 1926, featuring contestants from Texas, Mexico and Canada. In 1927, the contest became the truly international beauty contest with girls from eight countries. Two separate events were held over two days, one to award the title of Miss United

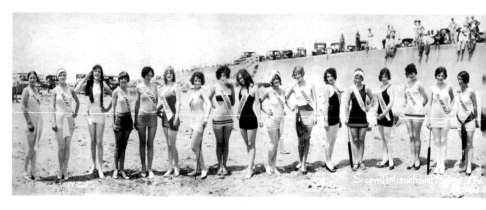

"International Pageant of Pulchritude, 1927."

States and one to award Miss Universe. The pageant was already considered an opportunity for potential movie and stage actresses to be discovered.

"It will be my aim," Tobin declared, "to give the great crowds that are sure to come for the spectacle a real treat and something that will be new and different and provide a setting befitting the beauties and matching their charms.

"We will try," he added, "to give each float an individual touch and, so far as is possible, employ color scheme and motif that will harmonize with the occupant."

Quite an upgrade from 1926, when contestants were paraded in rolling chairs.

The pageant's first parade took place along Galveston's famed Boulevard on May 21, featuring 36 beautiful women (ages fourteen to twenty-five). The viewing crowd was estimated at between 50,000 and 100,000. The *Galveston Daily News* stated that the event drew 250,000 people.

Aside from the contestants, the *Daily News* reported,

> *the beautifully decorated floats on which the beauties were mounted and perambulated by uniformed attendants came in for a large share of attention. These floats, which were personally decorated by Jack Tobin, decorator of national reputation, were features of beauty and provided an attractive setting for the lovely maidens.*
>
> *None of the floats were similar in shape, conception or decoration and they called for outbursts of admiration along the route.*
>
> *Among some of the very lovely ones was that of Miss Beaumont, silver and blue base, with vase of vari-colored flowers; Miss France,*

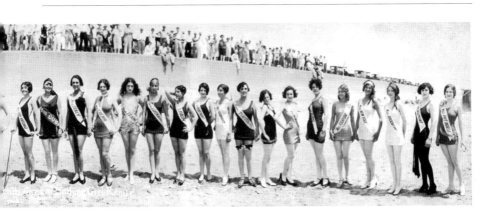

float symbolic of the tri-color of France, with large red poppies; Miss Cuba, miniature Moro Castle with bronze background and orange color water lilies.

Miss New York City, Dorothy Britton—a wholesome, American, milk-fed beauty—won in 1927.

Tobin spent the month of July 1927 in Galveston preparing for the third annual Junior Bathing Girl Revue in August. The parade of the little silk-and satin-clad Texan beauties (ages three through twelve) took place on the Seawall Boulevard, and the junior pageant, coronation and ball were staged the following night at the Garden of Tokio.

Crowds estimated at between forty and sixty thousand flanked the nearly twenty-block route, waiting hours for the processional of twenty-five diminutive beauties. Equally as attractive as the girls were Tobin's floats, gaily decorated to harmonize with the suits worn by the little lovelies, ornate in silver, gold and iridescent colorings.

He continued to design various events and venues for the next few years, before opening a flower shop near the state capitol grounds in September 1933, supplying floral displays for the funerals of Texas's leading public servants.

That March, when B.U.L. Conner of the *El Paso Herald Post* asked Tobin whether Douglas Fairbanks Jr. should attempt to woo back Joan Crawford, from whom he had recently separated, Tobin answered, "Wooing them is lots of fun, but the reward is often not worth the effort. Wooing the same girl twice is bound to be awfully disappointing. There could be no element of surprise at all."

In 1938, Tobin and Jimmie Holmes opened La Cucaracha (The Cockroach), a Mexican food café, at 802 Red River. By the summer of 1939, La Cucaracha was the Spanish Village (an Austin institution for ages,

infamous for its cockroach infestation), and Tobin had packed up and left Austin for California.

Tobin died in San Francisco, where he had been living for the past year, on April 29, 1961. His body was shipped to Austin for burial. His brief obituary stated, "Tobin for many years was a florist here and was well known as a party decorator for many of the leading social functions of the city. He also at one time was the pianist for a well-known Austin dance orchestra."

Tobin was a talented designer, but he never attained the national prominence enjoyed by his classmate, Ralph Jester (born in Tyler in 1901). Jester was something of a musician (he sang in the glee club), but he also had a talent for art in general and cartooning in particular, showing off his distinctive style in the *Cactus* yearbook and student humor magazine the *Scalper*. He continued his education at Yale, where he was an editor of the *Yale Record* humor magazine. Jester went on to create some of the *New Yorker* magazine's finest cover art. Jester's cover for the July 24, 1926 issue of the *New Yorker* is considered a benchmark for Jazz Age design and is widely available for sale today.

In 1931, he moved to Hollywood, where he was costume designer for some of Cecil B. DeMille's most spectacular movies. He was costume designer for *Cleopatra* (1934), except for Claudette Colbert. *Cleopatra* was so significant a movie that it merited its own documentary short, *The Hollywood You Never See*, in which Jester played himself.

Jester was unit director for Cecil B. DeMille's 1949 production of *Samson and Delilah*. In July 1948, after Palestine was ruled out as a location, DeMille sent a second unit, headed by Jester and Arthur Rosson, to North Africa to shoot background scenes and obtain authentic-looking props. The unit shot in twenty locales, from Algiers to Casablanca. Due to the extreme heat, the crew packed ice around the film containers to protect the film stock.

He was also costume designer for DeMille's *The Ten Commandments* (1956); *The Life, the Loves and the Adventures of Omar Khayyam* (1957); *Solomon and Sheba* (1959); and *The Buccaneer* (1958). Several of these movies received Oscar nominations for best costume design. Legend has it that the actors in *Omar Khayyam* asked Jester to sew invisible pockets into the flowing robes so they could carry lunch, money, cigarettes, car keys and handkerchiefs.

Jester ordered a plywood house in 1938 from Frank Lloyd Wright for his property at Palos Verdes, California, but it was never built, although the plans were used to build the Pfeiffer House in Scottsdale, Arizona. Jester died in 1991.

11

FROM SISSONNE TO SAMBA

"She is kind of a leavening agent, stirring people up to the heights, raising the level of the moment in creative life," an intimate friend of Janet Collett told an *Austin American Statesman* reporter in the 1950s.

Janet Collett, in her prime, was that perfect coordination between art and intellect, between beauty and intelligence—perhaps the most beautiful woman Austin has ever produced. Even as a child, her many portrait photos revealed her self-confident, almost regal bearing. Folks knew this girl was fated to do great things.

In conversation, she showed a keen intelligence and honesty about her art. Dancing was the center of her life, but her breadth of knowledge about music, painting and great literature was rarely encountered. She talked of pictures and the dances she composed from them. She knew music from all ages. She knew the ancient dances. She knew the intricacies of dance philosophies and the historical backgrounds of the modern styles. She strived for simplicity because she thought dancing should be understood in and of itself. She assimilated and blended all the great and varied theories about dancing. Collett did it all. She had danced with Arthur Murray (who taught her to lead as well as the best male dancer) and Anna Pavlova and could go toe to toe with Isadora Duncan.

By the summer of 1926, Janet Collett was the toast of Broadway, lead dancer in *The Vagabond King*, an operetta telling a highly romanticized tale about the fifteenth-century poet François Villon.

The production opened at the Casino Theatre on September 21, 1925, and ran for 511 performances. It was twice made as a movie (1930 and 1956)

The thrilling duel in the Fir Cone Tavern between Francois Villon and Thibaut d'Aussigny in the musical play "The Vagabond King" Casino Theatre, New York.

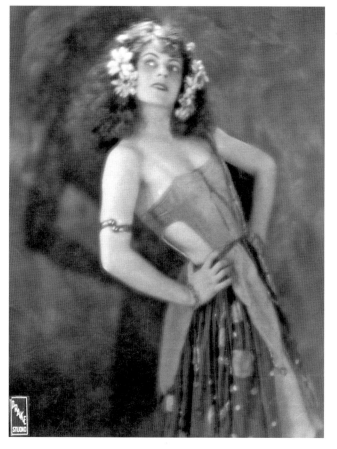

Above: *Advertising card for* The Vagabond King, *1926. Author's collection.*

Left: "Janet Collet, Gypsy Dance Before the King, *The Vagabond King.*" *AR U.2(47), Austin History Center, Austin Public Library.*

and has been in production somewhere in the world almost constantly since its premiere. The production was lavish, with an unusually large pit orchestra. Collett was not part of the original cast, being subsequently recruited by the producers to beef up the show. She had played in the popular musical revue *Cherry Pie* with such success that when she joined *The Vagabond King* cast, a new number was added to the show just for her.

When the curtain fell on her first night, her place on Broadway was established. Collett was not unknown, but in *The Vagabond King* she took her advanced theories of high art to Broadway audiences and carried a large part of the show, earning praise such as: "One of the highlights of the success of the performance comes from Janet Collett, the dancer...Janet Collett makes a truly wonderful impression with her several classic interpretations...Janet Collett has a charming Southern accent which she does not use on the stage because her feet talk for her."

A dozen years earlier, she had been a freshman at the University of Texas, fresh from playing shows in her Austin backyard. Born Jeanette Collett in 1899, she was an only child from an artistically inclined family of means. Collett was inspired to dance when she saw Anna Pavlova and the Ballet Russe in Austin. She began to spend summers in New York and Chicago studying ballet.

At UT, Collett pledged Pi Beta Phi sorority and belonged to several clubs, playing some "silly young thing" roles in the Curtain Club. She graduated Phi Beta Kappa in an era when beautiful women were expected to play dumb. The *Cactus* staff wrote of her upon graduation in 1919: "Imagine a Phi Beta Kappa with bobbed hair. Jeannette is one. One of the Pi Phi students who makes the frat average while her more frivolous sisters play the social game."

Collett planned to attend graduate school at Columbia University, but her mother wanted her to see the world first. So Collett went to New York City for a year to study dancing. She returned to UT to dance under the eye of Susie Fisher, who taught dancing in the Department of Physical Training for Women. Fisher urged her parents to let Collett dance as a career. They consented.

Collett went to California to study under Perry Mansfield and, two months later, was dancing in the prologues of the Grauman movie palaces. Sid Grauman did not dictate styles to his performers, and the dancers who performed between feature films could present arrangements of high artistic merit. She danced in three D.W. Griffith productions and a short feature but found movie work extremely dull. The Denishawns (Ruth St. Denis and Ted Shawn) were teaching in Los Angeles, and in the summer

of 1923, Janet joined their classes, which had already produced dancers like Martha Graham.

From California, she went to New York to work with the great Russian choreographer and dancer Mikhail Fokine. Exciting and inspiring, he stimulated his pupils by developing new creations in class. Collett also went to Martha Graham and other teachers, absorbing their ideas and learning their various approaches. Meanwhile, she worked in concerts and for one season with Pavlova, whom she found delightful in her funny concern for all the girls in the company.

After joining the Pavlova Company, she was chosen to dance in *Cleopatra* at the Met. Moments before the curtain rose, she was wrapped up in a towel wringing her hands. The scanty top to her Egyptian costume was nowhere to be found. They held the curtain while the director took the top from another girl's costume. Collett was ready to soar. Afterward, she said that she was a little afraid to be in the same room with that girl.

She spent two months as a specialty dancer with the Keith vaudeville circuit in and around New York. After studying in New York with the Russian dancers, she went with John Murray Anderson's productions in moving picture houses in Boston, which later developed into the Publix shows.

Collet ("Collette" to her friends) next joined the cast of *Hassan*, a serious, poetical play of great beauty with a noble cast of stars but ill fitted for Broadway. *Hassan* soon folded its tent.

Collett returned to Austin to spend the summer of 1925 with her parents. She presented a series of dances at the Hancock Opera House on July 15: "Romance" by Rubenstein, "Victorian Serenade" by Tchaikovsky, "Hurdy Gurdy" by Goosens, "Gavotte" (of Louis XVI period) by Lully and "Fantastic Oriental Dance" by Ippolito Ivanov.

Her first performance before a home audience included Governor Miriam Ferguson, UT president W.M.W. Splawn and board of regents chairman H.J. Lutcher Starck. She danced beautifully, fairly floating so light was her step. She had created every number and designed her costumes. Despite the oppressive heat, the big audience sat spellbound while Collett soared from pinnacle to pinnacle of success, being showered with flowers and storms of applause.

A woman said of her husband as they left the theater, "Nothing in the world except Jeannette could have pulled him out tonight."

Upon her return to New York, she had charge of the dancing in *Cherry Pie*, where the boys from *The Vagabond King* would find her.

She would leave that show after a year in New York and Chicago to spend a year in Paris and Vienna, resting and studying.

She refused an offer to be a leading danseuse in a Broadway play in the fall of 1927 and returned home, where she fell and broke a small bone in one of her ankles. On November 24, the *Statesman* reported that she had been kept at home for the past few days but was recovering rapidly, and she expected to be out and about in the near future. Her accident did not interfere with her dance.

While at home, she performed at San Antonio's Fiesta in April 1929, dancing for the Queen of Fiesta's elaborate coronation in Municipal Auditorium. Her number, "The Sun Dance," concluded the program and was in honor of Louis XIV, France's "Sun King."

By Christmas 1929, Collett was back in New York City doing some special dance work and socializing with the many other Austin and Texas folk there. She began teaching dancing and, in August 1930, signed a contract with the Walter Hampden Theater on Broadway that winter. She was the principal dancer and got to do some creative work in a series of children's plays featuring fairy stories, including a speaking part in the plays.

By September 1931, Collett had come home to open a school of dance, focusing on ballet. Her New York and European days were over.

In April 1932, Collett directed the annual University Round-Up Revue. The first part carried out a southwestern motif, with cacti, a cowboy chorus and an old-time dance. The second part was the presentation of the Sweetheart of the University and the Sweethearts of the other six Southwestern Conference schools. She directed the Round-Up Revue and other events for years thereafter and took her dance students on tours across the state.

Her tastes in dance were catholic; one day a week at her school was dedicated to popular dances like tango, rhumba, samba and even the lindy hop. She also taught modeling classes for aspiring UT co-eds.

In 1948, Collett married Austin architect Wolf Jessen, some sixteen years her junior.

At sixty, she was still lean, lithe and unconsciously graceful, her light brown hair worn in a loose casual bob, not unlike her college days.

Jessen died in 1977 at the age of sixty-two. He designed many of Austin's most prominent buildings, such as Municipal Auditorium and UT's Jester Dormitory, but music was his real love. He was the Austin Symphony Orchestra's first-chair flautist since its founding in the 1930s until his death.

Janet Collett Jessen died on October 27, 1982, in Austin at the age of eighty-three.

12
FLOWER CHILD

As American boys entered the European fields of battle in the fall of 1917, fourteen-year-old Gertrude Prokosch entered the University of Texas. The youngest co-ed in the country, she was admitted to the university after passing examinations in English, Latin, ancient history, German, algebra and geometry and making perfect grades in four of the subjects.

Born in Chicago in 1903, she and her family moved to Austin in 1913, when her father, Professor Edward Prokosch, joined the university faculty. He was famous for riding his bicycle everywhere.

Prokosch was already an accomplished pianist and an unusually gifted dancer, interpreting the music with unerring instinct and an almost countless number of graceful movements. She was blessed with splendid physical development.

But she was still a child, natural and unspoiled, enjoying romps and walks outdoors and giving doll theater performances to her friends, leading the dolls, speaking their parts and often writing the plays herself.

Most folks think that flower children didn't make the scene until the 1960s; they didn't know about Gertrude Prokosch.

Before entering UT, she had danced publicly in February and March 1917 in a program of folklore tableaux and dances given by the Mutterdank Society. Prokosch performed in two ensembles, "Classical Dance" and "Fairy Dance," as Princess Ilse with the Dwarfs and a solo in "Hindoo Dance." She studied artistic dancing at UT and performed original solos at campus recitals through at least February 1919.

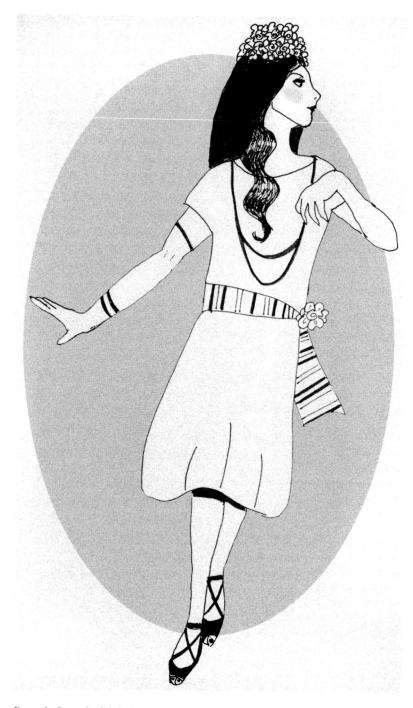

Drawn by Samantha Zelade from an original newspaper photo.

In May 1918, the federal Department of Justice placed her father under investigation for possible disloyalty to America. He resigned from the university in July 1919 over those questions of loyalty.

The Prokosch family left Austin shortly thereafter. Gertrude graduated from Bryn Mawr College with a BA in 1922 and an MA in art history in 1928, concurrently studying music and dance in Berlin, Philadelphia, New York and Providence, Rhode Island, from 1922 to 1928. She then studied music and dance at the Yale University School of Drama from 1929 to 1930.

Prokosch danced, taught, performed, produced and choreographed modern dance as "Tula" from 1922 to 1946 before turning to the study of American Indian dance. She did extensive fieldwork and published hundreds of articles in publications like the *Journal of American Folklore*; she also contributed to dance theory and notation.

In 1930, she married Hans Kurath, dialectologist and lexicographer, who had studied under her father.

Prokosch was a leader in organizations such as the Society for Ethnomusicology and Congress on Research in Dance and active in Ann Arbor, Michigan, where she wrote for the *Ann Arbor News* and founded the Dance Research Center in 1962. She died in 1992.

13

LA CAMINANTE

Though polar opposites, Ike Sewell (Chapter 15) and Eudora Garrett were the most memorable UT Jazz Age alumni. *Daily Texan* reporter Vivian Richard profiled Garrett in February 1925. Garrett was such an oddity that newspapers all over the country ran the story:

Because she believes with Walt Whitman in absolute freedom of thought for the individual, and with Peter Pan in the realization of dreams, Eudora Garrett has lived alone two years in a tent near Lake Austin. There, with only her brown dog, Son, and her books for company, she studies for the five courses she takes in the University. There, too, she "thinks out for herself" philosophies of life and dreams, the dreams that each of us would like to dream were we not afraid.

No evasion veils the clearness of her purposes. She likes nature. She likes both the yellow disc of the moon rising over the cedar hills and the steady drip and swish of rain pattering down on the tent top. Days when others are hovering over the fire, Miss Garrett sits snug and comfy by her oil stove and plays "Indian Lament" on her portable graphophone while the wind shakes her khaki house.

But love of solitude and quiet does not deprive this hermit maid of interest in her fellow-beings. I found her clad in the corduroy trousers and shirt she wears to each of her classes, looking sad over the words of a gypsy girl who had just said, "I am not happy!" The gypsy woman is only one of a troop of Serbian wanderers now camped at the lake who adore Miss "Eedora."

"Eudora Garrett, far right." *From the* Cactus, *1924, Texas Student Publications. Author's collection.*

"I like the University," Miss Garrett said. "Before I came here I knew my courses were not just what I wanted, but I couldn't find the trouble. I discovered it when I found at Texas University the subjects I had been wanting all along without hardly realizing it."

A player of the piano, of the violin, of the mandolin and the ukulele, an artist of ability—one can hardly believe these things of the slim girl in brown boots and corduroy trousers, who cleans the sparkplugs or resets the carburetor of her own car. Once, before she bought the car, she wanted to spend a few days at her ranch home near Santa Anna, so she donned the big black Stetson she wears off campus, and walked from Austin to Santa Anna.

That walk was something she wanted to do. So is living in a tent, wearing knickers, reading poetry by Robert Brooke what she wants to do. Miss Garrett believes firmly in the unselfishness of not troubling others and in doing the thing that lies nearest the heart.

"All my life," she said, "I've wanted a camp like this. Now I have it and I like it. Here I can write—and think—and learn."

Once hailing journalism as her field of endeavor, she has relinquished that aim, at least from a mercenary standpoint, to delve into poetry, religion and psychology. She still writes prose and poetry though she has never submitted any of her work for publication.

"They'd want me to change it," she said. "And I wish to be free. I wouldn't want to change. When I have thought things out for myself a few more years, then perhaps I'll try at submitting my work."

During last summer she worked on the Austin American *and was for a short time assistant issue editor on* The Daily Texan. *At present she is preparing a manuscript on the Hindu religion and philosophy in connection with her University courses.*

Even the most prosaic acknowledge that no more fitting place could be found to write or dream than in this hermit maid's canvas home. From the rustic table, piled with books, to the magic rug on the floor, the whole room breathes of originality. The rose-and-blue magic rug, which causes, Miss Garrett says, all who step over it to forget their troubles, carries a story with its acquisition, as does also the bronze image of the "Thinker" and the tiny log cabin of incense. The case of books contains many a volume few people would take the trouble to read, or could understand if they did; the collection of records includes haunting Indian refrains and violin masterpieces.

Just how she acquired her tent home is a story in itself. At the exposition two years ago, Miss Garrett saw a painting of a woman. There was a haunting something in the eyes of this woman and she wore tilted on her head a big black Stetson hat. It was the portrait of a vagabond, yet of an aristocrat, and it intrigued Miss Garrett until she sought the painter of the picture and the owner of the Stetson hat, Mrs. D.B. Dickard of Austin, another lover of the out-of-doors who could appreciate the ranch-reared girl's wishes.

Together, they planned the camp. Mrs. Dickard's house overlooks Lake Austin, so it was near there the tent was set up. Now she has given Miss Garrett the picture of the woman in the Stetson hat and Miss Garrett herself wears a Stetson almost identical to the artists'.

But well as she loves to wear trousers, as much as she abhors frocks and furbelows, Eudora Garrett indulges in a few feminine vanities. In a cretonne-curtained cabinet well hidden from the casual observer, she showed me, with quite the air of a conspirator, cold creams and powders and lotions.

She went on to blaze her own path in the collection and preservation of folklore. Her writing on Indian folklore "made good reading," according to the *Austin Statesman* in 1928; she became a feature reporter for that paper not long after her lifestyle story went national.

Garrett eventually made her way to New York City, where she worked as a music and theater columnist for a local daily. In 1932, she and Alix Young Maruchess, a violinist with an international reputation, revived the wandering minstrel of the Middle Ages, taking concerts to people used to little more than the pastorals of cows and chickens and the radio.

A few years earlier, Maruchess had renounced the violin in favor of the viola and an almost forgotten eighteenth-century instrument, the viola d'amore.

Garrett accompanied Maruchess on the piano, when one was available. Otherwise, Garrett played an old Salvation Army street organ. Garrett also served as business manager, publicist and what not. If they ran short of

funds and recitals were too far apart, they drove their caravan (which they assembled from junked cars and second-hand furnishings) into a farmyard and offered an evening of music for a couple of meals. In towns, they played in whatever halls were vacant, charging little admission. Many nights they slept by the roadside; their motor van was equipped with bunks and an oil stove for cooking and heating.

It was Garrett's idea; she explained, "I was just restless. Wanted to see new things. Wanted to do something new." That spirit of adventure guided Garrett for the rest of her life.

At the Texas Folklore Society annual meeting in 1933, Garrett, then living in Dallas, presented "Folk-Lore of the Tarascan Indians" with guitar accompaniment.

By the summer of 1937, she was in Fort Worth at the corner of Burleson and West Seventh, producing a nightly tent-show melodrama, *The Tale of the Moth and the Flame*, or *Little Nell*.

"Ta-ra-ra-boom-de-ay" girls from the Gay Nineties danced and made merry; a tavern quartet sang old-time melodies such as "They Locked Me in the Upper Room and Threw Away the Key" and "She's More to Be Pitied Than Censored."

She had recently completed a collection of musical arrangements for the guitar to suit the folk songs gathered under a government-funded project.

On March 17, guitar instructors gathered in Albuquerque for the annual WPA Federal Music Project Conference, where they met with Garrett to review the book.

Garrett worked as a reporter and civilian defense editor for the *San Antonio Light* in 1943 and part of 1944 before moving to Mexico City.

By 1948, she was an ace reporter for the International News Service, in the male-dominated world of reporting in Mexico.

Garrett was back living in Santa Fe by 1950, working for the Association on American Indian Affairs. She had a fifteen-minute radio show on KTRC, where she played Mexican selections from the repertoire she had accumulated in Mexico.

By February 1951, "La Caminante," or "The Traveller," as Garrett called herself, was back in Mexico, living in Cuernavaca and covering the social season for the English-language daily *Mexico City News*. Everyone in the world seemed to be passing through Mexico, and everyone in Cuernavaca was giving parties for them.

By 1954, still living in Cuernavaca, Garrett was an alcoholic, slowly dying of cancer. There she met young Audre Lorde, who went on to become

146

a prominent poet and lesbian activist; they began a friendship and brief physical relationship. Garrett "totally engaged" Lorde in the erotic, psychic and physical aspects of lesbian love for the first time and showed Lorde "the way to Mexico" for which she had come looking. Garrett was the first woman Lorde knew who had had a mastectomy, and she did not wear a prosthesis to conceal the fact that she had only one breast. Garrett never talked about dying, preferring to talk of her work.

Garrett died of a heart attack on July 5, 1955, in Mexico City.

Lorde contracted breast cancer years later and said Eudora came to her in her sleep the night before her surgery, with her gap-toothed, lopsided smile, and in Lorde's dream they held hands for a while.

In 1961, the Eudora Garrett Award for Folksong was established to honor her contributions to the field of music in Santa Fe.

14
GOLDEN CROSS

Ruth Cross was a Christmas Day present (1887) to Dr. Walter and Willie Cross in Sylvan, in rural Lamar County. Her mother, a music teacher who spoke Greek and Latin, encouraged Ruth in her studies. From infancy, she was obsessed with saving every penny possible to get an education and secure literary recognition. In Lamar County's rural schools, she learned what it was to work like girls from poorer cotton field families.

After graduation from Paris High School, she enrolled in the University of Texas in 1904, paying her way by teaching in small Texas and Oklahoma towns. She taught for a while and then went back to school until her funds were all spent, at which point she started teaching again. When an eye malady impaired Ruth's vision, her mother moved to Austin to help her with her studies. After her mother died, Ruth's friends helped her.

While teaching and studying, she depended on friends and often on comparative strangers to correct her school examination papers and read her studies aloud to her. She saw enough to make her way about alone. But her lovable character in those trying school days won her many friends who took notes, read for her and did everything but recital for her.

She graduated Phi Beta Kappa with a BA in creative writing in 1911 and moved to Longview, where she taught, emphasizing oral work in her classes in order to spare her eyes.

Teaching was just a way to subsidize her passion: writing fiction. She got a portable typewriter, learned to touch type and soon had a stack of rejection

slips that only incited her to greater effort. She stuck to her writing despite discouragements that would have driven most people to despair.

After studying for a summer at the University of Chicago, she was a housekeeper; travel companion; interior decorator; builder and seller of houses in New York, Nevada and California; and always a writer.

Her first fifteen years of literary efforts, beginning at age thirteen, brought her sixty-five dollars. Dallas-based *Holland's Magazine* was one of the first magazines to publish her largely autobiographical cotton fields stories, such as "The Last Kit an' Bilin,'" beginning about 1918.

The *People's Home Journal* ran her novelette, *A Question of Honor*; Louis B. Mayer made it into a movie in 1922. It came to the Queen Theater that May, along with news that Cross was writing her first novel, about Austin and University of Texas life before World War I. Two years later, Harper published *The Golden Cocoon*.

In mid-March 1924, *The Golden Cocoon* was in bookstores across the country, including the University Co-op. It told the sensational story of Molly Shannon, a poor North Texas cotton field girl who survived heartbreak, first with a philandering University of Texas professor and then as the governor's controversial wife, before leaving her glamorous life in Austin to struggle as a writer in New York City. A rumor that much of the book was autobiographical caused an almost immediate scandal.

The Golden Cocoon went into its third printing within one week of publication, earned favorable reviews and went through five editions in 1924. In June, Cross won the $500 D.A. Frank Best Novel Prize for best novel by a UT student or ex-student between 1919 and 1924.

The *Austin American* wrote on May 4, "Miss Cross, of course, is claimed by all of Texas, and has done for Austin what no other person has done, in the gift of *The Golden Cocoon*, a story of Austin and university life which has taken the public by storm this year."

Warner Brothers paid $25,000 for the movie rights. By October 1924, Cross had finished thirty chapters of her second novel, *The Unknown Goddess*, much of which took place in and about Dallas and Paris, Texas.

Cross returned to Austin just before Thanksgiving 1924 to a welcome just short of adulation, despite *The Golden Cocoon's* dismissals of UT and its faculty as "a backwash of incompetents whom life had rejected." Almost one hundred women attended a luncheon honoring her at the Driskill Hotel. She spoke to a packed house in the YMCA gym. Having one's first book published and becoming a success overnight was like having scarlet fever, she said. One breaks out, thinks she will never survive and then peels off and is human again.

Publicity photo, circa 1925. Author's collection.

Texas literally gushed with material for fiction of all kinds, she said—the oil fields, the cotton patches, the coast country, the hills, the border country, the great plains, the old towns with their historical background and ancient buildings.

Flushed with the additional success of a one-act play on the Keith vaudeville circuit, in 1924 Cross married financier George Palmer, with whom she shared a passion for horticulture. They bought and renovated Edendale, a forty-acre farm in Connecticut.

The movie *Golden Cocoon* premiered in 1925.

Hubert Mewhinney, the *Austin Statesman*'s movie critic, didn't think much of the movie or the book:

> *In an unguarded moment, I once let myself be enticed into the first two chapters of* The Golden Cocoon. *After this unfortunate accident, I returned lamenting that Ruth had not remained in the cotton field, singing the sweet songs of labor, rather than venturing down the flinty road of literature. The film version, however, could be distinctly worse. In fact, it enjoys one distinction never before granted to a movie, in that it is superior to the novel that inspired it.*

The Unknown Goddess was published in 1926, and because she incorporated recognizable citizens and events of Paris, the Paris city library banned it and removed all traces of her work.

Cross, whose latest novel, *Enchanted*, had just come out, visited Austin for Round-Up Week in April 1930 as speaker and guest of honor at the annual Theta Sigma Phi Matrix Table, where southern women writers were honored. She visited the Texas Book Store, where she signed copies of *Enchanted*. The bookstore and Theta Sigma Phi sponsored a manuscript contest for young women writers in connection with Cross's visit.

After *The Big Road* (1931), *Soldier of Good Fortune* (1936) and *Back Door to Happiness* (1937), she wrote two nonfiction works, *Eden on a Country Hill* (1938) and *Wake Up and Garden* (1942), along with magazine stories and articles. She contributed to Heinz's *Magazine of the Air* on WABC radio and broadcast an original program called *Your Garden and Home*.

The Golden Cocoon made Cross a star, but her subsequent books did not achieve the same widespread critical and financial success. Critics lauded her realism and local color but complained that when her characters left rural Texas for the big city, the plots tended to deteriorate into melodrama.

Cross sold Edendale just before her husband died in 1947. She lived in New York City for a few years before moving to her mother's hometown of Winnfield, Louisiana, to be near her sister's and brother's families. In 1975, she donated her papers to Northwestern State University at Natchitoches, which published her final book, *The Beautiful and the Doomed*, in 1976. She continued to write; at the age of eighty-eight, she was starting a novel about her psychic experiences. She died in Winnfield on September 30, 1981.

15
"Oh, Pod!"

The University of Texas has some memorable alumni: Tex Ritter, Eli Wallach, Janis Joplin, Farrah Fawcett, Matthew McConaughey, Charles Whitman…but nobody quite like Ike Sewell.

Freshman I.M. "Ike" Sewell was the most "striking" man on campus in the fall of 1923, a strapping Jewish boy born on a ranch near Wills Point, Texas, where his family had settled in 1860. Sewell had the largest pair of hands on campus, and he wasn't shy about using them, either smacking his opponents silly on the gridiron or good-naturedly back-slapping his friends. Like Will Rogers, Ike Sewell apparently never met a man he didn't like.

Sewell attended Castle Heights Military Academy in Tennessee. After he finished high school, he briefly went into the café business before deciding that college life beat stale pies, dirty forks and breaking dishes.

He immediately "got over" at the University of Texas, to use the expression of the time.

He played freshman football, was elected class president and pledged Sigma Chi, where his strengths quickly became legend, as the 1925 *Cactus Thorn* noted: "Brother Ike Sewell put his hand on the back of Brother Whiteside's chair and broke it."

Sewell got acquainted with everyone, and his greeting, "Old Pard" (his pronunciation came out sounding like "Old Pod"), got to be the campus greeting.

As *Western Weekly* magazine put it in 1929, "He smiles and hears your name once and doesn't forget it. If he should forget it, he'll remember the face and you'll be 'Old Pard.'"

Sewell went on to be a three-year Longhorn varsity starting guard, a 1927 All-Southwest Conference selection and an All-American mention; in 1928, he was varsity line captain. He was considered one of the SWC's smartest players. Coach Clyde Littlefield pronounced him a fast, deadly tackler who ran beautiful interference. But despite his place in UT football history, he is most famous for inventing Chicago-style deep-dish pizza.

As a freshman in 1923, Sewell played well but was slow in getting started and following dodging runners. So he ran track for a season. The work paid off for him when he returned to the gridiron.

The 1925 Longhorn football season opened on September 26. It was Sewell's first varsity game; he was a starting guard. The Horns plowed through Southwestern University. Although only five-ten and 170 pounds, Sewell's big shoulders and huge hands made him a formidable bulwark in the Horns' line.

Sewell was the center of attention without even trying. He showed up for practice on October 14 with "a sort of sleeping porch affair decked over his face," as the *Daily Texan* described it. He had a high nose, and since the beginning of training, its arch had been continually lacerated without sufficient time for healing.

Disaster struck on November 3, when Sewell and several other starters were declared scholastically ineligible. It was too bad because Sewell had "been playing a wildcat game lately."

But just three days later, Sewell was back on the team after passing follow-up exams. He was already one of the team's strongest bids for all-conference honors.

The season ended with the traditional Thanksgiving Day game with Texas A&M, which won 28–0. The Longhorns finished second to A&M in the Southwest Conference race. Sewell made the all-conference second team.

Sewell's first varsity season was brilliant but erratic. Perhaps it had something to do with airplanes.

He was managing fraternity brother Jerry Marshall's flying school, headquartered in their frat house. Marshall was working his way through college taking students and Austinites for pleasure rides. He didn't need to work, but flying was his life.

The school's field comprised a 140-acre tract of land two miles north of Austin on the Georgetown road.

Marshall staged an all-day airplane attraction on Sunday, December 13, featuring $2.50 rides with stunts in the afternoon. Several hundred spectators watched breathlessly as UT grad and southern fancy diving champion

"Chili" Grange climbed from the front cockpit to the landing gear in midair with the plane going eighty miles per hour at eight hundred feet.

Three students began flying lessons the next day. A week later, Grange was wing walking, and there were two planes for passenger rides.

After spending Christmas at Wills Point, Sewell blew into town on January 4, 1926, and began learning how to fly.

The *Cactus* yearbook sales campaign began on January 31, 1926, with a Jerry Marshall aerial spectacle. At 9:00 p.m., he ascended to a height of three thousand feet. He dropped a series of dragon bombs to attract students' attention, followed by series of red, silver and green phosphorus flares automatically dropped by means of electric fuses.

The word "Cactus" was spelled out in electric lights on the underside of the plane's wings; more than one hundred bulbs were necessary, and two small dynamos on the tips of the wings furnished the power, rotating miniature propellers and generating the electricity for the display.

On Monday morning, at the 11:00 a.m. class break, Marshall emerged from the horizon with a smoke bomb, leaving an opaque cloud behind him, and flew at a low altitude across campus, dropping two thousand cards advertising the 1926 *Cactus*. Five of the cards were marked to entitle the holder to a free copy of the *Cactus*.

In addition to his flight school management duties, Sewell was also hawking candy bars: "Ike's other sweetie threw him a curve, so he took off with Mary Jane, a candy sandwich," read a *Daily Texan* ad.

At four o'clock in the afternoon of April 18, Marshall did a dead motor landing from an altitude of three thousand feet. He cut his motor when he began his dive, did a complete flip and again went into a dive, straightening out only as he neared the ground to land.

By the end of May, students could soar through the air by the light of the moon. Marshall had gotten permission to make night flights as late as 10:00 p.m. "Since the moon has been very full lately, flying by night is possible," Marshall said. "You would be surprised to know that a person high in the air on a moonlight night can see the ground and landmarks almost as plain as during daylight."

Sewell and Marshall formed a flying circus at the end of the school year. "We plan to do advertising work for many Texas towns, and also aerial photography work while we are traveling over the country," Sewell told the *Daily Texan*.

The "University of Texas Flying Circus" took to the air on June 18 for a three-week tour of Texas, followed by the Midwest and several eastern states.

"Ike Sewell [left] and Jerry Marshall." *From the* Cactus, *1926, Texas Student Publications. Author's collection.*

They barnstormed county fairs, doing stunts, parachute jumping and carrying passengers. Marshall knew all the air circus tricks and at least once substituted for his parachute jumper. He was barnstorming in Childress when a parachute became unleashed from the front cockpit passenger and blew backward, entangling Marshall's head and arms. He kept his composure, and flying blindly with his feet operating the controls, he finally extricated himself from the parachute.

In two and a half years, the circus carried thirty-one thousand people without an accident. In college towns, the Sigma Chi houses were circus headquarters, and the fliers gave their brothers free rides and rushing parties in the sky. Each plane's side sported the Sigma Chi coat of arms. Sewell always said that he and Marshall had pledged at least a dozen men while in the air.

By the summer of 1927, Sewell had decided to come back to UT. The air circus had performed in sixteen states. He became eligible for the 1927 football season and began an intensive training regimen. In the middle of a typically brutal Texas summer, he spent thirty-eight days helping lay an oil pipeline west of Junction or, as he put it, "seventy miles from a railroad and forty miles from the nearest town."

For over a month, Sewell "wore the same 'suit' to work every day, never saw an unmarried woman, never ate a dish of ice cream, never read a newspaper." He cut gravel and dug foundation holes in solid chalk for up to ten hours a day.

These "ideal" training conditions got Sewell into perfect shape. The men ate fresh vegetables, fruit and meat daily. They slept in open tents, and the day's work generally sent them to bed early.

But not too early. After dinner, they usually held part of an elimination series of wrestling matches for the camp championship. None of them knew the science of wrestling, but there were many first-rate rib crackings. Sewell threw the camp cook and truck driver and was fixing to throw the dishwasher, but as he applied a half nelson, he slipped on the dishwasher's greasy arms, fell over his head and lost the match.

The company had between twenty-five and thirty football players, and they practiced regularly after work, with nightly kicking and passing practice when the moon was out.

As alternate night watchman, Sewell had no encounters with bandits but said he sounded the alarm one night when he found one hundred jackrabbits in the supply tent eating all the onions.

The foreman scorned Sewell as a "college cowboy" and piled extra work on him until Sewell performed a seemingly Herculean exhibit of strength, saving the foreman from possible death or serious injury.

One day, prior to lowering a section of pipe into the ditch, Sewell and his boss were underneath it clearing away rocks when the jack slipped out of position. Sewell arched his back under the load while the boss crawled out, hailing him as a hero. He never found out about the wire anchored to a tree holding up the pipe.

After completing his term of work, Sewell visited the "boss shack," a ranch house for a thirty-two-thousand-acre ranch. The "shack" was equipped with hardwood floors, a radio set, an electric light plant and an electric refrigerator. Sewell enjoyed a four-course meal, which was interrupted when the ranch foreman came in to resign because another ranchman had built a house nine miles off and the country was just getting too crowded, Sewell swore he said.

Sewell declared it was better training than any work he had ever done, harder than delivering ice, working as a stevedore or anything anywhere else.

Sewell was such a good storyteller that some called him another Grantland Rice, America's leading sportswriter.

As 1927 football practice began, the budding Grantland Rice began a sports column, "From the Guard's Post," carried in the *Daily Texan* and the *Austin American-Statesman*.

The fact that Sewell had managed a successful commercial aviation company in 1926 before returning in 1927 to play football at UT was reported all over the country.

As the 1927 football season kicked off, Sewell's summer training program was just what Coach Littlefield had ordered. Sewell played the game of his

"I got hurt in the game yesterday."

"I didn't know you played."

"No, but I sprained my larynx yelling."

From College Humor *(Collegiate World Publishing Company, 1928). Author's collection.*

life—to date—in UT's third game, a muddy 20–6 win over the Trinity Tigers on October 8.

Some players were telling tales of things that happened during the game at Pete's hamburger stand a night or two later. Sewell was in the spotlight in one of them. His opponent in the Trinity line was having a little trouble with Sewell, who was handling him a tad roughly, such that the Tiger guard accused the genial Sewell of toting a hijacker in his back pocket. The referees' investigation showed Sewell's weapon to be his pair of hard palms.

On October 15, Texas upset Vanderbilt, 13–6. This annual clash was the 1920s equivalent of the Texas/Oklahoma game, always played on the neutral ground of Dallas. After the sweet, sweet victory over the Commodores, one sportswriter exclaimed, "And oh, Pod! Did this Sewell play a game. Well slightly. He was literally tearing that Commodore line to shreds with those big manly paws of his. Time after time we heard this question asked by Vandy supporters: 'Who in the ----- is that No. 3? He is in every play.'"

Texas pounded Rice 27–6 on October 22, but it was a costly win. Sewell, considered

the best guard in the conference, went to St. Edward's Hospital. He played the game with an enormous boil on his leg, and kernels had set up. Doctors first feared that it was blood poisoning, tantamount to a death sentence in those days.

Practically the whole Longhorn backfield was on the injury list. Most were expected to play the October 29 game with Southern Methodist University but were not in any sort of condition, not having practiced all week. Sewell was still in the hospital, and despite a gallant effort the Longhorns lost 14–0.

The team resumed practice sans Sewell, whose leg was so stiff that he could hardly walk. But he hoped to play in the game with Baylor on November 5.

Sewell was one of the few athletes who got more print in Texas papers when he couldn't play in a game because of injuries than when he was healthy.

Even when Sewell was sidelined, everyone knew he was at the game; his never-ending peppy chatter helped keep his mates fighting, although Longhorn opponents characterized it otherwise: "Gab, Gab, Gab, Blah, Blah, Blah" all game long, and "Gabby Steers" adversaries often told him to shut up because they couldn't hear their signals over his din.

Against impossible odds, Sewell returned to the team and got in the Baylor game, which the Horns won, 13–12.

He came out of the game with a broken thumb. After the final practice before the next game, with the Kansas Aggies, Coach Littlefield asked Sewell if he would be able to go for two quarters, to which Sewell replied, "Oh, Pod, four quarters would only be a light workout for me."

The Horns slaughtered Kansas 41–7 on November 12. Sewell scooped up an Aggie fumble and ran thirty-five yards to score a touchdown.

Sewell was so beloved on campus that he was the good-natured butt of several jokes in the *Texas Ranger* humor magazine, such as this one from November 1927, which was reprinted in newspapers all over the country:

> *A DUBIOUS COMPLIMENT*
> *Ike Sewell landed himself a new job the other day as a guard out at the asylum. Ike was strolling through the grounds yesterday afternoon when one of the patients came up to him and asked: "We all like you better than our last guard, sir."*
>
> *"Thank you, my good man," replied Ike pleasantly, "and why?"*
>
> *"Well," replied the inmate, "you seem to be more like one of us."*

UT lost the annual Thanksgiving Day battle with Texas A&M, 28–7, but Sewell and the rest of the Texas line outplayed the Aggie line.

Old Ike Sewell has finally flopped his hands a few times and flown from the campus again.

This time he's off for an extensive tour of Europe, his first objective being Germany, we understand.

We gather from recent newspaper reports that Germany is beginning to have a pretty stiff time handling their war indemnity, and we know darn well that it's going to be a real tough break for them by the time Ike makes his trip through their country "O Poddin" them out of the other gold they have managed to hide away in their socks. Anyway, Ike will be back next September to play his last year with the Longhorns and we're sure he'll have many a tale to tell.

Texas Ranger, 1928.

At the end of November, Sewell, as right guard, was overwhelmingly chosen to the All-Southwest Conference team despite the injuries that had kept him out of several games.

Sewell was scheduled to play with the Southern Collegiates in Beaumont on New Year's Day 1928 but decided to visit Germany to "inspect what the Germans have in the way of defying gravity," as the *Port Arthur News* put it on February 1.

He financed an extensive bicycle tour of Europe, including the Amsterdam Olympics, by writing a weekly travelogue for American newspapers. He went across the Atlantic third class. When he landed in Europe, he had only one dime, but his ability to make friends resulted in three weeks' room and board with a German friend until he received his first check from the American newspapers.

Sewell spent most of the summer in Paris. Although he got as low as a "Dutch dime" several times, he still had a hell of a good time, by his own admission. When he got to Paris, a black American who owned a prominent café got Sewell a job driving a "rubber-neck" sightseeing bus for American tourists.

He hung around cafés where Americans were likely to appear at the beginning of tourist season and met them with near misty eyes, and they in turn grasped Sewell as if he were Santa Claus.

But before the season was over, he hated to see an American coming, having come to understand the French people's scornful attitude toward "those crazy Americans," whose idea of a good time in France was to "get gloriously tight." Sometimes they fought. It was against the law in France to hit a man with your fist, but the gendarmes went to considerable lengths to see that the Americans beat one another without interference.

Many of the tourists were the sons of rich men, and they tipped extravagantly. When Sewell went out with a young American girl, he was sometimes embarrassed when the waiter eyed his tip and sniffed—in that peculiarly French way.

At the Olympics, Sewell befriended athletes from many countries. When it was time to return to Texas, he was broke and stowed away on the American Olympic team's ship. Sewell said he wore a United States sweater, went to meals with the Olympians and even met the ship's captain. On the voyage's last night, eleven boys in the brig formed a "Stowaway Club" and elected Sewell president.

Sewell was back barely in time for the first practice of UT's 1928 season. The Texas line was built around Sewell.

When he appeared at practice, local sportswriter Dick Vaughan commented, "Ike Sewell looked like a fat girl to us. His skin was white, bleached by a summer in Europe, where the sun is colder than it is on the Texas pipelines, where he worked last summer."

Sewell may have looked fat to Vaughan, but in fact, he had reported underweight and was being fed heavily and detailed from hard work.

Team trainer Doc Wesian gave the boys fresh-squeezed orange juice after practice on the premise that it was good for the skin. It was also the first year that the team wore the official UT burnt orange. School patriotism was at such a high pitch that if you specified it at the time of purchase, you could get your new car painted orange.

"Oh, Pod!" Sewell's daily sports column, resumed late in September.

Jerry Marshall was flying airmail—too busy to read the newspapers, evidently, because in a letter to Sewell, he asked for six tickets for the A&M game on the fifty-yard line and not too high up. "It would be wonderful if I could help my old buddy out," Sewell wrote in "Oh, Pod!" "but it is doubtful if Pres. Benedict could get six tickets on the 50-yard line for the A&M game."

Sewell played in the opening game with St. Edwards but injured his knee and could not play in the next game, against the Texas Tech Matadors.

In the annual clash with Vanderbilt, Sewell's head was cracked so hard that it still ached a week later, on the eve of the Arkansas game.

"How many years will pass before the University of Texas football squad takes to the air as a means of being transported to the site of their football encounters?" asked Sewell presciently on October 19 in "Oh, Pod!"

Some say never, but I predict that it won't be so many years before a university team will have a lunch in Austin and fly over to Dallas to meet the Oklahoma Sooners after lunch.

FIFTY YEARS HENCE

"The referee blows the whistle for the game to start."

From the Cactus, *1927, Texas Student Publications. Author's collection.*

162

> *Planes are being constructed at the Junker works in Germany that will carry 62 people. This giant plane will have four 600 horsepower motors and cabins with sleeping accommodations will be built on the wings. By using a plane of this type the University of Texas athletic council could book games in most any part of the country without taking too much time from the students' books.*

Days later, Sewell reported that a prominent midwestern basketball team would be flying to some of its games.

Then as now, fans debated the merits of the football players of yesterday and today. "Was football more of a he man's game 20 years ago than it is now?" Sewell wondered that October.

> *Has the modern open game with its passes and wide open plays made the original game into a modern pink tea affair with candy leg athletes? I believe that football as it is played today in mammoth stadiums with the players decked out in silk outfits and served water out of a tea cart in bottles, is still an affair where the weak-hearted falter and the stout-hearted survive.*

Opinions aside, the long football practices of yore were gone forever. The Southwest Conference set a two-hour practice limit. A few years earlier, teams were lucky to get away from practice before dark.

"Oh Pod!" ran for the last time on December 5.

Sewell's last football season proved anticlimactic, the *Statesman* observed on December 6:

> *Ike Sewell played his last year for the Longhorns and he played a good game. He was line captain and his fighting spirit helped the team over the rough places. Ike has been willing the entire year to be replaced by men better than he was. Sewell did not play the same type of game that made him an all-conference guard a year ago and he did not play as long in each game. He was content to be on the sidelines and watch the Longhorns go without him as long as he thought the better man was playing.*

Sewell's farewell to football was on a team of Southwest Conference stars that played a team of non-conference stars in Fort Worth on December 29.

Before leaving UT, Sewell wrote an article for *College Humor* magazine, "The Love of the Game."

The editors of *College Humor* said of Sewell:

> *As a freshman Ike Sewell was president of his class and won his letter in football. Today he has three varsity letters, was all-Southwest guard in 1927, and this year served as one of the two football captains at the University of Texas. He can stunt an airplane. He has traveled Europe on a bicycle named "Old Glory." He writes a column on sports which is printed in six Texas newspapers. And at the University of Texas, there is a saying: "If Ike Sewell doesn't know him, he doesn't go to the University."*

Sewell seriously considered becoming a sportswriter, but by January 1929, he was director of public relations for Texas Air Transport (which would become American Airlines), at the recommendation of Texas Air Transport pilot Jerry Marshall. At the Fort Worth airport, Sewell greeted all incoming passengers. The first holder of the first job of its type in the country, he again made national headlines.

As *Western Weekly* magazine put it:

> *Ike is ambition, adventure and energy personified. Sewell isn't an aviator. He is a director of public relations. In other words, he's a "glad-hander." After ten minutes around Ike you feel as if he'd give you the proverbial shirt and although you're likely mistaken, it's a good feeling to have, anyway.*

School had taught Sewell more than football, the magazine noted. Among other things, it gave him healthy doubts about the marriage business. In small towns, Sewell explained, it was the accepted thing to get hitched, even though you were a trusted ribbon clerk pulling down $85.00 a month with a promise of a $2.50 raise in ten years. In college, you got the idea that money must play a part in the happiness of marriages. Marriage, as an institution, was due for a halt, Sewell declared. It was shot to pieces with divorces and unhappiness.

Not that he didn't like the girls. Hatcheck girls and his Sigma Chi brothers' sisters smiled gladness and pleasure when Sewell was around.

From Fort Worth, he went to El Paso to manage the American Airways office and played on the local polo team. In August 1931, Sewell left El Paso for the American Airways office in Dallas.

In February 1932, at the height of the Depression, railroads and airlines competed to see which could provide the most amenities to their passengers. The "Katy" line installed air-conditioned dining cars where passengers

could cool off between meals. Afternoon tea was served at no charge, and attendants served free mineral water in the club cars.

American Airways offered free coffee and waffles, magazines and newspapers and maps showing its planes' routes. But the courtesy service to which the line pointed with the most pride was the time Sewell carried six passengers across the Brazos River on his back when an airplane was forced down on the prairie by a low ceiling.

After Prohibition ended, Sewell took a job with the Fleischmann Distilling Corporation in Chicago and rose through the ranks to regional vice-president.

Despite his football glory days, Sewell is best remembered for the deep-dish pizza pie, which, according to most stories, he co-invented with Chicago restaurateur Ric Riccardo and unveiled in 1943 at their new restaurant, Pizzeria Uno. Riccardo had returned from Italy with a taste for pizza. Sewell and Riccardo were supposedly going to open a Mexican restaurant in Chicago until Riccardo tasted Mexican food for the first time. Riccardo convinced Sewell to try pizza instead, despite Sewell's initial fears that Chicagoans would find traditional Italian pizza too lightweight. The deep-dish pizza, they felt, could serve as a full meal instead of a snack.

Because he "couldn't find a decent bowl of chili this side of Texas," Sewell opened Su Casa, Chicago's first upscale Mexican restaurant, in 1963. Sewell retired from Fleischmann in 1965 to tend to his restaurants. He died in September 1990 a wealthy man and loyal to Wills Point to the end. He was buried there, where he had kept a home for years. His widow, Florence, died of leukemia in 2000, leaving nearly $25 million to eight Chicago charities.

Jerry Marshall died in a passenger plane crash on January 14, 1936. At about seven o'clock that evening, Marshall took off from Memphis, carrying fourteen passengers and two crew members, headed for Little Rock, about an hour away. The Southern never arrived. Searchers found its remains five hours later in a swamp near Goodwin, Arkansas. There were no survivors. The cause of the crash remains undetermined. It was the worst disaster in the history of United States commercial aviation at the time.

16

LET SIXTEEN COWBOYS COME SING ME A SONG

Austin's Jazz Age didn't give the world a Louie Armstrong, but it did give us Tex Ritter, who together with his mentor, John Lomax, saved western music from extinction in the 1920s. Try to imagine country-western music without the western. Perish the thought. In the 1920s, country music was referred to as hillbilly music, and western music comprised cowboy songs. In the 1930s, they would begin to fuse into the music America loves most of all today.

John Lomax was born in Mississippi in 1867. By 1869, the family was living on a farm in Bosque County, on a branch of the Chisholm Trail.

In his 1947 autobiography, *Adventures of a Ballad Hunter*, Lomax described a night in 1872 when he awoke to the sound of rain on the roof. Through the rain, he heard a cowboy singing to soothe his restless cattle down by the creek. Time and again, young Lomax heard his melancholy yodel: "O, lay down dogies, like you've laid down before, Whoo—oo—ee—oo, whoo—ee—whoo—whoo—whoo—oo."

After nearly ten years of sporadic college attendance and teaching, Lomax entered the University of Texas in 1895, carrying a collection of cowboy songs he had written down in childhood. He showed them to an English professor, who dismissed them as "cheap and unworthy." Lomax burned the bundle behind the men's dormitory.

After graduation in 1897, he worked as the university's registrar, manager of Brackenridge Hall (the men's dormitory) and the university president's personal secretary. In 1904, he took a job teaching English at Texas A&M University and settled there with his new wife, Bess.

"John Lomax, upper right corner." *From the* Cactus, *1903, Texas Student Publications. Author's collection.*

In 1906, Lomax received a scholarship to Harvard University, where he studied under Barrett Wendell and George Lyman Kittredge, two renowned scholars who encouraged his interest in cowboy songs.

He brought his songs to one of Wendell's American literature classes and sang "The Ballad of Sam Bass." Wendell was amazed. It made everything else in the course seem boring and sterile.

Wendell and Kittredge supported Lomax long after he returned to Texas with a master of arts degree to resume teaching at A&M and collecting cowboy songs.

Lomax traveled up and down the old cow trails through Texas, Wyoming and Montana looking for songs. In the back room of Fort Worth's White Elephant Saloon, he found cowhands who knew many stanzas of "The Old Chisholm

Trail." A gypsy woman living near Fort Worth sang "Git Along, Little Dogies." At Abilene, an old buffalo hunter taught him the "Buffalo Skinners." In San Antonio in 1908, under a mesquite tree behind a saloon, a black saloonkeeper who had been a trail cook sang several songs, including "Home on the Range."

But cattlemen at a convention in San Antonio jeered and hooted at Lomax. "I have been singin' them songs ever since I was a kid. Everybody knows them. Only a damn fool would spend his time tryin' to set 'em down," one conventioneer said.

Lomax carried a fifty-pound Edison recorder, but most of the ballad contributors preferred that he learn their songs by ear.

While song prospecting in Cheyenne, he met ex-president Theodore Roosevelt, who heartily endorsed his work as "a real service to America."

His collection, *Cowboy Songs and Other Frontier Ballads*, was published in 1910, and that June, Lomax returned to UT as secretary of the faculty. He dedicated the book to Roosevelt.

A verse on the book's front page expressed the importance of singing in the cowboy's life:

> *What keeps the herd from running,*
> *Stampeding far and wide?*
> *The Cowboy's long, low whistle,*
> *And singing by their side.*

For the next seven years, Lomax continued his research and made lecture tours.

Then, in 1917, came "Ferguson's War on the University of Texas," which threatened to shut the school down and in which Lomax and his cowboy songs played a pivotal role.

Since his inauguration in 1915 as governor, Jim Ferguson had been down on the University of Texas, alleging waste and corruption and accusing faculty and staff of contempt for "common people" and "common schools." When asked in 1916 why he wanted six UT professors dismissed, he replied that he didn't need to give reasons.

As 1917 dawned, university supporters counterattacked. The Texas Senate investigated Ferguson's personal financial dealings. UT's Ex-Students' Association sent Lomax on a round of Ferguson-bashing visits to Texas newspapers.

On May 27, Ferguson announced that unless the regents fired President Robert Vinson, Registrar Lomax and three other faculty members, he

would veto the entire university appropriation. A mass of student protesters marched on the capitol the next day. Ferguson called them "a lawless mob of rich men's sons who desire to establish an educational aristocracy."

Ferguson made good on his veto. There were mass protest meetings in Austin and Dallas, while Ferguson attacked the "university crowd" in west Texas. Lomax later wrote:

> *Governor Jim Ferguson quoted stanzas of my cowboy songs in political addresses to cheering crowds, and sneered at the University of Texas for having me on its faculty, just as he sneered at a teacher of zoology, asserting repeatedly that this professor was trying to make wool grow on the backs of armadillos and thus bring down the price of sheep! Both of us were sorry fools to him.*

Dismissed in July, Lomax took a banking job in Chicago. Shortly afterward, Ferguson was impeached, and the board of regents rescinded its faculty dismissals, but Lomax did not return to his former job; he divided the next fifteen years between banking and working with UT alumni groups.

On October 10, 1917, the *Daily Texan* mourned the loss of the "truest friend a college newspaper ever had" but predicted, "Time will come when Mr. Lomax will return to the University of Texas. A man who has immortalized traditions in Texas deserves no such treatment as was accorded the author of *Cowboy Songs* by what was once the Board of Regents of our institution."

Lomax returned to campus as secretary of the Ex-Students' Association in the spring of 1919.

His second book, *Songs of the Cattle Trail and Cow Camp*, was published in December 1919. Yale's Lyon Phelps wrote the book's foreword: "Mr. Lomax has performed a real service to American literature and to America. He helps every one of us to understand our own country."

"John Lomax revolutionized our sense of American folk music," according to Jason Mellard of the Center for Texas Music History at Texas State University.

> *His predecessors fixated on finding medieval Anglo Saxon ballads still surviving in the Southern mountains, to prove America's continuity with British culture. They cared more about collecting lyrical variants to prove the retention of traditional verses, than the musicians or even the music itself.* Cowboy Songs and Other Frontier Ballads *declared our cultural independence, that American folk made new and vital songs relevant to*

American circumstances. Lomax didn't care about the traditionalists'
arcane and obscure debates, he was blazing his own academic trail and
trying to make a buck in the process.

Unlike Lomax's professors twenty years earlier, a growing number of UT
faculty and students were acquiring a taste for cowboy songs.

As publication of *Songs of the Cattle Trail and Cow Camp* approached, Lomax
was giving his "Cowboy Ballad" talk across the country to great acclaim.
UT's B Hall residents were the first to hear the talk in Texas on November 9.

The ballads, Lomax told them, portrayed the romance of the cowboy's
life, his attitude toward life, death and his religion.

The cowboy was typically profane and familiar in his religion. He spoke of
God in the language of the range, as "the boss stockman," and of the devil
as a "cattleman who was well stocked, but who would always make room for
one more sinner." People back then didn't usually think of cowboys as being
religious, but cowboys often sang of God in terms of great familiarity, and
then a moment later they might be heard singing with great irreverence.

The audience sang several stanzas of "The Old Chisholm Trail," the
great cowboy epic, which has thousands of verses that express every
possible experience a cowboy could have. One cowboy had recited 143
verses to Lomax.

Most of the songs, he explained, were originally sung unaccompanied
and ad lib. Like one cowboy said:

> *We old cowboys didn't have no voice, sounded like rusty iron rubbing*
> *together. We'd stand getting around the campfire and raise our heads one*
> *after another just like coyotes and howl. One man and the next man would*
> *howl his turn and that's the way we did it.*

The growing appreciation for cowboy music on campus had spread to the
Men's Glee Club by the early 1920s.

The club's May 8, 1921 concert featured spirituals and cowboy ballads
like "The Bold Vaquero." Richard Hittson sang the solo of "The Bold
Vaquero," and having been bred in the saddle out on the lone prairie, he
put all the vim and vitality, as well as the cowmen's deep hidden feeling, into
his rendition and earned an encore. (Hittson and his wife would go on to
become choir directors of Austin's Hyde Park Christian Church.)

Lomax wowed 'em at Yale over the 1921 Christmas vacation, as a Yale
student wrote to UT chemistry professor James Bailey: "Lomax was here the

first of the month and gave his lecture on cowboy ballads. These people go wild over that stuff. He is probably as popular a lecturer in the East as I have heard mentioned since I have been here."

Lomax spoke to a standing room–only crowd of UT students on January 11, 1923; many were turned away. Lomax had not lectured on campus for several years, so most of the students had never heard him speak before.

Miles Hanley, in charge of the lecture, introduced Lomax as "the first Texan he had heard anything about" and observed that people outside Texas had heard so much more about him than about any other native Texan that they usually considered him either the president of the university or the governor of the state.

Lomax commenced with a short talk on how and why cowboy songs came to be written. The ballads could be about almost anything, including sentimental songs about home and home folks, wanderlust, the Mexican wars, ranch life, outlaws and the cowboy's own recklessness. Many of them showed a great response to nature and appreciation for the prairie's bleak and austere beauty, which grew on them in their solitude. Songs like "Lie Still My Little Dogies" showed the cowboy's love for his herd.

He then sang some of the songs he had learned. Before singing, Lomax said that he had heard cowboys sing much worse than he did, but judging from the audience's appreciative silence, this was the best-liked part of the program.

"The Gol Darned Wheel" related the experience of a herder who lost his reputation because he rode on a "gol darned wheel" an easterner had brought to his ranch. "High Chin Bob" was a cowboy who attempted to rope and drag a mountain lion, with a humorous lack of success.

Lomax then read several poems about death. The cowboy was familiar with death and took a kind of lugubrious pleasure in singing melancholy ballads about it.

Lomax last commented on the passing of the cowboy, who was fast fading from the picture. His work was over with the settlement of the country and the passing of the pioneer: "I like to think of him as riding over the hill and fading fast from sight, singing."

A few months later, Woodard Ritter rode over the hill into Lomax's life.

Woodard Maurice Ritter was born in January 1905. His parents were ranchers in Murvaul, Texas. He studied voice, trumpet and guitar and graduated with honors from Beaumont's South Park High School in 1922.

Ritter entered the University of Texas in 1922, intent on becoming a lawyer. But music kept getting in the way. Ritter never graduated.

Ritter debated and gave speeches in high school; he took public speaking courses at UT and was active in the Hogg Debating Club. He often locked himself in his rooming house's bathroom to practice speeches. Everyone knew when Ritter came home because he loudly practiced his scales as he climbed the stairs to his second-floor room. He hit the first note of the scale on the first step and climbed the scale as he went up the steps. He descended the stairs in the same manner.

During his first two years at UT, he washed dishes at the Scottish Rite women's dormitory and worked at the library. Then he tried selling life insurance. After peddling policies "to every relative I had," he started after his friends. "When I noticed my classmates beginning to duck behind the corners of the administration building every time they saw me, I lost heart and gave it up," he said.

In September 1923, Ritter successfully auditioned for the Men's Glee Club and began singing second bass. From then on, John Lomax, J. Frank Dobie and Oscar J. Fox all encouraged his study of authentic cowboy songs.

Fox, who became an internationally famous composer of cowboy ballads in the 1920s, published the first of more than fifty songs in 1923. He never wrote lyrics but set existing poems to music, beginning with songs Lomax collected, like "The Cowboy's Lament," "The Old Chisholm Trail" and "Whoopee Ti Yi Yo, Git Along, Little Dogies."

The Men's Glee Club annual spring concert tour for 1924 featured twenty classical and popular pieces, including four Lomax cowboy songs Fox had arranged: "Home on the Range," "The Old Chisholm Trail," "The Cowboy's Lament" and "Rounded Up in Glory." The tour started in San Antonio, where a large crowd greeted them, including delegates to the Cattlemen's Convention.

Life on tour with the glee club was no beer and skittles, as Ritter and William Fetzer found out during the 1925 spring tour when they missed the last train out of Cameron. Carrying two heavy suitcases between them, they started walking toward that night's concert in Giddings, sixty miles distant.

Some girls picked them up, and when they dropped the boys off, Fetzer bought them a box of candy. Ritter was broke. Every time they got to a small town, they would ask if anybody was heading toward Giddings. They got five or six rides and reached Giddings just in time for the concert.

Joe Cannon and Wray Ryan were also left behind but hopped a passing freight train and paid five dollars (all they had between them) to ride in the caboose.

The glee club's frequent trips interfered with Ritter's studies, and his grades suffered. During his junior year, 1924–25, the glee club made more

than twenty out-of-town appearances, including three extended tours. Ritter took only nine courses that year, making four D's and an F.

The glee club's spring concert tour charmed audiences in twenty-three cities and towns. The club elected Ritter as president in May 1925 and chose Fox as its director. Ritter and a few other club members "staged a coup," as he put it years later, to replace their director with Fox, "one of three notable men who encouraged me to sing and…helped direct my career." Fox taught voice, guitar, trumpet and sight-reading, and his work with Lomax fascinated Ritter.

But Lomax left UT the first week in May to become vice-president of the Republic National Company in Dallas.

The 1925 UT summer session included a series of campus singsongs, and on June 26, Fox performed some of his cowboy songs to the largest crowd in the history of the event. Some of the country's most famous singers were singing Fox's songs in their concert programs. The Victor Phonograph Company had recorded "The Old Chisholm Trail" and "Rounded Up in Glory."

Fox was born in Burnet County in 1879. He grew up on a ranch there before moving to San Antonio for his schooling, where he became interested in music. He went to Zurich, Switzerland, in 1896 to study piano and violin, choral direction and composition. He returned to San Antonio in 1899 and later spent another three years studying under private teachers in New York City.

Encouraged by the popularity that folk songs, spirituals and Native American chants were enjoying, Fox began arranging and composing cowboy songs, mostly from *Cowboy Songs and Other Frontier Ballads*.

Besides being secretary of the Texas Composer's Guild and a member of both the American Society of Authors, Composers and Publishers and the American Guild of Organists, Fox belonged to the Texas Folklore Society, serving as vice-president in 1923 and 1924. At the time of his appointment as glee club director, he had been the director of the St. Mark's Choir in San Antonio for eight years and continued to hold that position.

With many of the school's premier songsters returning that year, and a wealth of new voices, prospects for a banner year were bright. Fox taught Ritter and the rest of the club how to sing cowboy songs, with help from Lomax and Dobie.

Ritter had collected cowboy songs while growing up. He learned oral history at its purest from Lomax, listening to the words and inflections of cow country songs from venerable ranch people.

"Dobie played a large part in making me what I am today," Ritter said many years later. Greatly impressed by the charismatic Dobie, Ritter emulated his habit of pipe smoking, developing a lifelong affection for pipes.

Ritter's scholarly interest in cowboy songs and lore was life long, especially songs from *Cowboy Songs and Other Frontier Ballads*. He would sing Lomax songs for years to come in movies and on records.

Lomax and Fox helped Ritter develop a lecture and musical program called "The American Cowboy and His Songs" and found venues for him to perform on campus and around Austin.

Ritter made his radio premiere on KUT on January 11, 1926, as part of a glee club quartet.

The glee club gave its final program of the 1925–26 season before a large audience. "It has ever been the policy of the Glee Club to maintain a high standard of music for concert programs," president Ritter told the *Daily Texan*. "However, this year's program will appeal to the populace as well as the trained musician because the numbers have been selected with appeal to both groups." The cowboy songs and spirituals were the evening's hits.

Wray Ryan, tenor, sang "Rounded Up in Glory," a rollicking song that had found its way to all corners of the country, been recorded on the Victor label and used in the Texas Interscholastic League's music memory contest that spring.

Wherever it was performed, the song grasped and held the hearts of the listeners until the last line of the chorus:

> *You will be rounded up in Glory by and by,*
> *You will be rounded up in Glory by and by,*
> *When the milling time is o'er*
> *And you will stampede no more.*
> *When He rounds you up within the Master's fold.*

This had been the glee club's greatest year ever. The spring tour had been a smashing success.

The 1926–27 long term was another banner year. About five hundred men tried out for fifty-two positions. The club's trips were a big inducement, and the glee club was about the only opportunity on campus for singing, since the jazz dance music of the time seldom featured vocals.

The UT Men's Glee Club's 1927 tour started on February 14. It played various dates in the Hill Country, including Llano, Lampasas and San Saba. The program included a campfire scene in which boys dressed as cowboys sang ballads that Lomax had collected and Fox had arranged.

On a second tour, the club visited Yoakum, Victoria and Luling.

To paraphrase an old Texas phrase, Fox was "swimming in grease" in terms of national celebrity. *Musical Observer* magazine called Fox "a

typical Will Rogers of music" in its February issue, which carried an interview with him:

> *America is at last becoming aware of its own folk song possibilities. It would be difficult to imagine a class of folk more inherently our own than the American cowboy. The chief exponent of this musical genre is Oscar J. Fox, familiarly known as the Cowboy Composer.*

Fox was also preparing a volume of some twenty-five cowboy songs for publication.

Early in May, the Men's Glee Club traveled to San Antonio; its audience was estimated at more than five hundred. It repeated its San Antonio program, a mix of Anglo folk songs, spirituals and cowboy songs, at the Men's Gym on Friday evening, May 19.

Fox and Lomax cowboy songs were the feature numbers. A dozen singers, dressed as cowboys, were grouped around a campfire when the curtain was raised. Wray Ryan sang the solo part of "Home on the Range" and "Rounded Up in Glory," while Ritter handled the solos of "The Old Chisholm Trail" and "Old Paint." Ritter brought the house down with applause when he sang "Old Paint," a rollicking tune with an easy refrain. When it was time to end a dance and the gay punchers were trying to keep the festivity underway, they sang "Old Paint," which has as many verses as individual singers have imagination.

The glee club held its annual farewell banquet on May 24. Fox commended the club for its efforts and accomplishments, and the club unanimously endorsed Fox's work and reelected him as director for the coming season.

Fox spent part of the summer in Camden, New Jersey, where some of his work was recorded.

Members of the Old Trail Drivers' Association whooped it up when Ritter, accompanied by Fox, sang two groups of cowboy songs, including "Come All Ye Jolly Cowboys," at a dance in the Bandera Hills near San Antonio on June 25.

On July 1, 1927, Ritter made his farewell performance to Austin as soloist for Fox's annual summer school lecture and concert in UT's open-air theater. It was the same lecture that had won national praise at the Music Teachers' National Association in Rochester, New York, the previous winter and at the National Federation of Music Clubs in Chicago in April.

Ritter sang twelve songs, including two mournful numbers, "A Prisoner for Life" and "Cowboy's Lament" (also called "The Streets of Laredo").

"The Old Chisholm Trail" and "Greer County," humorous numbers, drew encores.

Fox's and Ritter's presentation on "Desperado" ballads was a show highlight. "Sam Bass," "Jesse James" and "A Prisoner for Life" were sympathetic to these bandits—who were tragic figures for the cowpunchers who made up verses for the ballads.

Fox told how poor Sam Bass "met his fate at Round Rock July 21," when "they filled poor Sam with balls of lead and emptied out his purse," while Ritter sang the songs illustrating the talk.

A few days later, the *Daily Texan* wrote of cowboy songs, "When one stops to consider that their preservation is almost entirely a result of the efforts of John A. Lomax, who made the original collection, and of Mr. Fox, it becomes evident that the debt to them is a large one."

There was a growing feeling that cowboy folk music would replace Negro spirituals on vocal concert programs in a few more seasons. Francis German, who had spent the past year singing and studying in New York, told of the growing popularity of cowboy music when he returned to Austin for a concert in the spring.

The glee club began the 1927–28 season sans Ritter, but cowboy ballads continued to be a prominent part of the club's programs.

Ritter knocked about Austin until *My Maryland*, one of the year's most anticipated musical extravaganzas with a cast of 150 and a male chorus of 60, appeared at the Hancock Opera House for three performances on March 2 and 3, 1928. Ritter, lacking the price of admission, climbed the fire escape and slipped inside the balcony door, attending all three performances. After visiting backstage, Ritter got a role in the chorus. With nothing better to do, he packed his belongings and went on the road with the show, which worked its way back to New York and closed.

After the show ended, Ritter returned to Texas to direct Houston's Third Presbyterian Church choir for twenty-five dollars a week. Sometime in the summer of 1928, he got the opportunity to do a thirty-minute show on Houston radio station KPRC on Saturday mornings. KPRC's programming centered on live musical performances. Ritter and the other entertainers were not paid, but radio exposure frequently led to paying gigs. Ritter filled his show with cowboy songs, thus becoming radio's first cowboy balladeer.

An oil company offered him a job in Venezuela, but he decided to try again to make it in New York City. His brother-in-law "had always told me that a year or two in the East would be good for a Texas boy because it moved a little faster and gave you a different outlook."

And so, Ritter lugged his clothes, guitar, portfolio of western songs and a suitcase full of books to America's biggest city.

At the end of the 1927–28 school year, Fox declined to serve as musical director and supervisor of university singing activities for a fourth year and moved to Dallas to become music director and organist at the Church of the Incarnation. The *Dallas Morning News*, in noting Fox's arrival, wrote, "Fox is doing for native melodies of the Southwest and West what Tchaikovsky did for the folk airs of Russia."

Gilbert Schramm took over as glee club director, and the group abandoned cowboy songs in favor of classical numbers, novelties, light popular airs and a vaudeville skit.

Ritter arrived in New York with thirty dollars and spent the rest of the summer singing cowboy songs for meals in Greenwich Village "emporiums" and for private parties, which sometimes were birthday celebrations for children of wealthy families. He sold his books to buy food. But one day, in the subway, he met a UT acquaintance who was about to visit home and loaned Ritter his apartment. By summer's end, Ritter had landed a chorus role in *The New Moon*, an Oscar Hammerstein romantic musical comedy set in eighteenth-century New Orleans. It didn't pay much but was a regular job.

The New Moon opened in New York's Imperial Theater in September 1928, and Ritter was part of a large, brightly costumed chorus of courtiers, ladies, servants, sailors and pirates. It enjoyed a run of 509 performances on Broadway.

Ritter's deep voice was a strong addition to the chorus, but his Texas accent precluded any speaking part, and the cast soon branded him "Tex."

The New Moon went on the road, spending more than two months in Chicago late in 1929. While there, Ritter appeared at Northwestern University as "The Singing Lecturer." He liked Northwestern so much that he enrolled in law school, attending classes during the day and performing at night. When the show moved to Milwaukee in January 1930, Ritter commuted to his classes. When the show shifted to Indianapolis late in January and then to St. Louis for two more weeks, Ritter missed final exams. He wrote an explanation to his professor, expressing hopes of reentering in the summer.

But that was before Ritter heard that the Theatre Guild was putting together *Green Grow the Lilacs*, with the types of cowboy and folk songs Ritter had sung at UT. *Green Grow the Lilacs* was reworked into the Broadway hit *Oklahoma!* in 1943. When Ritter auditioned in the fall of 1931, he read his lines like the Texan he was, sang the cowboy tunes in his matchless style, landed the role of Cord Elam and was understudy for Curly McClain, the male lead.

During three musical interludes between scenes, Ritter led the other cowboys in singing standards like "Git Along Little Dogies," "Goodbye Old Paint" and "Bury Me Not on the Lone Prairie." In scene four, Ritter soloed on "The Old Chisholm Trail."

The show opened at the Tremont Theater in Boston in December 1930. It ran in Philadelphia; Washington, D.C.; and Baltimore before opening on Broadway in January 1931 at the Guild Theater. New York patrons learned such cowpoke terms as "dogies," "mavericks" and "shivaree." Reviews were favorable, with special praise for the "old songs born and reared humbly in the West."

Green Grow the Lilacs ran for eight weeks on Broadway and then hit the road, playing Cleveland, Pittsburgh, St. Louis, Milwaukee, Minneapolis and Chicago. Ritter and Everett Cheetham roomed together. Ritter's exuberant singing performances made him one of the show's hits, while Cheetham won attention singing his own composition, "Blood on the Saddle."

While in Chicago, Ritter and Everett auditioned for NBC radio and were offered attractive contracts, with work to begin within a few weeks. They eagerly signed because *Green Grow the Lilacs* was scheduled for only one more week in Detroit.

They took the train back to New York to pick up Cheetham's car and drove back to Chicago, where they learned they would be working in NBC's New York studios. They returned to New York and went on the air. Ritter performed his songs and dialogue capably, but the microphone scared Cheetham "to death," and his discomfort was obvious to listeners. After a couple of weeks, NBC canceled their show, and Cheetham went home to Wyoming.

Ritter was back in Austin in the summer of 1931. As he considered resuming law studies at UT, he spent time with Dobie, Lomax and Fox. With the country mired in the Great Depression, it would be harder than ever to earn money for college.

By the fall of 1931, Ritter was back in New York. He could not find theater work, so he again sang for his supper. He regularly made the rounds of theatrical and radio agencies but landed only a few radio commercials. At Thanksgiving, he had ten cents in his pocket. He went to a restaurant, ordered French fries and poured ketchup all over them, but "this Greek that ran the joint gave me hell for using so much of his ketchup."

With the New Year, Ritter won the role of "Sage Brush Charlie" in *The Roundup*, which included western music during the interludes between the four acts. Ritter sang and played the type of cowboy ballads so popular in *Green Grow the Lilacs.*

Publicity photo, early 1930s. Author's collection.

The Roundup opened at New York's Majestic Theater in March 1932. The *New York Herald-Tribune*'s reviewer wrote that "Tex Ritter is excellent as a bronco buster," while the *New York Evening Post*'s critic said that Ritter "has an exceptionally winning personality." The best seats in the house cost only one dollar, but crowds did not materialize, and *The Roundup* quickly folded.

Ritter could not find another theatrical role. He knew the American Record Corporation was recording Gene Autry and approached Art Satherly, head of ARC's hillbilly division. Satherly had seen Ritter in *Green Grow the Lilacs*,

and he let Ritter record "The Cowboy's Christmas Ball" in October. Ritter accompanied himself on guitar. The song was never released.

Ritter began to appear on the radio, however, and Satherly offered him $100 for a recording session on March 15, 1933. Accompanying himself on guitar, Ritter recorded four sides. "A-Ridin' Old Paint" and "Everyday in the Saddle" were not issued. But "Jack O' Diamonds" and "Goodbye Old Paint" became his first record release.

"Jack O Diamonds," which Ritter renamed "Rye Whiskey," goes, in part:

> *Jack o' diamonds, Jack o' diamonds,*
> *I know you of old,*
> *You've robbed my poor pockets*
> *Of silver and gold.*
> *Rye whiskey, rye whiskey,*
> *Rye whiskey I cry,*
> *If you don't give me rye whiskey*
> *I'll lie down and die.*
> *O Baby, O Baby, I've told you before,*
> *Do make me a pallet, I'll lie on the floor.*

Satherly told Ritter that "Rye Whiskey" could be a bread-and-butter number for him, something Ritter already knew.

Satherly produced another session on April 14, 1933, hiring a fiddler to blend with Ritter's guitar. Ritter rerecorded "A-Ridin' Old Paint" and "Everyday in the Saddle," and these versions were released.

Almost two years would pass before Ritter recorded again, but in the meantime, his career accelerated impressively. In the fall of 1932, he was hired by radio station WOR to headline *The Lone Star Rangers*, New York's first western-oriented program. Ritter sang cowboy ballads and told tales of the Wild West, and his stint on *The Lone Star Rangers* led to other radio assignments, moving pictures and eventual worldwide fame.

John Lomax's wife, Bess, died in 1931. Widower Lomax left the Republic Bank. The following year, John Lomax Jr. encouraged his grieving father to resume his lecture tours. So the Lomaxes took to the road. In June 1932, they arrived at the offices of the Macmillan Publishing Company in New York, where Lomax proposed his idea for an all-inclusive anthology of American ballads and folksongs. It was accepted, and he traveled to Washington to review the holdings in the Archive of American Folk Song at the Library of Congress.

The archive contained a collection of commercial phonograph recordings and wax-cylinder field recordings of folksongs. Lomax made an arrangement with the library whereby it would provide recording equipment in exchange for which he would travel the country recording songs to be added to the archive.

In 1933, Lomax became honorary curator of the Archive of Folk Song, which became the primary agency for preservation of American folksongs and culture.

Lomax and son Alan set out in June 1933 on a tour of Texas prison farms, recording work songs, reels, ballads and blues from prisoners such as James "Iron Head" Baker, looking for a musical culture "untouched" by the modern world, where "they still sing, especially the long-term prisoners who have been confined for years and who have not yet been influenced by jazz and the radio, the distinctive old-time Negro melodies."

In July, they acquired a state-of-the-art, 315-pound acetate disc recorder. Installing it in the trunk of his Ford sedan, Lomax used it to record Huddie Ledbetter, better known as "Lead Belly," at the Louisiana State Penitentiary at Angola. During the next year and a half, they recorded musicians throughout the South.

On July 21, 1934, John Lomax married Ruby Terrill, who would, with the rest of the family, help with Lomax's ongoing folksong research.

Lomax traveled 200,000 miles collecting folk songs and visited all but one of the forty-eight continental states. Upon Lead Belly's release from prison, Lomax took him on a tour in the North and recorded many of his songs.

"Lomax took his American folk-song revolution even further in the 1930s with his promotion of Lead Belly," according to Mellard, "making the case that individual artistry mattered. He insisted that African American creativity was central to the American folk heritage, its vibrant beating heart."

With Alan, Lomax edited *American Ballads and Folk Songs* (1934), *Negro Songs as Sung by Lead Belly* (1936), *Our Singing Country* (1941) and *Folk Song: U.S.A.* (1947). His autobiographical *Adventures of a Ballad Hunter* was named the best Texas book of 1947 by the Texas Institute of Letters. He died in Greenville, Mississippi, on January 26, 1948.

Pretty High Cotton for a Boy from Greenville

Multitalented and good looking, John Boles was born in 1895 in Greenville, Texas, the son of a banker. He showed talent as an actor and singer from childhood. He was a soloist in his church choir while in high school and star pitcher for his high school baseball team. You could hardly drag him away from the baseball field to practice music. In one game, he had nineteen strikeouts in ten innings. He attracted the attention of at least one pro scout, but Boles's father turned the scout away, saying, "You leave that boy alone. He's going to be a doctor."

Boles entered UT in 1913 as a pre-med student and became prominent in university society and student activities, belonging to the glee club, the German Club, the Curtain Club and the Pre-Medic Society. After his first year with the glee club, he became a soloist for the rest of his stay at UT. He pitched in 1915, 1916 and 1917 for the Longhorn baseball team and played football in his senior year.

As his junior year drew to a close, the glee club's spring recital featured Hawaiian music. A visiting theatrical manager came to the concert and talked with the boys afterward. He suggested that they try out for one of the lyceum bureaus with the idea of getting a summer engagement. And so, the UT Men's Glee Club was booked for the vacation season for a Midwest Chautauqua tour with Boles as soloist. It was his first professional engagement. He promptly caught the show business "bug."

The glee club's concert in the spring of his senior year featured a variety of black folk songs, popular hits, vocal classics, choruses, instrumentals and mandolin-guitar quintets. Boles's tenor solo earned him an encore.

As he finished his senior year, he began intensive vocal training. The day before he graduated with honors, he married Mary Dobbs, a co-ed from Marshall.

His classmates wrote of him upon graduation: "Premier yodeler of Texas, and too good looking for rough games."

When the United States entered World War I, Boles volunteered and was sent overseas. He had studied French at UT, so he was assigned to a special regiment made up of French-speaking Americans. Many came from New Orleans and other parts of Louisiana and from states along the border with Quebec.

Once in France, the regiment went on special duty at General Pershing's headquarters in Chaumont.

"It soon became painfully evident that hardly any two of us French-speaking Americans were speaking the same brand of French," Boles said years later. "We had a rough time understanding each other and the French themselves couldn't understand us at all. In this respect, the regiment was pretty much of a fizzle."

So the regiment's members were channeled into different tasks, such as MPs and dock guards.

Boles spent eighteen months in the Department of Criminal Investigation because his French was considered a little better than average. He also sang at entertainments and remained in Europe after the Armistice to study voice.

Back in Texas, Boles enrolled in medical school but dropped out and returned to Greenville to raise cotton. During this time, he sang for church services and funerals. When Oscar Seagle, voice teacher and famous concert artist, came to Texas on a tour in the spring of 1920, Boles got an audition with the great baritone in Dallas. Seagle told Boles he was wasting his time growing cotton and asked him to come to Schroon Lake, New York, to study with him. With no money, Boles became Seagle's business manager and secretary and coached other students in French.

Friends pleaded with Boles to try road shows because he constantly needed money. But he chose to wait, and with his wonderful voice and good looks, he rose through the ranks to snag the lead role in the 1923 Broadway musical *Little Jesse James*, playing opposite Miriam Hopkins. This established him as a Broadway star, and he attracted the attention of Hollywood producers. Austin was one of the stops when *Little Jesse James* went on the road.

Boles struggled for years to overcome his east Texas accent. He thought he had succeeded by the time *Little Jesse James* opened. But girls in the show came back from their dates with Yale and Princeton men to report that their friends all wanted to know, "Who was that young southern man in the lead?"

"And with Miriam Hopkins and her Georgia drawl," Boles told the *San Angelo Standard-Times* in 1961, "it must have sounded like a class reunion on Tobacco Road."

After starring in Broadway hits such as *Mercenary Mary* and *Kitty's Kisses*, he made his first film in 1924 for MGM and starred in two more MGM films before returning to Broadway.

Boles's talent made Geraldine "Gerryflapper" Farrar choose him to play opposite her in the musical comedy *Romany Love Spell* in 1925. Gloria Swanson was in New York, saw Boles and persuaded him to star in *The Love of Sunya*. After that film, his Hollywood career began to take off.

The Hancock Opera House's feature film for the first week of May 1927 was *The Love of Sunya*. The film depicts a young woman granted the ability to see into her future, including her future with different men. It was Swanson's first independent production. Swanson financed *Sunya* with the help of her lover, Joseph P. Kennedy.

The *American-Statesman* wrote, wonderingly, of the movie and its stars:

> *John Boles, former university student, has the clean-up position of the week with Miss Gloria Swanson—naive, isn't it, putting him ahead of the star of women stars? Anyway, he's home town, and should be more important to all of us than any combination of Gloria and Clara Bow.*
>
> *Remarkable, that picture is. Miss Swanson has a five-sided character in it—Gloria, the incarnation of an Egyptian girl; Gloria, a modern American girl sought by a reincarnated yogi; Glo--, the temperamental opera singer who shocks Paris; Gl---, kept by a millionaire; G----, the prematurely aged school teacher. Figure it out yourself, if you can.*

The *Daily Texan* reviewer, on the other hand, thought it a masterpiece. "*The Love of Sunya* was such a success that Boles starred opposite Swanson in her second United Artists production."

On a visit to Swanson's New York penthouse apartment, with its solid gold doorknobs and a huge closet holding three hundred pairs of shoes, Boles thought to himself, "This is pretty high cotton for a boy from Greenville."

In 1928, two John Boles silent movies passed through Austin: *The Water Hole*, a cowboy flick about which little is known other than it was filmed in Death Valley, where the cinematographer suffered heatstroke and almost died when he went out into the 110-degree sun without a hat; and *The Shepherd of the Hills*, a Missouri-based hillbilly melodrama in which he played

Young Matt. The movie was a great success and was remade in 1941 with John Wayne starring as Young Matt.

The Shepherd of the Hills played at the Majestic Theater on February 1.

Boles almost didn't get the role of Young Matt. When he got off the train in Hollywood, some of the movie people looked at his spats and fedora hat and shook their heads at the ex–cotton farmer. "He'll never do," they said. "He's a city slicker."

Next, he was considered for a part in a sophisticated urban drama, and this time, the Hollywood cognoscenti shook their heads again and said, "He'll never do. He's a hillbilly type."

"That's Hollywood," he joked in 1961, as he toured the country plugging a remake of *Back Street*, in which he appeared with Irene Dunne in 1932.

Boles's silent screen career had not exactly been brilliant. Despite his initial splash in *The Love of Sunya*, he was still just a good-looking leading man struggling for stardom.

When the arrival of talking pictures revolutionized the movie business, it was Boles's chance of a lifetime, given his wonderful voice, good looks and screen experience.

Starring in *The Desert Song*, the first "talkie" screen musical romance, Boles became a nationwide sensation. In the movie, he repeated his tenor lead role in the earlier stage presentation of *The Desert Song*. *The Desert Song* opened in Austin on June 30, 1929.

That fall, *Rio Rita*, a Flo Ziegfield production starring Boles and Dallas-girl-turned-Hollywood-siren Bebe Daniels, came to Austin for a week's run at the Hancock Theater. It was one of the year's highlights. As was typical for a Ziegfield show, the movie's hype was over the top:

> *Music, Beauty, Romance, Glamour and Pageantry, United to Create What*
> *All America Has Acclaimed the Eighth Wonder of the World,*
> *Rio Rita*
> *Radio Pictures'*
> *Colossal Glorification in*
> *Voice, Song, Color and Beauty of*
> *Ziegfeld's*
> *Greatest Girl-Music Spectacle*
> *With Bebe Daniels*
> *And hailed as the screen's greatest singing star*
> *John Boles*
> *The Newest Romantic Idol.*

"John Boles and Bebe Daniels." Rio Rita *promotional card. Author's collection.*

The film is based on Ziegfeld's 1927 Broadway musical (with UT-ex Jack Harkrider as art director and UT '26 graduate Bonita Finney as solo dancer). *Rio Rita* was Radio Pictures' biggest and most expensive production for 1929, a huge success, and was chosen as one of the year's ten best films by *Film Daily*. The last portion of the film was photographed in Technicolor.

Bebe Daniels was Rita Ferguson, a Mexican beauty pursued by Texas Ranger Jim Stewart (Boles) and local warlord General Ravenoff (Georges Revenant).

Along the way, Rita and Ranger Jim sang a number of songs. "The Rangers Song," sung by Boles (wearing a big Mexican sombrero) and his company of Texas Rangers, establishes Boles as one of the earliest singing movie "cowboys," if not the first.

Boles was one of the most sought-after singing motion picture actors by 1930. *Stars of the Photoplay* wrote, "Gloria Swanson signed him for the lead in *The Love of Sunya*, but until the talkies gave his voice a chance, John was just another actor. He is 6 feet 1, weighs 180, has brown hair and grey-blue eyes."

That same week, *Song of the West* came to the Queen Theater.

Song of the West, a musical operetta, was based on the 1928 musical play *Rainbow*, written by Oscar Hammerstein II and Laurence Stallings. It was the first all-color, all-talking feature film to be filmed entirely outdoors.

The story takes place in 1849. Boles plays a young army scout who kills an officer in self-defense and skedaddles to California for the gold rush, where he opens a gambling hall in San Francisco and falls in love with the daughter of his former commander. Soldiers eventually find him, forcing Boles's character to make a hard decision. Joe E. Brown, playing Boles's doomed sidekick, provides the film's comedy relief.

The film was finished in June 1929. Following dismal previews, Warner Bros. shortened it by two reels, removing some of the musical content. Despite this, the film grossed $920,000 worldwide, and the featured songs were quite popular. Boles recorded two of them for RCA Victor.

The *Daily Texan* film critic was less than impressed with *Song of the West*:

> *The so-called epic sweep of the Old West during the westward march of pioneers to the gold coast in the days of '49 is the expansive canvas on which Warner Brothers have painted the all-talking, singing, dancing Technicolor picture entitled* Song of the West. *The glamorous panorama of the covered wagon trail to California lends itself admirably to this undertaking, and with a good deal of buffoonery, melody and high romance make this picture moderately interesting and entertaining, nothing more. John Boles, a Texas ex, lends his rich and powerful tenor voice to a number of songs more tuneful than memorable, but Joe E. Brown in a comic role turns in the most noteworthy performance. Vivienne Segal is the heroine, and there is a chorus, a "rousing" chorus is the word, of 100 voices. The story is a complicated one of vicissitudes and dangers which beset the long trail into the West, a saving thread of tender love and romance.*

Boles was one of many Hollywood stars featured in Paul Whiteman's history-making film *King of Jazz* (1930), which also featured Austin's George Chiles. Boles sang two numbers: "Song of the Dawn," a solo performance in which he wore a cowboy outfit on a cowboy/western set backed by a cowboy chorus, and "It Happened in Monterrey."

Boles's best-known role is that of Victor Moritz in the original *Frankenstein* (1931). He took the role of Edward Morgan in *Curly Top* (1935) with Shirley Temple.

Boles also starred in *The Life of Virgie Winters* in 1935 with another UT alumnus, Helen Vinson (1922–24) of Beaumont.

Boles's last western movie came to Austin in 1936. *Rose of the Rancho* (previously filmed in 1914 by Cecil B. DeMille) was based on an operetta about Rosita Castro, who, disguised as a man ("Don Carlos"), leads a

vigilante gang battling usurpers bent on stealing valuable land grants. Government agent Jim Kearney (Boles) foils the gang's attempt to lynch accused bandit leader Joe Kincaid (Charles Bickford). Kearney falls in love with Rosita, unaware that she is Don Carlos. When Kincaid and his hordes storm the Castro rancho, Kearney is battling alongside Rosita.

Shortly after Thanksgiving that year, Boles visited his alma mater. He was returning a visit that Governor James Allred had made to him in Hollywood the previous year. Boles said that he had to go down to the law school building to realize he was on the same campus. The wooden shacks in which he had attended classes had been replaced with fine new buildings. While on campus, he visited with his old Longhorn baseball coach, Billy Disch.

In 1937, Boles starred with Barbara Stanwyck in King Vidor's classic, *Stella Dallas*.

Boles's film career waned during the early 1940s, and he returned to the theater. In 1943, he starred with Mary Martin on Broadway in the musical *One Touch of Venus*; it ran for two years. Over the decades, Boles had saved his Hollywood money, and from the mid-1950s on, he worked as a successful oilman in San Angelo. There, on February 27, 1969, Boles died from a heart attack, leaving behind his wife and two daughters and a host of fans who had not forgotten him.

18

HULLA-BALLEW

Smith Ballew was Tin Pan Alley's hitman; he could hit high notes like no one else. Bing Crosby asked Ballew to fill in for him on a song with a high note Crosby couldn't reach, so a story goes. Blessed with an impressive vocal range, Ballew sang everything from the most complex jazz to the hokiest love songs. Yet he is best remembered as one of Hollywood's early singing cowboys.

A popular but since discredited legend says he even dubbed for John Wayne in two "singing cowboy" westerns (1933's *Riders of Destiny* and 1934's *The Man from Utah*).

Sykes "Smith" Ballew was born in Palestine, Texas, in 1902. He studied arts at Sherman High School and Austin College. Story has it that he learned to play a seventy-five-cent mandolin in order to accompany "Old Ned," a black musician who taught him southern ballads. While attending Austin College in Sherman, he organized his first orchestra, the Texajazzers, with his brother, Charlie.

While in Galveston in the summer of 1921, the Texajazzers met Jimmy Maloney and the Sole Killers. The Texajazzers comprised Tommy Joiner, trumpet; Jack Brown, trombone; Charlie Potts, sax; Charlie Ballew, piano; Smith Ballew, banjo and vocals; and Dee Orr, drums.

The Texajazzers played the Youree Hotel's roof garden in Shreveport later that summer. While there, Smith and Charlie Ballew, along with Jack Brown, decided to transfer to the University of Texas. Here, they joined up with Maloney and several of his Austin friends to form a band they named

Jimmie's Joys: Charlie Willis, trumpet; Jack Brown, trombone; Jimmy Maloney, clarinet, alto sax; Collis Bradt, tenor sax; Charlie Ballew, piano; Smith Ballew, banjo; and Dick Hamel, drums.

Despite the success the Joys were enjoying, Ballew left Jimmie's Joys and UT in April 1924 to marry Justine Vera. He revived the Texajazzers and began playing at the Fort Worth Club; they became popular throughout the Dallas/Fort Worth area.

In 1927, he dissolved the Texajazzers, moved to Kansas City and was working through the Music Corporation of America (MCA), a Chicago-based music-booking agency, when he got a job with drummer Dee Orr. Ballew moved to Chicago and began working with pianist Dick Voynow in the Wolverines Orchestra, a group composed largely of Chicago-area students, including Bix Beiderbecke. Hoagy Carmichael heard Beiderbecke and brought the Wolverines to Indiana University in the spring of 1924. After eight trips there on eight successive weekends, the Bix Beiderbecke legend was born.

Beiderbecke's stint with the Wolverines was brief. The Wolverines couldn't hang on to its men; soon, only Voynow was left.

Ballew founded his own orchestra, which enjoyed some success, including a radio gig with Radio Station WMAQ, but he got crosswise with MCA and left.

He couldn't work without a Chicago union card and was nearly broke when he went to see Ben Pollack's Band, back from its summer 1927 tour, at the Blackhawk Restaurant.

Ballew was barely seated when Glenn Miller, now in Pollack's band, walked up and greeted him like a long-lost friend. To Ballew's great relief, Miller picked up his check. He introduced Ballew to Pollack, who liked his singing. A few days later, Ballew was singing and playing banjo in the Pollack band for $125 a week and living in the hotel with Miller.

Ballew became so popular through the band's broadcasts over WGN radio that Ted Fiorito offered him a big bonus to join his band in New York, but when he landed in the big city, there was no job and no money. So he busked the streets for a while and lived in a succession of cheap rooms.

His New York career began as pit band singer in the Broadway show *Good News*, a collegiate musical that ran from September 1927 through early January 1929. Show songs included "The Best Things in Life are Free" and "The Varsity Drag," a Charleston-style dance number that became an international craze. Through that job, Ballew met Tommy and Jimmy Dorsey, who introduced him to Joe Venuti, Arthur Schutt and other top musicians.

His first significant recording was with the Dorsey Brothers Concert Orchestra: "Was It a Dream?" in July 1928. In April 1929, Ballew sang with Beiderbecke for a recording session that produced "No One Can Take Your Place" and "I Like That."

In 1929, he organized the Smith Ballew Orchestra, which included Glenn Miller and Bunny Berigan. By January 1930, Ballew's orchestra, which included a member of his first group in Sherman, was playing during dinner at Whyte's and later in the evening for the Park Central Hotel's supper dances, broadcasting over the radio from both places. The group cut phonograph records with Chicago's OKeh Records. Ballew's recording career spanned some twenty years, during which time he cut records for more than thirty labels, including OKeh, Victor, Brunswick, Columbia and Decca.

New York cartoonist, fellow alumnus and friend "Stookie" Allen wrote to the *Texas Ranger* in 1929:

> *Smith Ballew (Phi Delt) also a former member of Jimmy's Joys, is now a big shot in the music and entertainers racket in N.Y. and will probably be drawing down plenty of what it takes by this time next year…and that I wish I had what he is dragging down now…and that you can hear him at your favorite record store on OKeh platter No. 41270 and Victor No. 22070…and that he will open this Saturday at the Palace, N.Y…and that this same Palace is the last word in vaudeville houses…and that his wife is none other than that little tee-niney hot shot named Justine Vera that you used to get a kick out of seeing roll across the campus.*

His Piping Rock Orchestra was playing in Saratoga, New York, in August 1931 and began a late-night NBC series broadcast on Monday and Saturday nights.

After a couple of years, Ballew decided to concentrate on his singing career, and the band broke up. Ballew's orchestra never "set the woods on fire," but it produced more future bandleaders than any other outfit. Glenn Miller, Joe Venuti, Eddie Lang, Babe Russin, Bunny Berigan, Jack Teagarden and Ray McKinley were all members at one time or another.

Ballew's recording contract prohibited him from using his name for any other recording sessions. With a wife and baby to support, Ballew used a variety of aliases. By 1936, it was said that he had made more phonograph records—under at least seventeen different names—than any other person, past or present, and that he had written about twenty original songs.

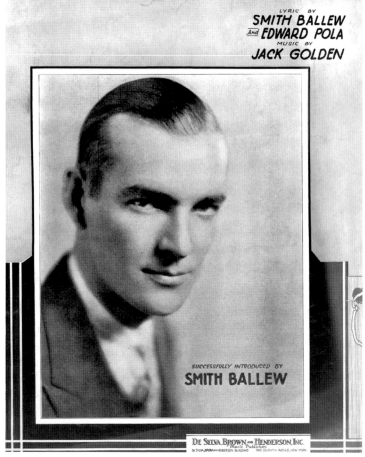

Sheet music cover, 1931. *Author's collection.*

In 1936, the Ballews caught the fast train to Hollywood. Silent film star Marguerite Clark, a dear friend, had been pestering him to get into motion pictures; she even asked Adolf Zukor to give Ballew a trial. Ballew resisted for a couple of years, but he and his wife finally got fed up with New York apartment life and one-night stands.

The Golden State lived up to its name for Ballew; he quickly landed a contract with Paramount Pictures for one movie every six months. Clark Gable's acting coach and first wife, Josephine Dillon, polished Ballew for his first screen role, in *Palm Springs*, a horse movie.

Several months later, the J. Walter Thompson ad agency asked him to be master of ceremonies for NBC radio's *Shell Chateau Hour* when host Al Jolson left. Paramount offered to release him for sixteen weeks; the Thompson agency declined. Ballew got an agent, who negotiated a better contract with RKO, which let him take the radio job.

Ballew debuted as master of ceremonies on the Saturday night program on April 4, 1936. After Ballew's debut, congratulatory telegrams poured in. Dick Kenny of the *New York Daily Mirror* wrote that Smith Ballew sang "'We'll Wait at the End of the Trail' the other night in a way that sent chills up this old sailor's spine."

Ballew was the singing star, as well as emcee, through the end of 1936, but the show's ratings gradually declined after Jolson's departure, and it was cancelled in July 1937.

Ballew made the forgettable *Racing Lady* for RKO. Then he met Sol Lesser of 20th Century Fox in a barbershop one day. Lesser said he enjoyed Ballew's work on the *Shell Hour* and asked if he would like to make cowboy movies. Ballew said, "Very much so," and Lesser snapped up Ballew's contract from RKO.

He appeared in twenty-four films, mostly westerns, including *Western Gold* and *Roll Along Cowboy* (1937), *Hawaiian Buckaroo* (1938), *Under Arizona Skies* (1946) and *The Red Badge of Courage* (1951).

During the height of his movie career, he was made an honorary Texas Ranger, and despite all the riding he did in his screen work, he loved riding horseback in the great open spaces around Hollywood.

Ballew did the roping and horse riding tricks for Randolph Scott, according to W.C. Nunn's biography of Ballew. He grew up riding horses, so it was nothing special, Ballew explained.

By August 1936, the Ballew family was finally living in a house. For the past twelve years, they had lived in hotels and apartments.

Their three-story, hillside house was furnished in the French style. Daughter Justine insisted on a fountain for the neighborhood's mockingbirds so that they could have fresh water and take a bath. Ballew liked the location because it was within walking distance of some tennis courts, where he played every day.

Ballew had boxes and trunks that had been in storage shipped to Hollywood, including more than five thousand phonograph records he had made. He planned to make some more records in Hollywood, in addition to the movies.

He was hankering to do some more radio work come 1938, something akin to the *Shell Chateau Hour*. He dropped his agent, who didn't know radio

booking, in favor of Zeppo Marx, now one of Hollywood's most successful agents. It was not one of Ballew's smartest career moves; Marx turned down a number of lucrative cowboy film offers without consulting Ballew.

By December 1940, Ballew and Stookie Allen were working a mica mine ninety miles north of Santa Fe. "It's great to get back to the good earth, and it had better be good because we're shooting the works on it," Ballew told a reporter. Ballew acquired the mine as partial payment on a movie contract. They shot the works on it, but the venture was a total disaster, and Ballew was broke at the dawn of World War II.

With a family to support, Ballew entered the aviation business. By November 1942, he was working on a Hollywood-area aircraft factory production line before joining Northrup Aviation's Purchasing Department. His friendship with Howard Hughes led to a similar job at Hughes Aircraft. When the company got into missile production, Ballew moved to Tucson. After a while in Arizona, a friend at Consolidated Aircraft in Fort Worth offered him a job, and he moved there in 1952. Consolidated became General Dynamics, and Ballew retired from General Dynamics in January 1967.

He was married twice, first to Justine Vera and then to Mary Ruth Clark in 1960, the year daughter Justine died. Ballew died in Longview, Texas, on May 2, 1984, and was buried in Fort Worth.

BUZZ EDENS AND HIS GIRLS

J udy Garland and Ethel Merman—two of the greatest voices of their age. They were Buzz's girls. Merman launched Rollins "Buzz" Edens's career, and Edens molded Judy Garland into a star. Garland's daughter, Lorna Luft, said that he was the only man who came close to qualifying as a second father to Garland and that he was the only man she trusted after her father's death.

Accompanist, adapter, arranger, composer, producer and songwriter, Edens was a creative giant during the golden age of Hollywood musicals.

Edens was born in Hillsboro, Texas, in 1905, the youngest of eight boys. Unlike his boisterous brothers, Edens was studious and artistic, a gifted pianist. His parents, despite their modest means, scraped together enough money to send him to the University of Texas in the fall of 1923.

His bed was barely made before he was playing piano and guitar in Steve Gardner's Orchestra. Each man could play at least two instruments, and together Gardner's eight-man jazz group could play twenty-one instruments.

Ambitious and precocious, Edens created and presented his original Broadway-style production, *Vanities of 1924*, at the Hancock Opera House on February 25. The cast included sixty Austin girls. The eight-act show featured music taken from the Ziegfeld and Greenwich Village Follies and the Music Box Revue.

The Longhorn band's annual statewide tour a few weeks later featured a variety of musical and vaudeville acts, including Edens and Dorothy DuMars. Edens played piano while DuMars played and danced in "My Cross-Eyed Daddy" and "Cave Man Kid," to the point that the old words

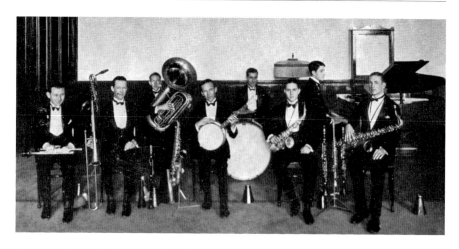

"Steve Gardner's Orchestra. Rollins Edens is seated at piano." *From the* Cactus, *1925,* Texas *Student Publications. Author's collection.*

"good" and "splendid" had to be dug up and used more than once, one reviewer wrote.

Gardner's Orchestra snagged the contract to furnish dance music for the Stephen F. Austin Hotel's Longhorn Roof Garden that summer and went back to playing frat dances and the Saturday night Germans in the fall.

Edens was no mere jazzer. When soprano Marguerite Huddle returned from New York City to visit her mother in October 1924, she sang several classical selections, accompanied by Edens on piano, for the Pan-American Round Table's luncheon meeting at the Driskill Hotel.

Edens was a busy young man in the spring of 1925. Besides playing with Gardner, he directed the vaudeville acts in the annual spring Varsity Circus at Memorial Stadium and formed Buzz Edens and His Girls, a musical comedy group featuring Edens and four comely Austin girls.

During the Longhorn Band's March 1925 tour, Edens led the "Premier Entertainers," a mix of dances, dialogues and clever musical numbers, including Buzz Edens and His Girls and an act called "A-Sittin' Pretty."

The *Daily Texan* reported on April 2, 1925, that "King Jazz" would be introduced to the principal cities of the Orient for the first time by an American orchestra; five young UT musicians had contracted with Admiral Steamship Lines for a three-thousand-mile, fifty-day tour. Claude Cain, late of the Texas Collegians, headed the band, which included Lee Howell of the Moonshiners; Guy Holman; and Edens and Roy Willis of Steve Gardner's Orchestra.

The quintet, equipped with $2,000 worth of musical instruments, left Austin late in May, playing dance dates in the cities they passed through

on their way to Seattle, where they boarded ship on July 1. The orchestra played for the picture shows, at meals and at dances in return for first-class passage and meals on the ship. College orchestras often made trips across the ocean with steamship companies, but this was the first time that a university orchestra would receive wages in addition to passage.

Admiral started employing college orchestras aboard trans-Pacific cruise ships in the summer of 1923. Bands from the universities of Indiana and Michigan, among others, bid for the deal. The student musicians soon discovered that they were not privileged to mingle with the passengers. They were classed as crew members and confined to the crew deck and quarters. In Japanese, Chinese and Philippine ports, they were permitted to earn extra money by playing at hotel dances while the boat was docked. But on the whole, the bands were glad to get home. One voyage was enough.

From Seattle, the ship went to Vancouver and thence across the Pacific to Japan and China, where Cain's Orchestra played Yokohama, Kobe, Shanghai, Hong Kong and Manila. They completed the tour in time to begin the 1925–26 school year.

Back from the tour, Edens, who was also one of the university's best designers, put his creative flair to work decorating the KC Hall for the 1925 Thanksgiving German on the night before the big game with A&M. His decorations featured a lavish use of greenery and flowers in the hall's walls and ceiling and banking the stage, where Fats Obernier's Orchestra played. Elaborate souvenir programs specially designed for the occasion were distributed.

Edens was out of Austin and Steve Gardner's band by the time the 1926–27 UT school year began.

While on the summer oriental tour with Cain's Orchestra, a manager from New York City heard Rollins and helped him land a job with a jazz band there.

Sometime after arriving in New York, Edens changed his first name to Roger, for unclear reasons, but William J. Mann suggested that it is "possible he considered 'Rollins' just too precious, too dandy, for the hard-drinking, woman-chasing world of orchestras and musicians."

But Edens did not forget Austin.

Stookie Allen pointed out in the November 1929 issue of the *Longhorn-Ranger* magazine that

> *Buzz Edens, the guy that staged all those swell shows for the Varsity circus a few years ago, is now leader of an orchestra in a swell Publix theatre*

*out in Long Island, but is in town at this time with a musical comedy
that he has just written that he and I think will put people in the aisles on
Broadway…tsk…such opinions sez you.*

Edens's Broadway break came in 1932. After nearly seven years playing
with the Red Nichols Orchestra and in other Broadway pit orchestras, Rollins
was playing in the orchestra for George Gershwin's newest production, *Girl
Crazy*, when fate stepped in. The show starred Ethel Merman and featured
pianist and voice arranger Al Siegel. When Siegel had a heart attack on
opening day, Edens volunteered to replace him. Edens's performance so
impressed Merman that he arranged Merman's next show, *Take a Chance*,
and accompanied her on stage.

When Merman went to Hollywood to appear in Samuel Goldwyn's
production of *Kid Millions* (1934), Edens went with her.

Edens's wife, the former Martha "Oof" LaPrelle, a famously hard-
partying girl he had dated while at UT, moved to California with him. But
as a buyer for a fashion house, she traveled extensively, and they spent much
of their time apart. Even Edens's closest friends in California rarely saw her.
Coupled with LaPrelle's distaste for Hollywood, it's no surprise that they
soon separated and eventually divorced. But Edens kept a photo of LaPrelle
on his desk for years although he was living with another man.

In Hollywood, Edens caught the attention of Arthur Freed, an MGM
production executive. Edens was accompanying an auditioning female
vocalist who left Freed unimpressed, but he liked Edens's arrangements of
the songs she sang and the way he played them. Freed hired Edens, and he
began his MGM career as musical supervisor with Victor Fleming's *Reckless*
(1935, starring Jean Harlow).

Edens joined a team of talented composers, arrangers, lyricists and
choreographers. Freed wanted the best team possible to make the best
musicals possible, so he hired without regard to sexual orientation. Freed
was not gay, nor were all of his team members, but so many of them were
gay—including Edens; composers Cole Porter, Frederick Loewe, Robert
Wright and Chet Forrest; choreographers Robert Alton and Jack Cole; and
director Charles Walter—that they were known within the movie industry
as "Freed's Fairies."

After his divorce from LaPrelle, the almost constant presence of close
friend and co-worker Kay Thompson deflected rumors of his homosexuality.
At a time when being openly gay was a Hollywood death sentence, Edens
stayed successfully closeted, and his career soared.

Edens arranged songs for non-musical movies like the Marx Brothers' *A Day at the Races* and worked with the studio's musical talent.

Edens met Judy Garland in 1935, when he replaced Garland's father as pianist for her MGM audition. Edens quickly recognized her talent, and they established a creative relationship and friendship that lasted until her death. Garland sang his adaptation of "You Made Me Love You" at Clark Gable's 1937 birthday party. Her performance so impressed the studio brass present that night that Garland sang the song in *The Broadway Melody* of 1938.

As Garland's star rose, so did Edens's. He was musical arranger for many of her early films. He played rehearsal piano for her on *The Wizard of Oz* and encouraged Garland to show Dorothy's vulnerability in her performances. "Without Roger," Lorna Luft said, "we might never have had 'Over the Rainbow,' at least not the way we remember it."

Edens arranged Cole Porter's score of *Broadway Melody of 1940*, adapted the score *For Me and My Gal* (1942, with Garland and Gene Kelly) and adapted the Broadway score for Vincente Minnelli's debut film, *Cabin in the Sky* (1943).

For Me and My Gal, which took place between 1916 and 1919, had no new songs, so Edens had to get permission to use period songs. They had to be chronologically correct and further the plot. He had to rearrange the songs to fit Garland's style and vocal range and keep them within the style of that day, yet not so corny as to sound ridiculous to 1942 audiences.

By the mid-1940s, Edens was associate producer on films like *The Harvey Girls* and worked all MGM's major musicals, including *Meet Me in St. Louis* (1944). Edens helped produce many of the extravagant show numbers associated with the great Hollywood musicals. His leading projects included *Easter Parade* (1948), which won him an Academy Award; *On the Town* (1949), for which he wrote several new songs and won his second Oscar; and *Annie Get Your Gun* (1950), for which he received his third Oscar. Edens's successes continued with *An American in Paris* (1951), *Show Boat* (1951), *Funny Face* (1957), *The Unsinkable Molly Brown* (1964) and *Hello, Dolly* (1969). Before Garland and Merman left Hollywood for Rome in the summer of 1960, he threw a party for them, and the two sang until 3:00 a.m. Edens, a longtime smoker, died of lung cancer in Hollywood in 1970.

BIBLIOGRAPHY

BOOKS

Bond, Johnny. *The Tex Ritter Story*. New York: Chappell & Co., Inc., 1976.

The Cactus. Yearbook. Austin: Texas Student Publications, various years.

Clayton, Lawrence, and Joe W. Specht, eds. *The Roots of Texas Music*. College Station: Texas A&M University Press, 2003.

Cross, Ruth. *The Golden Cocoon*. New York: Harper & Bros., 1924.

De Veaux, Alexis. *"Warrior Poet": Biography of Audre Lorde*. New York: W.W. Norton and Co., 2006.

Lomax, John. *Cowboy Songs and Other Frontier Ballads*. New York: Macmillan Company, 1929.

Luft, Lorna. *Me and My Shadows: A Family Memoir. Living with the Legacy of Judy Garland*. New York: Simon & Schuster, 1998.

Malone, Bill C. *Country Music U.S.A.* Austin: University of Texas Press, 1985.

Oliphant, Dave. *Jazz Mavericks of the Lone Star State*. Austin: University of Texas Press, 2007.

———. *Texas Jazz*. Austin: University of Texas Press, 1996.

Sann, Paul. *The Lawless Decade*. New York: Crown Publishers, 1957.

PERIODICALS

Magazines

College Humor, various issues.
The Coyote, various issues.
Longhorn-Ranger, various issues.
The Scalper, various issues.
Texas Ranger, various issues.

Newspapers

Austin American
Austin American-Statesman
Austin Statesman
The Blunderbuss
Brownsville Herald
Daily Texan
Denton Record-Chronicle
El Paso Herald-Post
Galveston Daily News
The Gossip
Llano News
Paris (TX) News
Prescott Evening Courier
San Angelo Standard-Times
San Antonio Evening News
San Antonio Express
San Antonio Light

Other

Brown, Lawrence. "Jimmie's Joys." *Storyville*, No. 85 (August–September 1985): 212–27.

Gene Ramey Collection, 1977–2004. Dolph Briscoe Center for American History, University of Texas at Austin.

Houston, Reagan, and Roger Ringo. "A Visit to Smith Ballew." *Storyville* 59 (June–July 1975): 164–71.

Hurst, Jack. "Out in the Boondocks, Ritter Tracks a Fox." *Nashville Tennessean*, May 31, 1979.

Kramer, Jack. "Tex Ritter: America's Most Beloved Cowboy." In *Back in the Saddle: Essays on Western Film and Television Actors*. Edited by Gary A. Yoggy. Jefferson, NC: McFarland & Co., 1998.

Raichelson, Richard. Liner Notes. *Jimmie's Joys: The Complete Golden and OKeh Recordings*. Toronto: Jazz Oracle Phonograph Record Co., 2012.

Stinson, Burney. Personal Scrapbook. Courtesy of Burney Fritz Stinson.

WEBSITES

Texas Folklore Society. http://www.texasfolkloresociety.org.

Texas State Historical Association. "The Handbook of Texas Online." https://tshaonline.org/handbook/online.

University of North Texas Libraries Digital Projects Unit. "The Portal to Texas History." http://texashistory.unt.edu.

Wikipedia. http://www.wikipedia.org.

ABOUT THE AUTHOR

Richard Zelade is a collector and teller of Texas tales—heroes, outlaws, fussin' and feuds, real tales, tall tales, small tales, music, whores, wars, sex, drugs, rock-and-roll, eccentricities, legends, characters, roadside attractions and tasty grub.

He was born on May 25, 1953, in Brazoria County, Texas. He received a BA, with honors and special honors in history, from the University of Texas at Austin in 1975.

Zelade began writing professionally in 1976. His work has appeared in *Texas Parks & Wildlife*, *Texas Monthly*, *People*, *Southern Living*, *American Way* and many other publications. He is the author of several guidebooks, including *Hill Country* and *Austin*, published by Lone Star Press in Houston.

A multidisciplinary historian, Zelade studies Texas geology, weather, geography, flora, fauna and ethnic folkways, including the medicinal and food uses of native plants.

ALSO BY RICHARD ZELADE

Riding Through Central Texas: 22 Cycle Excursions. Austin, TX: Violet Crown Press, 1981.

Hill Country. Houston, TX: Gulf Publishing, 1984.

Austin. Houston, TX: Gulf Publishing, 1985.

A Century of Serving Texas: A History of the State Fire Marshal's Office, 1910–2011. Austin: Texas State Fire Marshal's Office, 2011.

Lone Star Travel Guide to Central Texas. Lanham, MD: Taylor Trade Publishing, 2011.

Guy Town by Gaslight: A History of Vice in Austin's First Ward. Charleston, SC: The History Press, 2014.

Contributor/Co-Author

Hein, Peg. *Tastes & Tales from Texas*. Austin, TX: Hein & Associates, 1984.

Stone, Ron. *The Book of Texas Days*. Fredericksburg, TX: Shearer Publishing, 1985.

Hein, Peg. *Tastes & Tales From Texas*. Vol. 2. Austin, TX: Hein & Associates, 1987.

Texas: The Texas Monthly Guidebook. 2nd ed. N.p.: Texas Monthly Press, 1988.

Texas: The Texas Monthly Guidebook. 3rd ed. Houston, TX: Gulf Publishing, 1992.

Patoski, Joe Nick. *Como La Flor: A Biography of Selena*. New York: Little-Brown, 1996.